URBAN|WILDERNESS

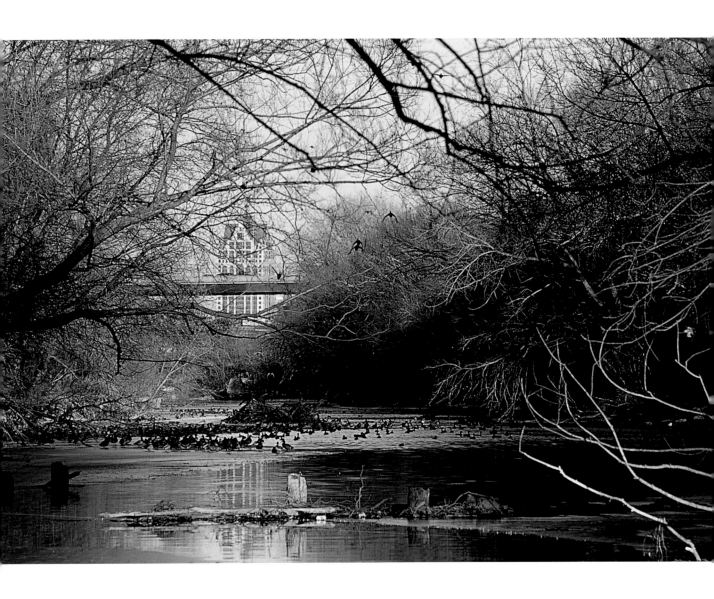

Center Books on American Places

GEORGE F. THOMPSON, SERIES FOUNDER AND DIRECTOR

URBAN | WILDERNESS

Exploring a Metropolitan Watershed

Photographs and Stories by Eddee Daniel

THE CENTER FOR AMERICAN PLACES

AT COLUMBIA COLLEGE CHICAGO

Published in 2008. First edition.
Printed in Singapore on acid-free paper.

The Center for American Places
at Columbia College Chicago
600 South Michigan Avenue
Chicago, IL 60605-1996, U.S.A.
www.americanplaces.org

16 15 14 13 12 11 10 09 08 1 2 3 4 5

Library of Congress Cataloging-in-Publication Data

Daniel, Eddee.
 Urban wilderness : exploring a metropolitan watershed / photographs and stories by Eddee Daniel. --
1st ed.
 p. cm. -- (Center books on American Places ; 12)
 Includes bibliographical references.
 ISBN 978-1-930066-81-6 (hardcover) -- ISBN 978-1-930066-82-3 (pbk.)
 1. Natural history--Wisconsin--Menomonee River Watershed. 2. Urban watersheds--Wisconsin--
Menomonee River Watershed. I. Title. II. Series.

 QH105.W6D36 2008
 508.775--dc22
 2008005684

ISBN-13: 978-1-930066-81-6 (hardcover)
ISBN-10: 1-930066-81-3 (hardcover)
ISBN-13: 978-1-930066-82-3 (paperback)
ISBN-10: 1-930066-82-1 (paperback)

Frontispiece: *View towards downtown Milwaukee from 35th St., Menomonee Valley.*
Page viii: *Painted turtle, Jacobus Park, Wauwatosa.*

For my daughters, Alex and Chelsea

"Wilderness can be appreciated only by contrast, and solitude understood only when we have been without it. We cannot separate ourselves from society, comradeship, sharing, and love. Unless we can contribute something from wilderness experience, derive some solace or peace to share with others, then the real purpose is defeated."

—SIGURD F. OLSON, REFLECTIONS FROM THE NORTH COUNTRY (1976)

CONTENTS

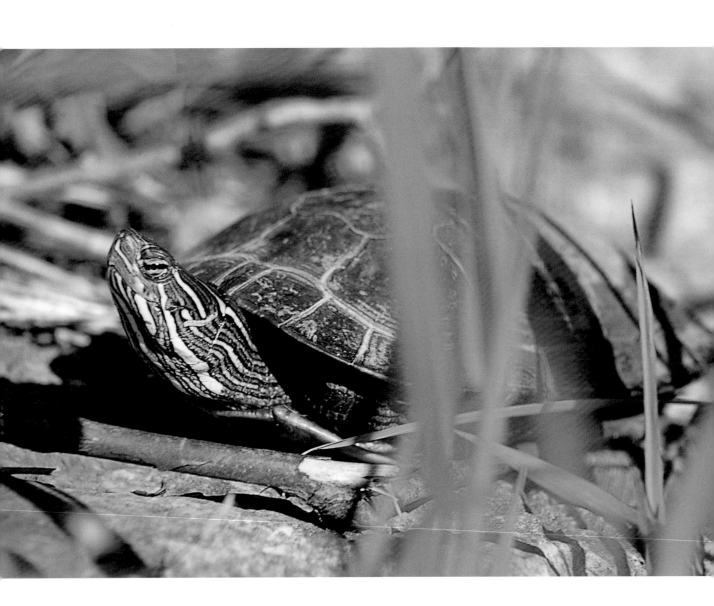

THE IDEA OF WILDERNESS was born of the tension between civilization and nature. The impetus for this book came when I recognized that tension in my own community and, further, when I realized that the underlying assumption is false: civilization and nature are not inherently separate conditions. Rather, they reflect how we think about the world as a unified whole. Each of us understands the relationship between the ideas and realities of civilization and nature based on our historical, cultural, and individual experiences. My own experiences have led me to explore the edges where these realities collide and to share my discoveries through words and images.

No one taught me to be an explorer. It was just something I did as a child because I had the great fortune to be surrounded by wonderful natural areas and because I grew up at a time when children were allowed to roam. Since then I have found that this inclination has lasted a lifetime. Wherever I travel, one of my first impulses is to go outdoors and walk around in order to discover where I am. Sometimes what I discover is urban and sometimes it is wild. Now I live near the Menomonee River in Milwaukee, Wisconsin, a place where urban and wild intersect.

We can observe a river and the natural lands around it up close, examining minute details, such as the delicate colors of jewel weed in bloom or the way water flows around a particular stone. In doing so, we may create a sense of the whole by increments. We can also back away from the river and, with a new perspective, observe how it interrupts the pattern of city streets, how those very same details—and even the river itself—are hidden within a dark canopy of leaves and how people use and abuse the water and the land. The river, then, much more than a passive and picturesque artifact in the landscape, represents meanings and values that are at the core of how we understand our place in the environment.

It is hard to observe any subject from these different viewpoints simultaneously, but a thorough examination requires it. Throughout the book these two viewpoints—the

intimate and the expansive—are interchanged, as are my telephoto and wide-angle lenses. Through photographs and anecdotes, the story of the watershed is organized by its geography, beginning at the headwaters and proceeding downstream towards the mouth of the Menomonee River. Each chapter is devoted to a particular section of the watershed and emphasizes themes specific to that vicinity. Several important tributaries are given chapters of their own. Within these pages the reader embarks on a journey of discovery: looking closely at subtle and, perhaps, surprising natural beauty, but also stepping back occasionally to reflect on the concerns and ecological issues inherent in viewing nature in an urban context.

The text and the photographs are meant to be complementary ways of seeing the landscape, methods of storytelling that are related but also distinct and able to stand alone. The individual stories, like the images, are intended to be read as vignettes rather than as a continuous narrative. This expresses the episodic nature of my explorations, which took place over several years and in all seasons, as well as the often fragmentary character of the urban wilderness.

It is also important to note the inevitability of change. The Menomonee River watershed is a dynamic place in the landscape, and the stories in this book represent a place in time. Some of the places described in these stories have changed significantly since they were written: some natural areas have been restored or improved and others have been lost to development. These changes are part of the ongoing story of the urban wilderness.

INSPIRATION CAN TAKE MANY FORMS. It can incubate slowly over many years, and it can come in the flash of an "aha!" experience. This book came about as a combination of both. Among my earliest and most important influences, both as a photographer and an environmental activist (and long before I imagined myself as either), was the pioneering color photographer, Eliot Porter, who used his art to champion the natural world. As a teen I spent precious dollars on a paperback edition of his groundbreaking book, *In Wildness Is the Preservation of the World*. The same worn copy sits on a shelf above my desk as I write these words. The seed that was planted then took about thirty years to germinate.

Bob Boucher, the founder of Friends of Milwaukee's Rivers, an organization I joined in 1997, provided the catalytic spark for my undertaking of the *Urban Wilderness Project*. His vision of a unified system of environmental corridors within the Milwaukee metropolitan region inspired me to explore my surroundings once again, this time in the watershed of my current home. He enabled me to interpret his vision in my own way and empowered me to make it a personal endeavor. For these things I am in his debt.

This book has been more than a personal journey; it has been a truly collaborative effort and could not have been accomplished without the contributions of a great many people and organizations. I thank the official sponsors: the *Urban Wilderness Project* is an educational and advocacy project sponsored by Friends of Milwaukee's Rivers, Menomonee Valley Partners, Inc., Milwaukee Metropolitan Sewerage District, River Revitalization Foundation, The Sierra Club—Great Waters Group, Sixteenth Street Community Health Center, and the Urban Ecology Center. I consider it an honor to be working in partnership with these fine organizations and, in particular, with their leaders for their guidance and their faith in me and my project. They are: Lynn Broaddus, Laura Bray, Cheri Briscoe, Lilith Fowler, Kimberly Gleffe, Ken Leinbach, Peter McAvoy, Kevin Shafer, and Rosemary Wehnes, along with many more board members and staff.

The following individuals provided indispensable expertise and guidance, lending my words an authority I could not have commanded without their assistance: Nancy Aten, Glen Grieger, Karen Johnson, Larry Leitner, Cheryl Nenn, and Greg Septon. I am also grateful to have been able to work with Peg Kohring and all of the staff in the Milwaukee office of the Conservation Fund. I especially want to thank The Conservation Fund for its 2003 Kodak American Greenways Program Award to the *Urban Wilderness Project*.

For their unflagging support and encouragement during a process that sometimes seemed endless, I wish to thank my dedicated team of writers, readers, and confidants: Michele Arney, Jack Broughton, Ben Gramling, John Gurda, Shirley Jeffrey, Dan Small, and Jim Uhrinak.

Many officials and administrators in a wide variety of organizations, agencies, and all levels of government have helped by providing me with information, including: the U.S. Environmental Protection Agency, Wisconsin Department of Natural Resources, and the cities, towns, and villages of Brookfield, Butler, Germantown, Menomonee Falls, Mequon, and Wauwatosa. If there are no inaccuracies in my accounts it is due in large part to these many unheard voices in the chorus behind my solo. If there are, I apologize for my own lack of diligence in ferreting them out.

George F. Thompson, founder and director of the Center for American Places at Columbia College Chicago, saw potential in this project when it was little more than a gleam in my eye, and he guided me through many revisions to reach this point. My thanks to George and all who helped bring *Urban Wilderness* to light—and print.

To my wife, Lynn, I owe the most. It was she who endured my years of geographical exploration and soul searching and who never hesitated in bestowing her approval.

Finally, I thank my parents. Although they couldn't have known it at the time, it was their openness in allowing me the freedom to explore the natural world that led indirectly, but inevitably, to this point. I would not be the person I am today had they not taught me, more through deeds than words, that being mindful of the needs of other people and caring towards the earth are not activities divorced from our daily lives, but rather the way to live in the world.

This book was made possible by the generous financial contributions of the following individuals, corporations, and organizations:

Dorothy M. Boyer; Brico Fund, LLC; Cheri Briscoe; Janet Carr; CH2M HILL; David Ciepluch; The Conservation Fund; Kathy and John DeCarlo; Sue Dodson; Dorothy Inbusch Foundation, Inc.; Carolyn Edwards; Greater Milwaukee Foundation —Harry F. and Mary Franke Idea Fund; Kathy Hanold; Alice Hauen; HNTB Corpora-

tion; Shirley Jeffrey; Jim and Liesa Kerler; Don and Mary Jo Layden; Frank Loo and Sally Long; William Lynch and Barbara Manger; Peggy Maguire; Marquette University High School; Menomonee Valley Business Association; Menomonee Valley Partners, Inc.; Kevin and Luann Moraski; North Shore Presbyterian Church; Glenn and Jane Pelton; Nancy Perry; C.M. Phillips; The Rexnord Gear Group; Sierra Club—Great Waters Group; Sierra Club—John Muir Chapter; Wells Fargo & Company; Susan Winecki; Wisconsin Energy Corporation Foundation; Unitarian Universalist Church West; and Usinger Foundation, Inc.

URBAN|WILDERNESS

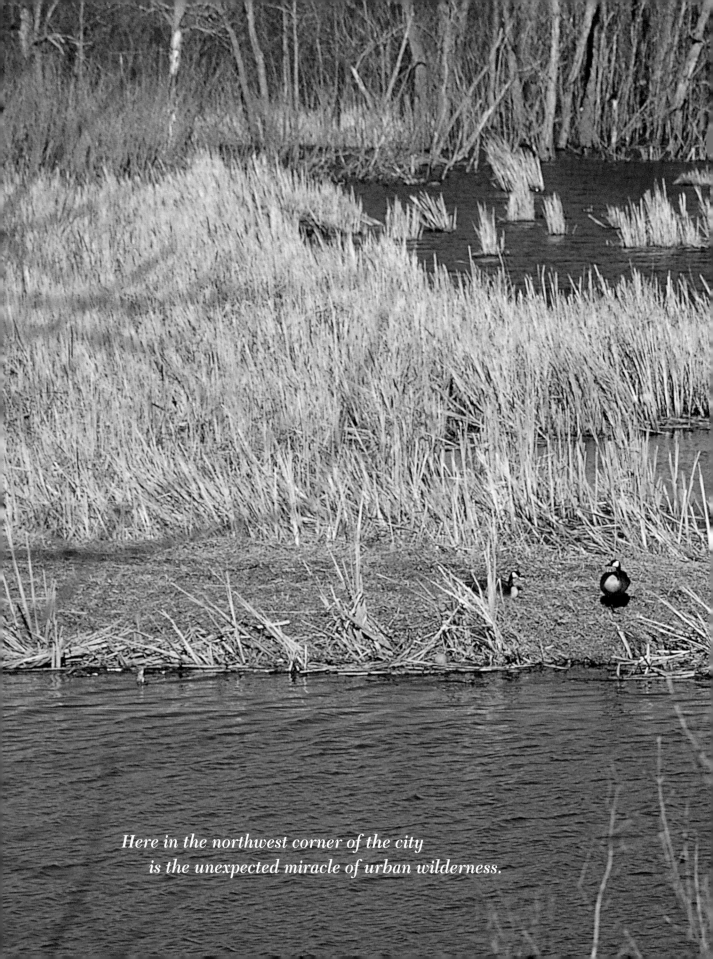

*Here in the northwest corner of the city
is the unexpected miracle of urban wilderness.*

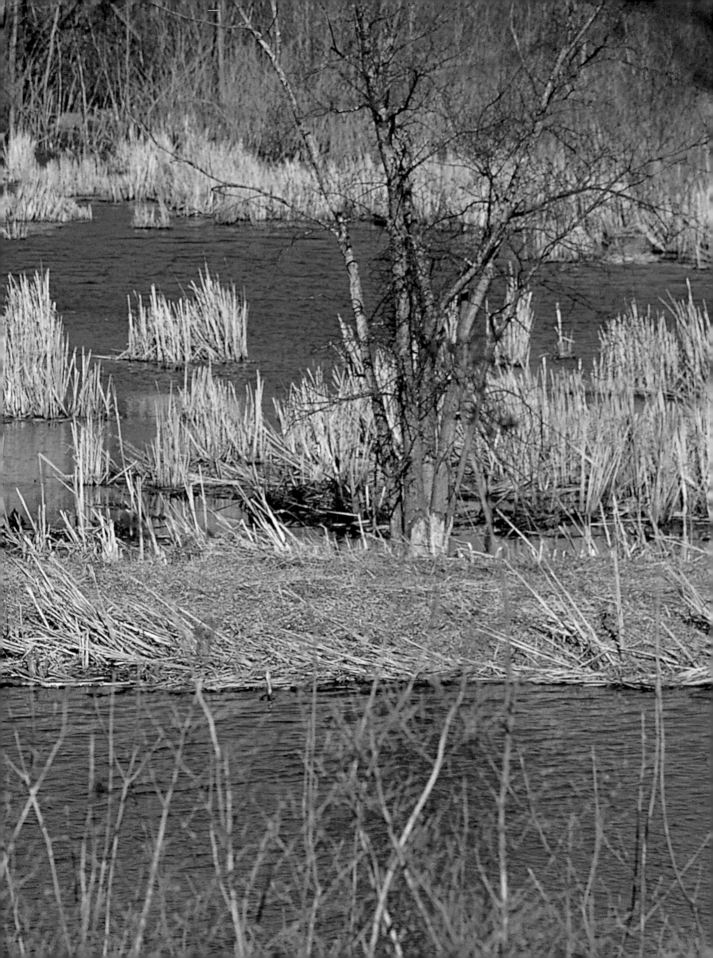

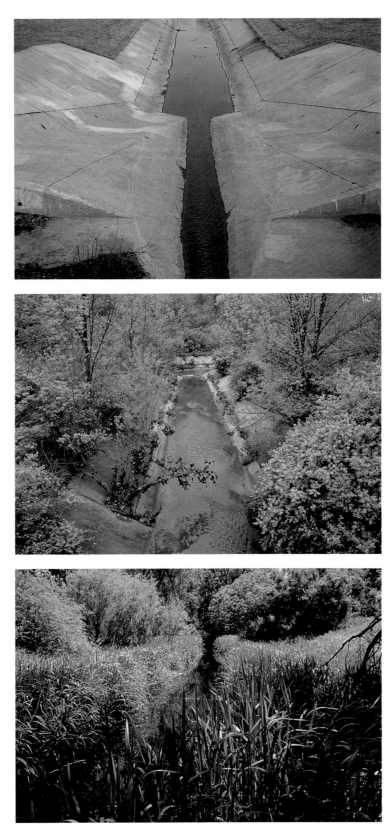

Top: concrete channel, Honey Creek, Milwaukee; center: drainage ditch, Underwood Creek, South Branch, West Allis; bottom: grasses, Dousman Ditch, Brookfield; previous spread: Little Menomonee River Parkway, Milwaukee.

I BEGAN TO EXPLORE THE NATURAL WORLD at such a young age that the memory is deeply buried in a crevasse of childhood. My house stood on a high plateau, above a dark forest canyon carved by an untamed torrent. Sheer cliffs dropped into its mysterious depths. Scaling down them led to a world of adventure and discovery. There were hidden recesses, thickets, and dells. There were islands over which to claim sovereignty and deep pools in which to plunge. A needle-laden pine grove in the shelter of overhanging rock became a secluded sanctuary, a place for contemplation and respite from the exertions of exploration.

Never mind that the plateau was a subdivision cul-de-sac bulldozed flat or that the "canyon" below could be reached by walking a short distance to where a road sloped down and spanned the burbling creek. The forty-foot drop was cliff enough; the wooded creek-side was forest enough. Never mind that the deepest pool reached only to a skinny ten-year-old's ribs or that the mighty cascades could be waded across. The cool, soothing rush of flowing water was real enough. The hoarse cough of frogs concealed in grassy banks was real enough. The scent of pine on the hill—and skunk cabbage in the muddy hollows—was real enough.

It was my first wilderness. And it was more than enough; it was formative. Research demonstrates that exposure to nature in one's youth is instrumental to developing a conservation ethic.[1] These early experiences helped shape my understanding of the world.

This book is an introduction to a river and a watershed. It is also a record of exploration and testimony to the discovery of an unfamiliar truth: not only is nature present in the city, but also the city is inseparable from nature. It is a declaration of what is possible in the context of what is actual. Its subject is a particular place—the Menomonee River watershed in the Milwaukee metropolitan region of Wisconsin. Its object is to expose and celebrate something that can exist in every American city and

town, something with universal implications, something intangible, even paradoxical: an urban wilderness.

The concept of wilderness, although it has changed over time, has been and continues to be a powerful influence on the North American psyche.[2] Historically and metaphorically, it assumes mythical proportions. Despite the real impact that American Indians had on the land prior to the Europeans' arrival, much of our national character was forged in the crucible of the vast landscape against which we pitted and measured ourselves. Hewing a homestead out of the wilderness was proof of one's mettle, and taming it was part of our manifest destiny. That rugged character, oriented toward achievement, has led to great accomplishments, not the least of which is the creation of vital cosmopolitan centers of government, commerce, and culture. That destiny, however, has also all but eliminated the very wilderness that shaped our character. It is even tempting to believe that, in conquering our fear of wilderness, we have outgrown the original measure of our civilization.

Wilderness is traditionally defined as nature untrammeled by humankind. There is much to be said for preserving what little is left, and fortunately a great many voices have joined the cry championing that cause. This book offers another perspective, a view of wildness that includes the city. According to Gary Snyder, "to speak of wilderness is to speak of wholeness."[3] Snyder insists, "it is proper that the range of the [environmental] movement should run from wildlife to urban health. But there can be no health for humans and cities that bypasses the rest of nature. A properly radical environmentalist position is in no way anti-human."[4] Nor is it anti-urban. We all live within ecosystems defined by watersheds and bioregions, whether we live in the country, surrounded by wildlife, or in the city, surrounded by people. It is arguably better for the environment as a whole that more people live in cities, since concentrated development patterns leave more room for agricultural and natural lands. Unfortunately, for most of us, in cities and suburbs alike, our modern lifestyle has made the ecosystem invisible and the watershed invisible. Sometimes even a river is invisible.

Like all rivers, the Menomonee has many facets: it is a habitat able to support wildlife within close proximity of people; it is an irregular ribbon of green space in an orderly, gray grid; it provides an attractive setting for a variety of recreational activities; it has also been a convenient dump, a sewer that washes away waste and debris. For industry, it is a utilitarian resource. For those who live in its floodplain, it is an ever-present threat of destruction. For others, it offers refuge as a source of solace and spiritual healing.

As rivers go, the Menomonee is modest. The superlatives that attach themselves readily to others—such as the Mississippi and Missouri, or the Colorado and Hudson—

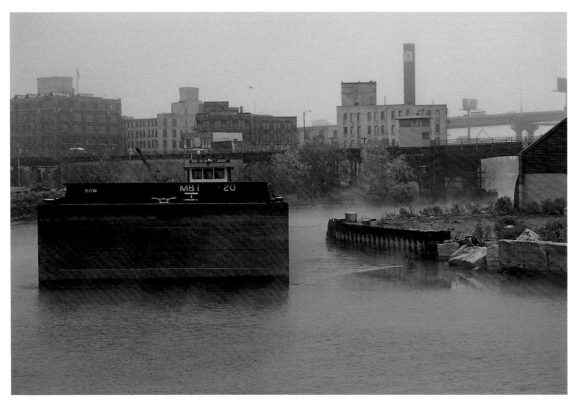

Canal near the Menomonee's confluence with the Milwaukee River. Milwaukee exists because of the utility of its harbor and rivers. Of the vast fertile estuarine marsh at the mouth of the Menomonee, nothing remains.

don't describe the Menomonee. Neither mighty nor majestic, the Menomonee nevertheless has its own story to tell. Though its name may be unfamiliar to outsiders, it is typical of many rivers found throughout urban centers in North America and the world.

Historically, settlements grew up along rivers because they were useful. Milwaukee exists because of the harbor on Lake Michigan, located at the culmination of its rivers. While the city shares its name with a larger river, because of its geography and historical significance, the Menomonee better represents the complex relationship between river and city.

Its main source rises in a wide, boggy draw named—wonderfully—Wilderness Park. Commonly called the Germantown Swamp, the draw is still surrounded by agricultural land—although that land shrinks yearly. Much of the river runs through quickly developing suburbs. By the time it reaches Milwaukee, it is little more than a canal in a completely industrialized valley that bisects the city. The wide Menomonee Valley is now the subject of intense scrutiny, as Milwaukee's residents and city planners rediscover its location and value. Redevelopment plans that include river rehabilitation have been put in motion. Although a few people always have extolled the aesthetic values of the river, it

is only recently that an economic interest in preserving—and even restoring—the natural river has begun to compete with its utilitarian functions as a conveyer of goods and effluents and as a generator of power.

In recent years, the Menomonee River has become a lightning rod for controversy. There is ever-greater demand for dwindling stretches of undeveloped riverfront property. Upstream development and failed flood-control projects have resulted in disastrous flooding. Water quality has improved since the implementation of the Clean Water Act of 1972, but the river is subject to continued pollution from "non-point sources" and occasional sewer overflows, despite the construction of multibillion dollar "deep tunnels" designed to prevent such occurrences. The restoration and preservation of natural areas, seen by some to compete with flood- and pollution-control efforts, can actually contribute substantially to these efforts, and the regional sewer district has a comprehensive conservation plan in place for this purpose.

Despite continued abuse, the river is indisputably valuable to the communities along its course. But there is tension among those who advocate private and public use of the resource. Milwaukee County is fortunate. A century ago, foresighted civic leaders designated many of the riverways in the county as public land and parks. The outlying suburbs are less well endowed. As development proceeds, pressure increases on what land remains. The key to maintaining a healthy urban watershed ecosystem is balance and the implementation of planning practices that recognize the importance of natural areas in every community.[5]

This book envisions a continuous network of natural lands along rivers, creeks, and streams in the watershed. Such a network would serve several purposes. First, it would maximize the potential for a healthy, fully functioning ecosystem with viable habitat for a wide diversity of plants and wildlife. Second, it would create links to connect the city, surrounding suburbs, and outlying agricultural lands. And, third, it would remain a place accessible to future generations of young adventurers, encouraging personal relationships with nature and the development of the conservation ethic that is essential to a sustainable future.

The purpose of this book is not to provide a glimpse of far-away or exotic locations, but to reveal the near-at-hand and illuminate the commonplace. It is also to promote learning about the world by direct exposure to it. My hope is that this book will inspire readers to explore their own local watersheds. It is far more important to discover where we are than to seek out new places.

In his famous essay, "Nature," Emerson begins by saying, "Foregoing generations beheld God and Nature face to face; we, through their eyes. Why should not we also

enjoy an original relation to the universe?"[6] He goes on to define nature as the "essences unchanged by man," and he observes that all of humankind's efforts are insignificant in the big picture of the world. That perspective, penned in 1836, is hard to accept today. In his wildest imagining, Emerson could not have foreseen the profound transformations of the natural world that so marked the twentieth century. The momentous shift in our ability and willingness to reshape our planetary home may be the defining characteristic of our time. From the sprawl of the megalopolis to the silent corrosion of the very atmosphere that makes life possible, we can no longer afford to see ourselves as separate from or even distinguishable from nature.

To live fully we must feel the wholeness of nature and understand the source of the air in our lungs, the nutrients in our veins, the water in our towns and cities. We can't live on Earth as if we are renting space in nature; we *are* nature, wherever we live. Socialization and selfishness often blind us to that reality. We must dispel the myth of division between the human and the natural, penetrate the veil of civilization, and welcome wilderness back into our lives.

So, let us "enjoy an original relation to the universe" and explore an urban wilderness. The Menomonee River can be our guide.

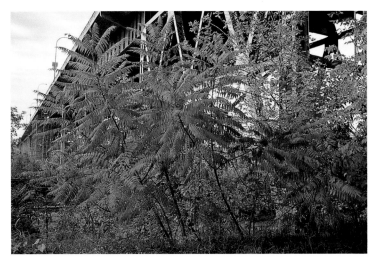

Top and bottom: Sumac and the 35th Street viaduct, Menomonee Valley. It is more important to discover where we are than to seek out new places.

PARKS AND NATURAL AREAS WITHIN THE MENOMONEE RIVER WATERSHED

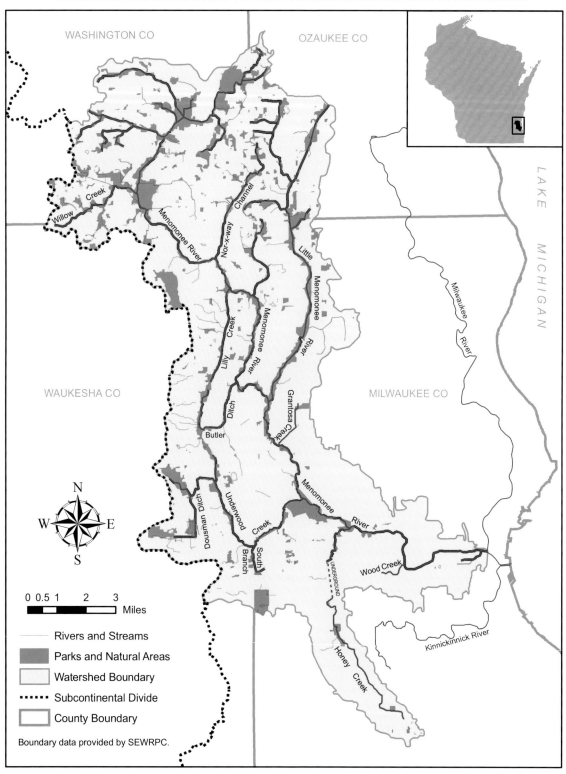

A N URBAN WATERSHED is defined not by municipal or other civil divisions, but rather by the natural flow of water within its landforms. This, of course, is true of all watersheds, whether urban, suburban, rural, or wild. Tributaries draw water from the areas surrounding the main river in the system, which then drains into a larger body of water, in this case the Milwaukee River and then into Lake Michigan. The western edge of the watershed lies along a subcontinental divide that separates the Great Lakes and the Mississippi River watersheds. Part of the larger Milwaukee River Basin, the main stem of the Menomonee River is approximately twenty-eight miles long. The watershed encompasses 136 square miles.

The Menomonee River was named after an American Indian tribe (commonly spelled Menominee) that, although it has historical ties to the watershed, has always resided primarily in northeastern Wisconsin. The name also refers to the wild rice that once grew abundantly in the estuary at the mouth of the watershed.

Much of the Menomonee River watershed was developed following incorporation of the city of Milwaukee in 1846. The entire watershed includes all or portions of seventeen different cities, towns, and villages, making regional coordination of watershed and land-use issues challenging. By the middle of the twentieth century, it had become the most industrialized watershed in the region. In 2000, only thirty-six percent of the land was still considered rural or open space, and it continues to be developed at a rapid pace. This is true despite an overall *decrease* in population in recent years, an indication of changes in land-use patterns that contribute to suburban sprawl. Between 1970 and 2000, the population within the watershed fell from 346,412 to 321,999.[1]

The natural lands and environmental corridors within the Menomonee River watershed are closely associated with its river, streams, lakes, and other wetlands, as illustrated on the two maps. These are generally classified into three categories: primary

CIVIL DIVISIONS IN THE MENOMONEE RIVER WATERSHED

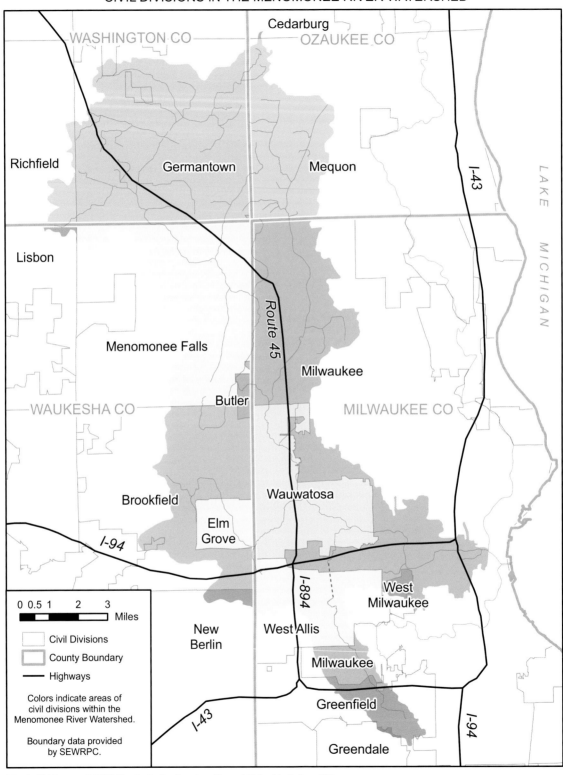

environmental corridors, which are at least two miles long and 200 feet wide; secondary environmental corridors, which are smaller and narrower; and isolated natural areas, which must be at least five acres but which are separated from environmental corridors by urban or agricultural development. In 2000, the combined total of these natural areas and corridors was 10,500 acres, or about twelve percent of the watershed.[2]

The precious fluids of the earth flow inward from these farthest reaches, gradually gathering and mingling in the arterial river that courses through the heart of the city.

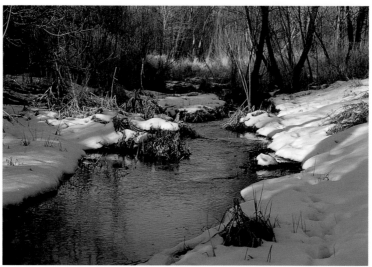

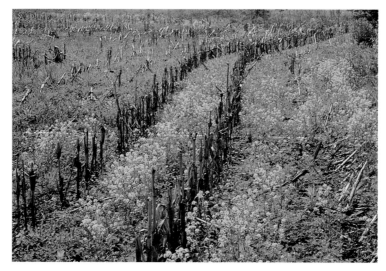

Top: Tamarack Swamp, Menomonee Falls; center: Willow Creek, German-town; bottom: near Dousman Ditch, Brookfield; previous spread: Lilly Heights Park, Brookfield.

H EADWATERS ARE BOTH the outermost reaches of a watershed and its many starting points, where the earth spontaneously gives up the water that is the source of all life. Leslie Marmon Silko, of the Laguna Pueblo in New Mexico, says, "In the end we all originate from the depths of the earth."[1]

The watershed emanates from springs and seeps that are the sources of numerous small streams and creeks, but its headwaters can be grouped into five major tributaries that fan out like an elongated mitten around the main stem of the Menomonee River. The main stem itself begins in the Village of Germantown near Wilderness Park, a nominal fragment of the wild lands that once covered the state of Wisconsin. The Little Menomonee River reaches north into the city of Mequon. Willow Creek, the farthest west, rises in Richfield Township; Lilly Creek in the city of Brookfield. Underwood Creek has two branches that originate in the cities of Brookfield and West Allis. Finally, the mangled thumb of the mitten, Honey Creek, flows out of the south from the city of Greenfield.

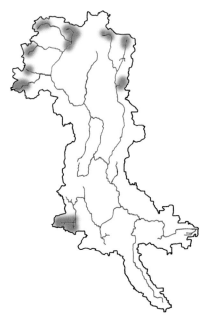

Of Water and Stones

Moses Fieldhouse died at age forty-three in 1852. These bare facts are available from the grimy but still legible inscription on his headstone, which is otherwise very white and polished with time to a pearly softness. The stone, its edges worn and rounded, remains upright in

Union Cemetery, located on Town Line Road, near the source of Willow Creek. There are other stones from that era; some have fallen flat, a few have broken in two. They are made of nearly translucent marble. Age-blackened incisions seem to float upon their surfaces, as if residual life glows from within. Newer stones, their corners sharp and their engravings crisp, have been added among the elder ones. Past and present mingle, the ancient dead neither forgotten nor separate. Uniform gray granite lends unintended uncertainty to the clarity of newly cut stones. By contrast, the older ones, in stark black and white, slowly have come to resemble the earth out of which they were carved. The grass is neatly clipped around new and old alike, even those that rest on the ground. Bouquets of cut flowers adorn several. Reverent care is evident.

Political boundaries divide the land with a surveyor's imposed geometry. Such boundaries seldom conform to visible natural contours, let alone the invisible line of a watershed. True to form, Town Line Road draws a ruler-straight line where the land draws curves. But here, where Union Cemetery graces the top of a prominent knoll, road and boundary briefly coincide with the western reach of the Menomonee River watershed. This edge of the watershed also coincides with the subcontinental divide that separates the vast Mississippi River drainage from the Great Lakes Basin. Looking out from this hilltop, one can envision water running off in both directions, toward Lake Michigan in the east and the Mississippi River in the west. With some effort, one can imagine a raindrop making its way from here either to the Atlantic Ocean or Gulf of Mexico.

Seeing the land as interconnected watersheds enables one to grasp the interdependent relationships among urban, suburban, rural, and natural lands. At Union Cemetry, it is possible to discover the name on a tombstone, more than 150 years after his death, of a man related to me only by common humanity. These enduring stones have power to establish connections where none were apparent, across time and space, between what is known and what is unknowable. Ocean-seeking water also establishes connections, connections that define watersheds, within ecosystems that may go unnoticed, but which nevertheless are inescapable.

Down the hill from the cemetery, a short way past the last house and across the road from a white-fenced horse farm, is cool, damp woodland. A choppy sea of horsetail covers the ground knee-deep. Their upward gesturing prongs are perfectly suited to trap the tufts of cottonwood seed that fall all around; the ground seems covered in frothy foam. Sunlight streaming through a broken canopy makes the forest floor glow white and gold.

A narrow pond of brackish brown water is also speckled with floating cottonwood fluff. Puckish, the pond is larger than it first appears. It curves behind a screen of sandbar willows that lines its verge. Wild irises grow here and there amongst the willows.

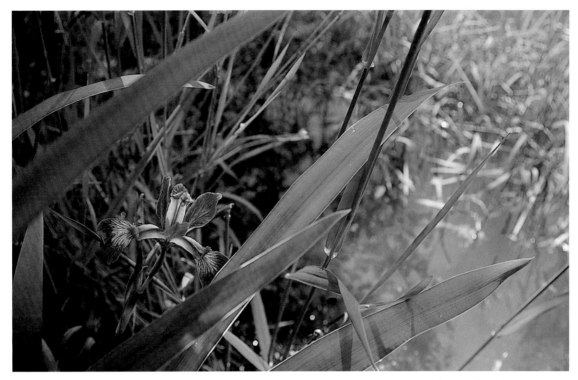

Wild iris, Richfield Township, near the headwaters of Willow Creek. The watershed's hidden ponds and fragmentary woods bear no markers proclaiming their importance to ecological integrity. We must be the bearers of this truth.

Though smaller and less flashy than their cultivated cousins, their casual presence in the wetland is unabashedly sensational. Three widespread, arrow-like petals thrust dramatically outwards, yellow centers burning through white, ending in triangular purple tips that flash with complementary brilliance.

Though soberly colored by contrast, the dragonflies are equally captivating. One darts back and forth so quickly, with jerky shifts of direction, dips, bends, and lifts, that its position in space is hard to pinpoint, like an entomological representation of an atomic particle. When it lands it remains as rigid as a museum replica of a biplane, which it superficially resembles. The richly veined wings, such a dark brown as to appear nearly black, and white abdomen make it hard to spot in the tangle of dead willow stalks on which it rests. Before I can fully focus it is gone, as if I'd imagined it.

The instantaneous meets the infinite, and it reminds me that water, like time, is opmnipresent, flowing through our veins and our landscapes. Unlike cemeteries, which are ethnographic as well as topographic statements about our relationship to eternal questions, the hidden ponds and fragmentary woods of the watershed bear no markers proclaiming their importance to ecological integrity. We must be the bearers of this truth within ourselves. My relationship to this unidentified woodland and its ordinary pond,

which few other people may ever see, is more profound than my relationship to Moses Fieldhouse and the others who are buried up on the hill. Perhaps one day we shall come to the wood and the water, as we do to the cemetery, to pay our respects. In nature, as in cemeteries, visitation stirs remembrance, cements relationships.

Reverence is appropriate. The flowers are already here.

Seeking the Source

Bearing both symbolic and real ecological import, the source of the main stem of the Menomonee River lies somewhere in a large, swampy woodland completely surrounded by cultivated fields—isolated, secretive, and, to a curious explorer, compelling.

It's a perfect winter day, sunny and cold but not frigid. The Menomonee has dwindled to a narrow brook, which today is as solid and safe as a sidewalk. Just off the road a dead raccoon lies fixed in place atop the ice. Superstition would make of it an omen; science would see a scavenger's good fortune, a treat found by some fox and partially devoured. A gaping hole in its belly reveals scraps of frozen viscera. The shelf of ribs is as hard as a stone sculpture; the carcass remains largely intact. Perhaps the full feast was thwarted by the severity of the season.

I linger in fascination over the ice that holds the dead animal in its grip. Its clarity reveals a galaxy of encased bubbles, with a marvelous and curious pattern. Instead of the usual randomness, these bubbles form clearly defined streams, as if they were cryogenically flash-frozen in mid-flow. How long does it take for a flowing creek to solidify? The water must continue to shift, glacier-like, as it stiffens. What patterns in our lives have become solidified like this without conscious control? What routines grow rigid with infinitesimal slowness while we fancy ourselves as free as bubbles in a flowing stream?

In a sliver of woodland between two farms, the diminutive river narrows further. It could be jumped in a pinch, but several makeshift bridges have been constructed. One is a study in overkill. It has a pair of sturdy logs where one would suffice and a rope handrail to top it off. I am reminded of the viaducts crossing the industrial valley downstream. More than this thin ribbon of water connects the beginning of the watershed with its markedly divergent end. Is the impulse to engineer natural terrains symptomatic of a human need to control nature? Can we control that need?

The broad, swampy woodland lies ahead like an invitation to an inner sanctum. Although until now the stream has run northeast, directly toward the widening, invitingly wild woods, it now veers north toward farmland. There it forms a boundary between plowed fields and open marsh. The ice turns to slush, its surface no longer

trustworthy. A gap opens in the wood. The stream is completely exposed. Even the tall grass has bent low, as if ducking for cover. Ahead, maybe half a mile away, the watercourse bends back toward the alluring sanctuary of wild woodland. But the ice is unstable and the field is agonizingly open. The mood is shattered and my quest suspended when a car pulls up in full view at the nearby farmhouse and dogs begin barking furiously. Like the raccoon, my resolve is gutted and impulse frozen—though for me it is fortunately a temporary condition. Postponing my pilgrimage for a more promising day, I turn back. The uproar from the farm deepens the silence in the wood.

Extremities

In an effort to reach as many sources of the watershed's tributaries as possible, I find myself in the city of Brookfield in midwinter, tramping across an open expanse of frozen level ground. Unobstructed, a bitterly cold wind races across the land. My earlobes sting, my fingertips grow numb.

This is no wilderness. To the south a perfectly flat field offers an unbroken view across the short stubble of severed cornstalks to where banks and office towers top a

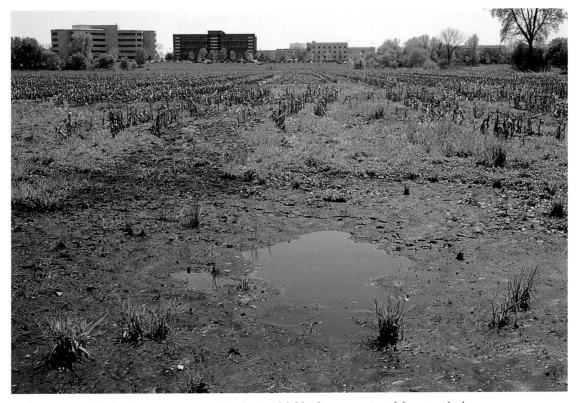

In the vicinity of the headwaters, Dousman Ditch, Brookfield. The extremeties of the watershed—seeps and springs and tiny trickles—are vital and sensitive.

slight rise a half-mile away. To the west lies an even more severe surface: A thin layer of new snow lies like a sheet stretched taut over a tabletop. Bereft of leaves, the distant tree line cannot conceal the near edge of a housing subdivision. Drainage ditches that divide the fields are the watershed's only visible presence. At the edge of the wood they disperse.

The extremities of the watershed—seeps and springs and tiny trickles—are like the capillaries at the tips of one's fingers: vital and sensitive. Water runs inward from these farthest reaches, gradually gathering and mingling in the arterial river that flows into the heart of the city. At my feet I find a frozen, blackened leaf, a pitiful reminder of warmer seasons. I pry it from the frosty ground and note the hierarchical structure of stalk, midrib, and veins, so similar to that of a watershed. Nature's congruencies never fail to fascinate me. I release it and watch it swirl swiftly away, then turn my back to the wind and follow before my extremities succumb to frostbite.

Wilderness Park

Acquiescent for a change, the swamp allows entry. Summer makes this quite impossible. The swamp sucks at one's feet and throws up vast clouds of mosquitoes. It is autumn now, which brings a comparative calm. The soil is dry, the insects dormant. Brittle leaves, brown and drab, crunch loosely underfoot. A great variety of trees—silver maple, green ash, basswood, even the beleaguered American elm—crowd together, young and old. In places I must weave in between and around them, as if each were pressing closer for an individual introduction. A squadron of alarmed mourning doves scrambles in abrupt and clamorous unison. The gray wood is suddenly a blur of gray wings, as if the trees themselves had erupted and taken flight. In a moment the commotion dies. The trees revert to stiffness.

At eye level a series of spray-painted red spots recedes into the depths of the swamp. Brash scarlet breaks down with distance into burgundy, then a charcoal brown so dark and gray that it seems almost natural. On an overcast day or at dusk, without the sun as a guide, the featureless uniformity of this swampy forest would present a formidable challenge even to the well-oriented. So it is no surprise that a hunter, hoping to make it home by suppertime, would need the rudimentary trail.

There are also less subtle paths. A cleared, grassy strip about six feet wide curves in broad arcs through the heart of the swamp. Because the ground is impassably saturated for much of the year, it is most likely for a snowmobile: a secret, private run carved into the wilderness, for, despite the intrusions, this is as close to *true* wilderness as can be

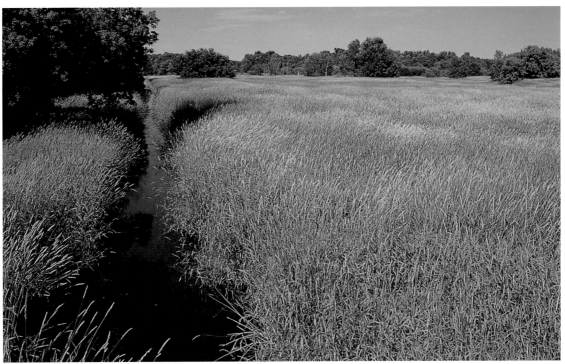

Greenseams Program conservation area, Germantown. Near the headwaters of the Menomonee, the village of Germantown has designated a "Wilderness Park," such a rarity in a metropolitan area as to be a treasure nearly beyond comprehension.

found in the watershed. Officially designated a "natural area of statewide significance,"[2] this ecologically precious—and partially protected—wetland is completely surrounded by farms and private land. Currently there is no public access. A "wilderness park" is such a rarity this close to an urban center the size of Milwaukee that it is a treasure nearly beyond comprehension. We are acculturated to seeing the land in polarities, as either "mine" or "theirs," private and forbidden or public and accessible; natural or unnatural. But, as N. Katherine Hayles points out, the paradox of wilderness anywhere in the United States is that it is "managed land, protected by three-hundred page manuals specifying what can and cannot be done on it."[3] Wilderness is both natural and unnatural, owned and un-ownable. Plans by the Village of Germantown to provide public access add to the unfortunate irony, for by doing so they may unwittingly diminish the very qualities that led officials to name it a "Wilderness Park."

In order to accept the wilderness, let us give up all notion of possession and instead allow ourselves to be possessed of its spirit. Where it is still possible, let us relinquish the land to wildlife, for the fox and the owl, the box turtle and the red-eyed vireo, and the yellow birch and white cedar are its inheritors. Then we will know that we are the beneficiaries of their inheritance, for in granting it we remain free.

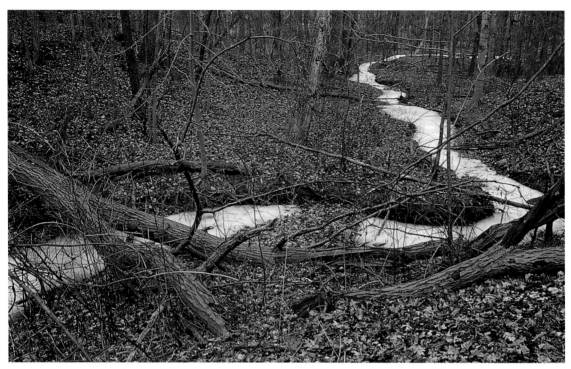

A minor tributary along the Menomonee River Parkway. In order to accept the wilderness, we must give up all notion of possession and allow ourselves to be possessed of its spirit.

Headwaters

A property owner who lives adjacent to Wilderness Park allows me to cross his yard. I am still looking for the headwaters of the river, but the stylishly quaint pond behind his house is the only water I find. The ground is sporadically soft and moist, and the many fallen trees are covered with a thick layer of moss, but it is mostly dry. The swamp is longer than it is wide, and after struggling through some troublesome brambles I emerge onto a newly planted orchard. At least I think it's an orchard. After the dense and tangled forest, it's a bit startling to be out suddenly in the open and confronted with tidy rows of white tubes standing in a field. Backlighting by the early morning sun reveals that thin seedlings are being supported and protected inside these translucent plastic sleeves. The orchard rises away from the wood. I have missed the stream, if it is here at all.

My map shows the source of the Menomonee to be farther north and east of here. It also shows several smaller tributaries branching off along the way. Most are on private land, but even if they were not it would be excessive (my wife might say obsessive) to try to reach them all. The ends of the thin blue lines on the map are just a cartographer's abstractions. Clearly the river has many sources. The "official" one holds no interest for me—but that way of thinking comes from a heritage that is not my own.

An American Indian friend of mine told me about the competition that developed among white explorers during the nineteenth century to determine which of the potential candidates was *the* source of the Mississippi. Several arguments were proffered, and the longest length of river miles finally won out. The Indian guides who were hired to assist the effort had long since tired of the matter, however, for it was foreign to their world view to care how long a river was. To them, the headwaters meant much more than a matter of distance; they were sacred places.

Today, I am an explorer without a frontier, not out to discover anything a mapmaker hasn't already drawn. Still, if I were free to roam these private lands, I would probably be true to my European blood and track down every brook, branch, runnel, and rill. But I doubt I would find anything at the ends of the blue lines that would have the significance of this wilderness park.

I turn away from the plastic orchard, back to the trackless swamp, seeking something for which there is no map: peace of mind perhaps, a substantive meaning, or a less definable essence. I can feel it here amongst the scraggy trees and knotted vines.

Finding the headwaters of my watershed is not the end of my journey after all, but the beginning of a process, a new understanding of how I am to live on Earth.

Turtle

Motionless but alert, a large snapping turtle is positioned at the edge of the trail leading down to the marsh. I freeze, caught in its sights. Away from its preferred aquatic domain, a snapper is highly aggressive. Its vise-like jaw, designed to cut rather than chew, can lunge with remarkable speed. Once clamped onto its unlucky victim, it won't let go. As a child, I witnessed the unforgettable result of this behavior when an unsuspecting friend got too close.

On the side of its head facing me, one eye stares me down, then slowly blinks, as if gauging my distance. I take a step forward. The turtle calmly draws its head back against the arch of its shell, in striking position. The coarse skin of its neck folds and bulges around its head. Every part of this creature looks rough, hard, or sharp. I estimate the shell to be fourteen inches long and ten inches wide, not especially large for a snapper, but a good, healthy size. Although I tower over the turtle, I am the one who feels intimidated, unarmored, and defensive. I give the turtle a wide berth, watching its poised, viciously sharp mouth. It remains as still as if it were a perfectly preserved fossil of its prehistoric ancestors, some of which first learned to snap at dinosaurs during the Triassic

Period, around 200 million years ago. As I pass across its field of view, a cold light of awareness switches from one attentive eye to the other, equally emotionless, following me with taut intensity. The open, sunny meadow contracts indefinably, physical presence giving way to temporal awareness, a passing moment of mortality in the face of ageless, mythic integrity.

When I return later, there is no sign of the turtle anywhere, as if it had been a spectral presence in an imagined landscape.

The Vanishing Stream

When I was very young my father taught me a lesson about being lost in a forest that I've neither forgotten nor questioned, the logic of its wisdom being at once elegant and indisputable. He said to follow a stream, for it inevitably leads somewhere and never runs in circles. I have imparted this advice to my own children with an aura of hallowed truth, my faith in it absolute and unwavering. Yet, here I stand, in bewilderment: I have just reached the end of a creek. Although not lost, I have dutifully followed what was plainly more than an ephemeral trickle for about half a mile. It simply ends, not emptying into a pond, another watercourse, or even soggy lowland. Here before me the small gully spreads, the water seeps unobtrusively into sand and the creek peters out into suddenly featureless forest. If I weren't seeing the phenomenon for myself I would no doubt dismiss the very idea as impossible; even a kind of geophysical blasphemy.

The lore of wilderness is as important to the American psyche as is its actuality to the preservation of wildlife and natural ecosystems. The individual bearing up against the elements in the face of difficult

Greenseams Program conservation area, northwest Milwaukee, a clearly defined slice in the forest.

odds, the triumph of determination, ingenuity, and faith—it is one of the oldest stories in the world. I am proud that I have never yet been seriously lost anywhere, and it doesn't require faith to realize I couldn't get physically lost here, the vanishing stream notwithstanding.

Through the trees ahead of me I can see a soft glow of light indicating an edge with open space beyond. When I reach it I find a wide, clearly defined slice where the forest has been cut, under which an oil pipeline is buried. I cross and enter the closed quarters of the forest once more, determined that the story of the vanishing stream not be a parable for the urban wilderness, for if there comes a day when I can no longer find my way along a nourishing, natural stream, then I will be hopelessly lost indeed.

The Enormity of Their Presence

They seemed to have appeared out of nowhere. How could five sandhill cranes, each of which can be five feet tall with a six foot wingspan, go unnoticed? It isn't merely physical size; it's the enormity of their presence, as when a celebrity walks into a room. It feels like a special occasion—a privilege—just to see cranes flying.

Four of them circle overhead in uneven formation. A fifth flaps clumsily behind, struggling to catch up; its ungainly motions make the effortless elegance of the others seem even more refined. They make a wide sweep of the marsh, as if searching for a place to land—unhurried, yet somehow conveying a note of anxiety. Apparently unsatisfied, they rise higher. An even wider circle still finds no center. They shift direction and draw more circles in the sky, now over farmland to the west. Will they find a place to land nearby? Will the wilderness that we have to offer suffice?

They continue on. The circles become narrowing spirals that spin ever higher until the cranes seem no bigger than sparrows . . . hummingbirds . . . insects. And then there is only a cerulean sky so vastly empty that it seems to have been cleansed even of mystery and is merely blank.

Restoration

I drive in between two large farm fields: rye on the right and soybeans on the left. The driveway and lot are paved with fresh wood chips, and my tires sink into them like a fluffy feather mattress. No sign yet marks the entrance, but, as I pull up and park in front of a rustic bench, I see that the name of this remarkable place is carved prominently into its

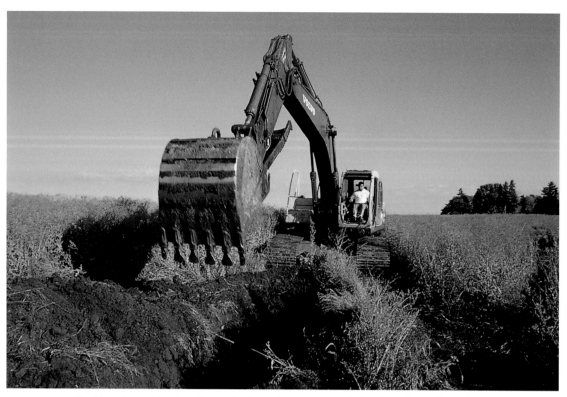

A backhoe shovel bites into dry earth like teeth in a ripe peach, breaking drain tiles to facilitate restoration of agricultural lands in the Mequon Nature Preserve.

backrest: Mequon Park. I step out into the shade of a small woodlot at the center of 400-plus acres of mostly agricultural land, all of which now belongs to the people of the city of Mequon—and, indeed, all of metropolitan Milwaukee.

A wide and welcoming trail, once used as an access lane by farmers, leads through the woods for the edification and restoration of visitors. Edification is achieved with laminated pictures and descriptions of flowers that presumably grow somewhere near the spot where each is staked. But August isn't the season for trillium, bloodroot, or any of the others. Restoration is provided for with a very generous number of the identical rustic benches in the Aldo Leopold style, placed every fifty yards or so, perhaps to make up for the short duration of the walk. On these benches one can sit and enjoy the increasingly rare variety of native trees and shrubs—prickly-ash, ironwood, chokecherry, leatherwood, witch hazel—along with more common oaks, basswood, maples, and others. But I don't pause today, for I've come in search of another kind of restoration.

The morning sun is bright and the day already hot as I emerge from the east side of the woodlot. A brake of invasive buckthorn has been cut and splayed out like a fish filet. Beyond that I hear the sounds of heavy machinery, though all I can see is the tall arm of a backhoe rising out of the wildflowers in a low portion of a wide fallow field. Tractor

treads have gouged a pathway through the tall weeds, leading me quickly to the work-site. The shovel bites into dry earth like teeth in a ripe peach, lengthening a deep trench and revealing layers of rich, dark soil.

The project director explains that the darkest layer, starting about ten inches deep, is original hydric soil left from the time that this depression was a wetland. He is pleased to discover that the farmers who have worked this land since the 1830s used very benign tilling practices that have left the rich earth relatively undisturbed. This will facilitate its restoration. At the bottom of the trench is a pipe—or what's left of it. The purpose of the excavation is to smash these pipes, known as drain tiles. Farmers install them in saturated soils to keep fields dry and tillable. Without the drain tiles, the soil can retain the groundwater that rises naturally from the depths of the earth, and the field can begin to revert to wetland and forest.

As I walk back through the woodlot the rapidity of this conversion is immediately apparent, for a swale at the edge of the wood holds a large pond that extends south into the adjacent field. A lush variety of sedges, wetland grasses, flowers, and shrubs have already become well established. Just a year ago, this field in the southwest corner of the preserve was the first to have its drain tiles removed. Walking over a short stretch of cultivated rye, I reach a field that looks like nothing but tall weeds. But I step carefully among the dog fennel, giant ragweed, curly dock, and horseweed, for I don't want to trample young seedlings no higher than my ankles that are nestled among them. Here, as a ten-acre test plot for the 438-acre project, new trees have been planted from seed, in eight sections marked off with painted stakes: red oak, bur oak, sugar maple, green ash, and basswood. Around them grow different types of ground cover, known

A newly planted oak seedling in a test plot, Mequon Nature Preserve. When our grand-children visit this place, they will find them-selves in the midst of a well-developed hardwood forest.

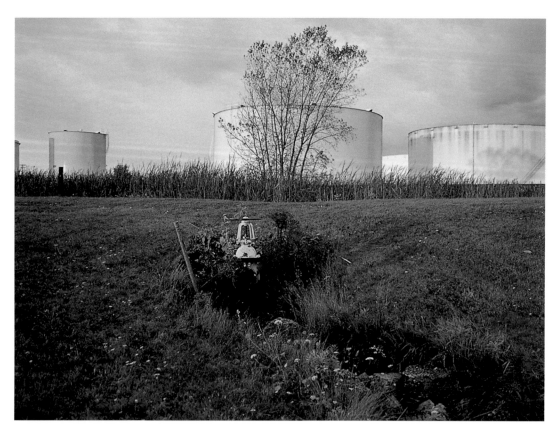

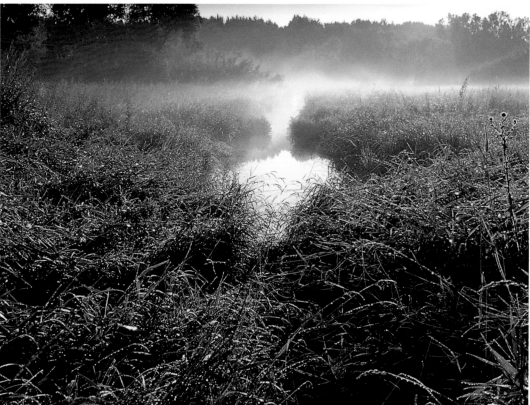

Top: oil tanks adjacent to Little Menomonee River Parkway; bottom: morning mist, Greenseams Program conservation area, Mequon.

as nurse crops. The area is divided into eight sections, each with one of four nurse crop treatments. Three treatments, seeded in two sections each for experimental replication, were annual rye; annual flax and annual crimson clovers; and native, perennial prairie flowers with red and Dutch white clover. In order to establish an experimental control, two sections were left to grow "wild" —without a nurse crop. This means that the planted trees grow along with whatever seed was already present or wafts in on the wind.

The Mequon Nature Preserve is situated on the northeastern edge of the Menomonee River watershed. From the subtle crest, it is still possible to look out in both directions across open fields combed neatly with parallel rows of crops, as they have been for seven generations, since the time when European settlers felled the first trees. In the distance lie wooded corridors in which hide two rivers: the Milwaukee River to the east and the Little Menomonee to the west. When our grandchildren visit this place, however, they will find themselves in the midst of a well-developed hardwood forest: oak canopies towering overhead, trunks in every direction, as far as the eye can see. In seven more generations, these headwaters, we can now hope, will yet function as they are being redesigned to do, part of the urban wilderness in southeastern Wisconsin.

The Romantic notion of landscape as sublime and enduring has given way to one that is malleable, even fragile. Today, the land can be bent to suit human needs, or broken through self-interest or short-sighted planning. We can also choose to include wildness in our landscapes and in our lives. We will be richer for it.

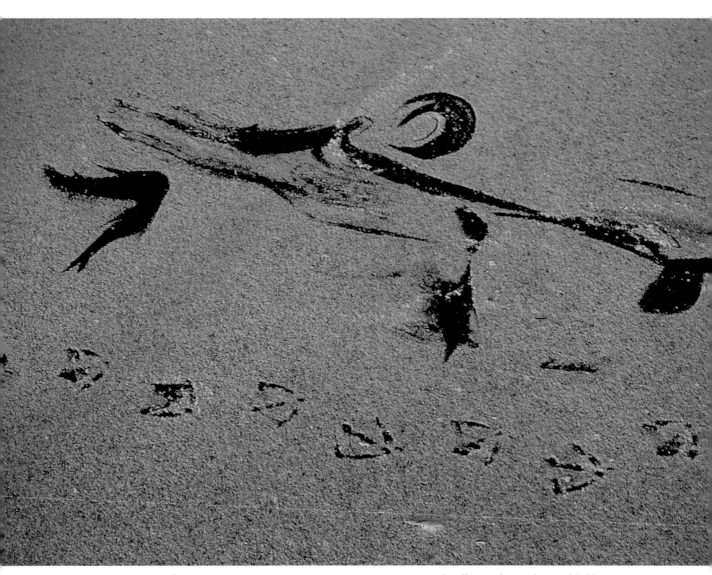

Goose tracks on ice, Menomonee River, Wauwatosa; previous spread: Lilly Heights Park, Brookfield.

COLLECTIVELY KNOWN AS WETLANDS, marshes and swamps act as sponges, absorbing rainfall, slowing run-off, and regenerating groundwater. A marsh is an unwooded wetland, while a swamp is wooded. They are among the most important natural features of any watershed but especially of one that has been urbanized and, therefore, compromised in its overall ability to absorb rainfall.

A vast and prodigiously fertile marsh was once the primary feature of the entire Menomonee watershed, dominating its confluence with the Milwaukee River and stretching the four-mile length and half-mile breadth of the Menomonee Valley. Of this marsh nothing remains. The small marshes and swamps that do are mostly located in outlying areas near, or coinciding with, the various head-waters. The largest is Tamarack Swamp in the Village of Menomonee Falls, portions of which are protected by the village in its 910-acre Tamarack Preserve (although suburban development continues to nibble away at unprotected edges).

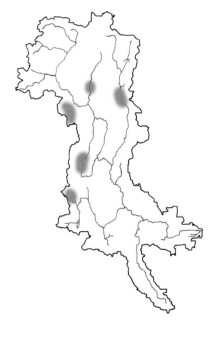

Sublime and Ridiculous

Winter has been exceptionally dry. The only snow is a very light film on icy surfaces, as if they had been dusted for fingerprints. An excellent wildlife indicator, the fresh-ness of the snow allows me to observe how many animals have visited the frozen wetland since yesterday. The pro-fusion of tracks is encouraging. Most are common

enough, ranging in size and abundance from voles to rabbits to raccoons to deer. The absence of dog prints, so plentiful in the metropolitain area, is also reassuring because dogs and cats that run "wild" are a pernicious threat to actual wildlife. But a large, nearly circular print indicates that a truly wild cat may have visited here today. It has the smudge of a padded paw, with five toes splayed out in a round pattern a good two to three inches in diameter, too big for the typical house cat. A rhythmic line of evenly spaced prints leads to a hole in the base of a dead tree. Bits of the soft, earthy interior have been scraped out onto the ice, but there is no sign of a successful catch. Farther on, the tracks disappear into deep grass.

This enigmatic animal has graced the confines of a narrow vale. Two fifteen-foot-high walls of earth block the view in both directions. An idle string of rusty yellow flatcars stands atop one of the two artificial ridges, as if to frame the horizon. Raised, parallel rail lines have created a long strip of inadvertent wilderness about thirty yards wide. This netherworld is so windless and still that its very silence echoes hollowly like the inside of a seashell.

Beyond the embankment, I find a beautiful pond surrounded by forest and no other sign of human presence—unless one counts the pond itself, which is no more natural

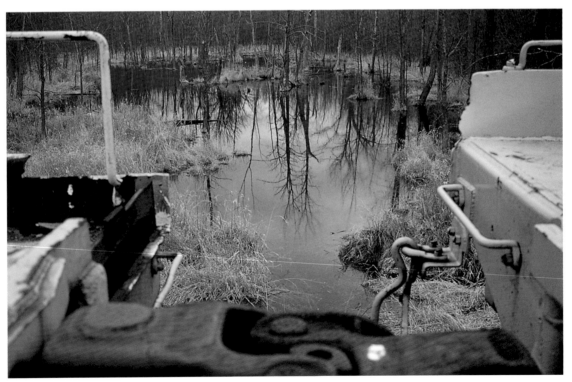

Greenseams Program conservation area, Milwaukee. An idle string of rusty yellow flatcars stands atop the artificial ridge as if to frame the horizon. .

than the raised railroad that created it like a dike. Gray trunks in various stages of decomposition rise from the sheet of white ice, looking as if they had been shackled in place and left to die.

Purists may object to an interpretation of wilderness that tolerates the proximity of railroads and other obvious human interventions, but in his landmark book, *The End of Nature,* Bill McKibben argues that no landscape remains unchanged.[1] Roderick Frazier Nash also observes the difficulty in defining what is meant by wilderness; he suggests, "A possible solution to the problem is the conception of a spectrum of conditions or environments ranging from the purely wild on the one end to the purely civilized on the other—from the primeval to the paved."[2] Neither the land nor our understanding of it is fixed; rather, the land is in flux, like an oral history that changes with each telling of the story, depending on the background, temperament, and imagination of the narrator. Wilderness can be a primary character in the story of this land.

The Romantic notion of landscape as sublime and enduring, which has engaged the American imagination since the early nineteenth century, is challenged by one that sees landscapes as malleable and fragile. This is both a moral and practical issue, one that relates to personal and societal values. As described by James D. Proctor, "Intrinsic value in nature implies that its worth is independent of its utility to humans; instrumental value implies that its worth depends on its ability to serve a human end. 'Is it good?' is a question of intrinsic value; 'What is it good for?' is a question of instrumental value."[3]

For this particular parcel an instrumental value has been identified. Purchased by the Milwaukee Metropolitan Sewerage District for what is called the Greenseams Program, it is part of the district's comprehensive plan to control future flooding risks in the watershed. For my part, I welcome any reason to preserve such critical natural areas. But there are many "human ends" beyond the utilitarian. If we choose to include wildness for its intrinsic value in our reconstructed landscapes and in our lives, then we will be richer for it.

Clambering down the steeply sloped embankment, I walk out among the gray trunks, standing in solemn majesty, statuesque in death, monuments to the law of unintended consequences. But nature's moods vary endlessly; the tragic can coincide with the comic. With irrepressible delight, I discover something I had never imagined: clumsy wildlife. In several places, one or more deer has obviously slipped on the ice. I picture the discomfited deer regaining its footing with insouciant nonchalance, pretending it to be in fun.

Most of the slips are minor, straight streaks of black ice a few inches in length; but in one spot it looks as though the hapless creature ended belly down with all four legs

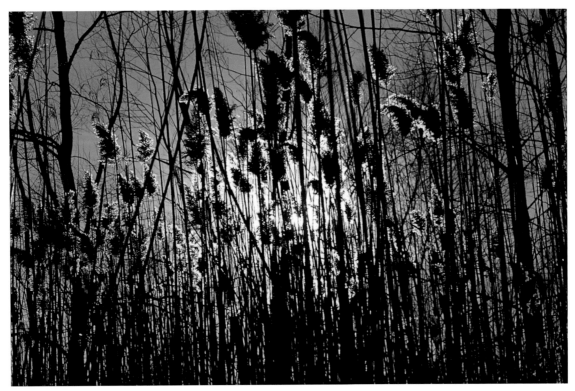

Wirth Swamp Natural Area, Brookfield.

splayed out across the ice. Its scrambling struggle to stay upright and prevent this ungainly, embarrassing outcome created wildly curvilinear streaks that would do justice to a Jackson Pollock painting.

"The sublime and the ridiculous" would be an appropriate title.

Litany of Affirmation

Spring arrived by fits and starts. An early and dramatic warm spell raised hopes and crocuses. After one day of cheerful blooming a resurgence of winter withered both. Spring and winter then played tag for weeks.

Now there is a matching disjunction in the landscape. Human activities accelerate the season. Fertilizer applied in suburban subdivisions enriches lawns to a fully ripened green. Along the warm south sides of houses a second wave of flowers—daffodils, a few hardy tulips—gain a foothold following the rapid capitulation of the crocuses. But here at the edge of the marsh, where there is a transition between lawns and natural lands, the imbalance is most evident. Instead of exuberant greens I see reticent browns. The broad sweep of the marsh is a study in all shades of ochre and sienna. Trees rise nakedly

from the earth, reaching for sun. Here, much closer inspection is required to detect signs of spring. Down close to the ground amongst the dense, matted brown grasses, one can just see the pinpricks of green shoots poking cautiously upward. Petite, purplish leaves of an unadorned wildflower, likewise hesitant, await greater assurance that budding will lead to blooming. Ah, but, as I near the reeds along the creek, not one but two great blue herons start up. The drumbeat of their wings is a litany of affirmation: it is spring indeed!

Where We Stand

Standing on a tuft, I find the grass to be more stable than it appears. Spring has undone winter just enough to melt exposed ice without thawing the tussocks that poke out of it. I look out across the open marsh: it is hard to imagine traversing it without getting wet, interlaced as it is with winding ribbons of standing water. But the drive to explore impels me forward. With each succeeding step I feel a quickening in my heart and mind as civilization recedes and wilderness circles round, closer and closer.

The open marsh changes to forested swamp. Deep in the woodland I come upon a secluded pond. A small flock of startled ducks immediately beats a frantic retreat at my approach. A sheet of ice remains floating, surrounded by a moat of dark water. A concrete tower protrudes from the center of the ice, as if positioned there to command this isolated opening in the forest. Though clearly topped by the rusty steel cover of a sewer hole, its pedestrian purpose is betrayed by a medieval, fortress-like attitude. The skirt of ice seems to emanate from its cold, alien form, as if to keep the forest at bay.

Deeper in, the forest assumes a sinister, adversarial aspect, "full of restless dread," as a Roman poet described "uncivilized" nature.[4] Still raw with wintry desolation, upthrust trunks claw at the sky. A welter of intertwining deadfall defies passage. Saturated ground prevents any foothold. Here, finally, is arrant wildness. For once I am stymied by a wilderness beyond symbolism and compromise, a wilderness worthy of fear and loathing, the kind that the pioneers, as Roderick Nash puts it, "conquered" and "subdued" as swiftly as possible, as if in military engagement.[5] I retreat.

A clean vista of open marsh comes as a relief. The landscape is wide enough to elicit a mix of elation and freedom that is bracing after my dark epiphany. But it is also circumscribed. The scene to the west is interrupted by inelegant architecture: a windowless concrete box, unsoftened by shrub or tree. To the north, suburban "settlers" have cut and cleared the wilderness into unconditional surrender, leaving hostage just enough to

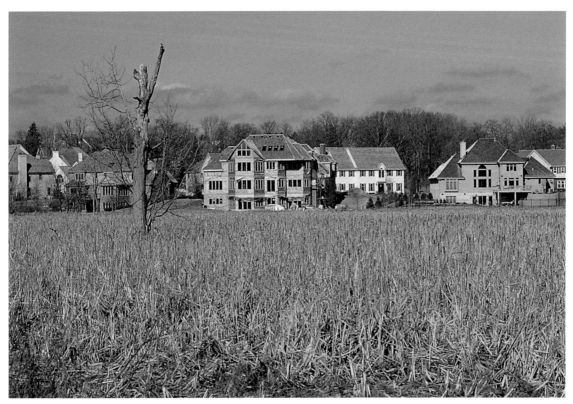

Wirth Park Wetlands Environmental Corridor, Brookfield.

afford a pleasant view. The view from here in the center of the marsh remains confrontational, as if the sheer scale of residential fortification can defend against the consequences of the subjugation of nature.

Stalking

Suddenly, it is fall. In pre-dawn darkness, the air is cold and damp. A fine mist rises slowly off the still water of the old quarry lake like smoke from dying embers of a fire. [6] Above the shadowy marsh a nebulous sky begins to pale around the edges of scattered clouds. With measured steps and deliberate stealth I near the tip of a spit of land that juts into the lake. A heron is just visible on the far side of the cove, exactly as expected, as if it were keeping an appointment we'd made. I freeze.

But then it is gone. Did over-eager anticipation stimulate a complicit imagination? No, it reappears as it takes a slow step, head down, stalking. When it becomes still it again vanishes into the mist. I ease carefully behind a bush, using it as a blind. Unhurried, the heron steadily works its way along the rim of indistinct reeds, alternately vanishing and appearing with the rhythm of mobility.

Abruptly, from beyond a clump of brush to my right comes the distinctively coarse bark of a second, much closer heron. There is a brief splash and a sweep of wings. Then, low over the surface of the lake, the dark form —like a remnant scrap of night— cuts through the mist, leaving it ragged in its wake. I wait, breathlessly, to see if the first will follow.

The dawning sky has turned a thin, nacreous blue-gray. A texture of standing reeds begins to materialize from the dense backdrop of foliage. Gradually, it becomes light enough to see the heron's stately form even when motionless; it stares in concentration down the menacing length of its foil-like beak. Soon a brownish tinge is discernible, as if its slate coloring has been stained, indicating that this is an immature bird. When I shift ever so slightly to avoid a cramped leg, it abruptly tilts its head in my direction, then cocks it further as if adjusting a lens. With unruffled dignity it struts slowly into a shelter of cattails and is gone.

The rising sun burns through a bank of clouds stretched across the eastern horizon. Dull green reeds flare with incendiary brilliance. An audience of one awaits, the curtain is raised—and the spotlight falls on an empty stage. But the performance was no less satisfying, and applause swells silently within me as I make my own exit.

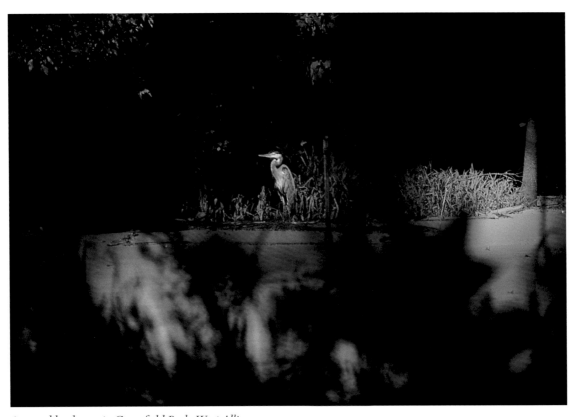

A great blue heron in Greenfield Park, West Allis.

The Wild Places

A long, low line of black plastic "environmental impact" fencing snakes off through the trees and grasses of the swamp like the tongue of a lizard tasting its way into new territories. Along its entire length the ruts of trucks have gouged the soil and flattened the grass on either side.

Tamarack Swamp is one of the largest, relatively intact natural areas in the watershed—too large for its own good, perhaps. Despite an abundance of fallow agricultural land nearby, the swamp continues to be consumed around the edges, as a mouse might nibble around a piece of bread. Planning maps show that some land is protected, but here in the muck no lines are drawn to differentiate these areas, just a few "private property" signs tacked to trees. I watch as two men get out of their car and crunch off purposefully through the frozen grass right past the ineffectual signs on a well-used trail.

Which is more alarming: a people that blithely ignore the constraints of society or a society that strains to prevent its citizens from entering a realm of wild places? The question isn't rhetorical, and the answer isn't obvious. Wilderness, which can help heal the wounds of civilization, must itself be healed from similar wounds. Before we learned to tame the land we had to tame the wild places in our hearts.

I set off in the other direction, away from the men, the sign, and the trail.

This swamp can be forbidding any other time of year, but winter has petrified the terrain, turning soggy tussocks into stone, making entry into its mysterious inner recesses conceivable. I begin with two intentions: crossing the width of the long, narrow swamp and touching the texture of wilderness. That I don't achieve my first is due, in part, to the speed with which I am enveloped by the second. Almost immediately I feel a thrill, rare in the urban wilderness: an absolute conviction that no one has preceded me. No human, that is. Animal tracks run everywhere I look. Easily recognizable deer and rabbit trails lay across an indecipherable riot of tinier prints, with occasional accents of coyote and goose.

I quickly pass through a narrow stand of tall hardwoods: beech, maple, poplar, and ash. The ground cover of knee-high grass gives way and the trees diminish, replaced by an increasingly enclosed landscape dominated by hummocks of shrubby alders about fifteen feet tall. Each hummock is remarkably similar, three to four feet in diameter with about a dozen one-inch trunks protruding at all angles from its little clump like an enormous pincushion. Most of the hummocks are at least a few feet apart. What makes the going rough is the interlacing of trunks across the intervening space like guards crossing spears. I almost turn back more than once, but with a little perseverance I discover that

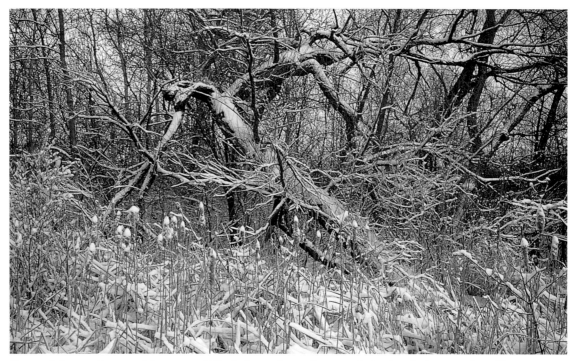

Tamarack Swamp Preserve, Menomonee Falls. Before we learned to tame the land we had to tame the wild places in our hearts.

the appearance of impenetrability is deceiving. There are no tangles. With a bit of humble bowing and coaxing the thin trunks relent and allow passage.

The scene varies little. Occasional openings contain shoulder-high reeds and even taller cattails, as if they'd been stuffed like packing materials within the wall of surrounding brush. Here and there, a small island rises sufficiently to allow an aspen or ash a dry spot to root. The unrelieved uniformity of the scenery robs my adventure of its glamour. I nearly succumb to tedium.

It is a paradox of civilized luxury— of comfort and time — combined with a paucity of actual wilderness that makes this adventure appealing. Living in the city, as opposed to living off the land, there is a danger that wilderness can become a theme park for nature lovers, experienced but never really known. We can subject ourselves to a tolerable level of discomfort as a distraction from our daily lives, knowing that it is temporary. But am I willing to make nature a part of my daily living?

Not in this place: some places should remain separate. Now that I have come, I will leave content to know that the swamp is here, a refuge for truly wild spirits like the many creatures whose tracks I've crossed. They are the rightful inhabitants of this land. For if a hundred thousand residents of this region suddenly decided that exploring this swamp is the path to enlightenment, the wild would be expunged from it as surely as if it were paved.

Blind Sight

Just inside the wood is a decaying hunter's blind, a simple affair made from an old wooden ladder. The platform is a row of narrow slats about twelve feet high on the trunk of a single tree. The wood of uprights and rungs alike has been weathered to an ashen gray, and the soft spaces in its grain have eroded, leaving sharp, unworn ridges. The bottom rung snaps like a toothpick when I test it. Shifting my foot to the outside edge, I try the second rung. It pulls away without a sound, as if relieved of the tiresome burden of rigidity. I abandon the effort.

Skirting the bleakest thickets, I head to open marsh. The winter sun, though bright, is low in the sky. The angle of the light accents each tuft of tall grass in starkly beautiful silhouettes. With the solstice scarcely past, the sun's recumbent trajectory is a feeble arc that barely rises above the tree line. Its proximity to the horizon dims the sky prematurely, making mid-afternoon seem late in the day, hastening the passage of time. Not being equipped to experience this much wilderness after sunset, I circle back. Before long the topography changes again as cattails and frozen marsh give way to trees and solid ground. Almost immediately, I come upon a wide trail carved out of the underbrush, undisturbed since the latest snowfall.

A second blind establishes a purpose for the trail. This time I climb without hesitation. Made of brand-new painted steel, it is braced with nylon straps into a triangle of huge willow trunks. I almost expect to find an electrical outlet and cooler full of beer at the top. The new platform seems a vain, over-engineered symbol of power as I survey a dreary, deer-less landscape all around.

Narrowing as it curves through a denser wood toward a farm up ahead, the trail acquires the parallel depressions of ATV (all-terrain vehicle) tires. Surprisingly, I find a third platform, impractically close to the last. This one's a major piece of construction, fashioned of weathered but sturdy lumber. As I climb—cautiously—the platform begins to feel unnecessarily high for hunting. Indeed, as I gain the top, I am struck not by the vantage it provides for ambush but by the breathtaking panorama of unfenced farmland and undisturbed marsh. The setting sun burns the sere landscape. Glints of red and gold play across the tips of tamaracks and cattails as far as I can see.

For once I suppress the nagging, unbidden questions. (How long will marsh and field be allowed to coexist in harmony? How long before the road, just out of sight to the west, snakes out in this direction?) An icy wind stings my cheeks, but I blink back the tears that swell at its bite as I gaze in wonder at the fragile beauty unfolding in every direction. Here is where we must begin. This is what we have, the best of *possible* worlds.

Nest

The mother red-winged blackbird tries to flit away unnoticed. Too late. Instead, she signals the whereabouts of her nest. I approach cautiously so as not to break its grip on the brittle brown cattails that support it about waist-high. The mother chirps insistently from the top of the nearest alder. The interior of the nest is dark, shaded by the tops of the cattails, which shield it like steepled fingers. As I peer inside the mother ceases chirping.

At first all I can make out is a jumbled pile of featherless sacs. Stretched taut over clearly visible internal organs are membranes of skin so thin and translucent that it seems they must burst open any second, spilling tender life in the world. The tightly massed brood pulses gently like a single organism, like a beating heart. Suddenly, a tiny head pops up, its sharp triangular beak open wider than the head itself, revealing a ribbed throat and a disarming trust in the providence of existence. The utter, defenseless fragility of life could not be more manifest than this.

The mother bird, understanding only the merciless laws of nature, will return expecting to find the violated nest empty, the hatchlings eaten. Since I have no predatory intent, I step away with deferential care. Here in the mud, I am out of my own "natural environment," the one altered by civilization. But, along with an unusual propensity to

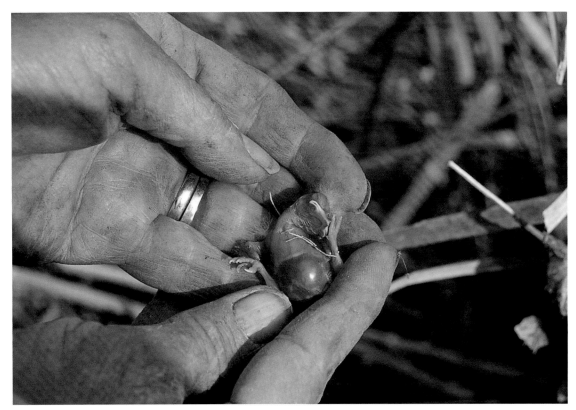

A red-winged blackbird's hatchling, Tamarack Preserve, Menomonee Falls.

dirty myself, I have brought into the marsh a certain civility and the uniquely human ability to question the consequences of my actions and choose accordingly. I choose to leave the nest intact.

Mud and Midges

Thickets of alder and dogwood replace cattails, but all still rise out of the standing water I've been laboring to navigate. Finally, in the center of a pool a large black willow stakes its claim to a hummock of scarce, dry soil. In the only remaining space next to the tree trunk are two deer-size depressions. The water beyond swirls with freshly disturbed mud. The deer must have fled moments before.

Around the hummock marsh buttercups, not yet in bloom, float like lacy sponges in the clear water above the turbid layer below. In the air above, spotlighted in sunbeams, midges dance their twenty-four-hour lives away. Here in the mud, before a flurry of seemingly insignificant, minuscule lives, no more than specks of dust under the wide umbrella of the willow canopy, the complexity of the universe is revealed. Against which standard will we measure our own lives? My hope is that our time on Earth will be marked not by the frenetic moment of midges but by the patient longevity of the willow.

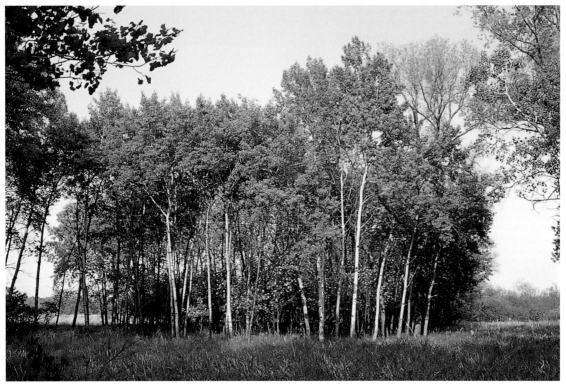

"Turtle Island," Tamarack Preserve.

Turtle Island

The island could not seem more wondrous had a sailor, shipwrecked and lost at sea for days, chanced upon it. After an hour of slogging laboriously through mud, along watery deer paths, tripping incessantly—first on cattails, then on dead alders, then on hummocks of grass and sedge—any solid ground would be welcome relief; so to come upon this vision of common beauty is almost too much to absorb.

Quaking aspens sigh in the breeze, rising out of a thicket of tall nanny berry bushes nearly bursting with bouquets of white flowers. I push through. The ground rises gently, smoothly, like the shell of a turtle. Are my legs unsteady or can I feel the great animal, the very earth itself, breathing? The island is a near-perfect oval mound. The wreath of nanny berry bushes and aspens is surmounted by tall bur oaks, white oaks, and ash. Incredibly, the center of the island is clear of vegetation, as if it had been prepared for a woodland wedding. Its floor is decorated with the tiny triangular leaves of spreading hog peanuts and softened with moss. To complete the effect, exotic, flowering honeysuckles create great splashes of red, pink, and white around the edges of this sanctuary.

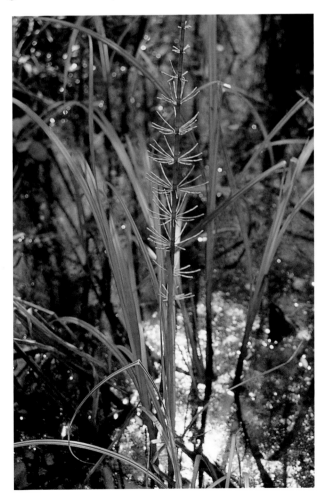

Shipwrecked or not, being present in such an incomparable space is an unexpected blessing. The continent rises beneath my feet, the cosmos is overhead; life-sustaining natural marsh communities surround me with their roots in the mud; and human communities surround that with their roots in the numberless generations of people who have brought me to be here in this place.

The American Indians, before my ancestors came to rename it, called this continent Turtle Island to symbolize the living power of the planet. Here, in metropolitan Milwaukee, I stand on Turtle Island, humbled by the power of its spirit.

Horsetail, Tamarack Preserve.

Here is immense power; the power to create and to destroy; to transform entire landscapes. And I know that I am the beneficiary of this power. My city and my home are manifestations of it.

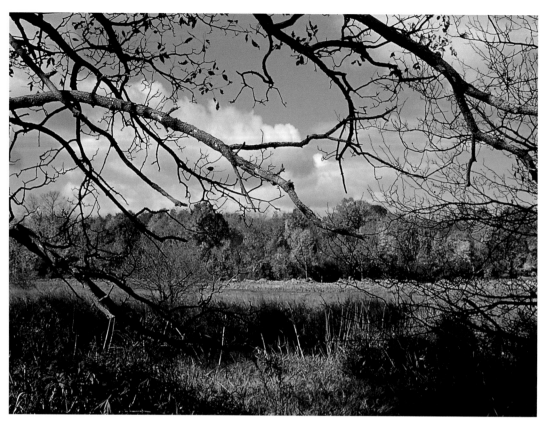

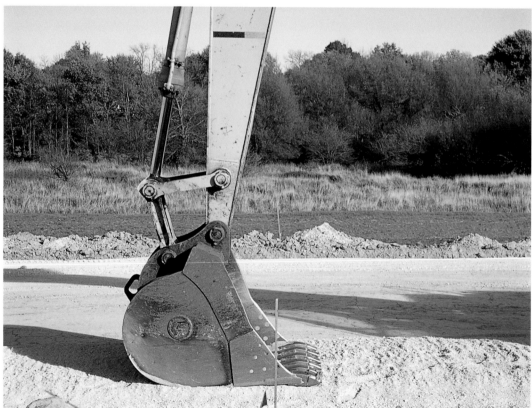

Top and bottom: development along Menomonee River floodplain, River Heights South, Menomonee Falls; previous spread: road construction, Tamarack Swamp, Menomonee Falls.

SINCE THE MIDDLE OF THE TWENTIETH CENTURY, the American landscape has been dominated increasingly by ever larger rings of suburbs and even exurbs that sprawl outward from its cities. "The American dream," which for European immigrants had its roots in the seemingly unbounded potential for freedom and upward mobility in a new land, has become closely associated with owning a piece of that land. This trend may be one of the most significant determinants of how we experience our environment. As Peter Friederici puts it, "More than pollution, more than the extinction of native species and the introduction of exotics, more even than the taming of wild forest and prairie into lawn and garden, this is the primary change Western culture has wrought upon the land of North America: we have chopped it up into so many bits that it requires a great effort to think it all of a piece again."[1]

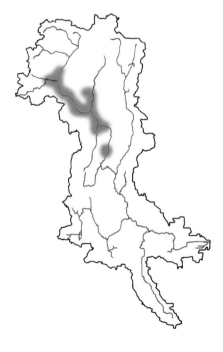

Most of the Menomonee River watershed is located in Milwaukee's inner and outer suburbs. The inner tier of suburban cities in Milwaukee County, as in many metropolitan areas, is densely developed and contains very little buildable land. In this chapter, I explore the outer tier in Waukesha and Washington counties, where properties tend to be larger, where some agricultural and vacant land remains, and where, because development continues to gobble up that land, the issue of sprawl is most apparent. I experience an inner shudder whenever I learn that another piece of urban wilderness has fallen to bulldozers.

Bounded

The snow cover has settled and thinned. In places, it looks like a threadbare, moth-eaten blanket thrown carelessly over the ground. The ice on Willow Creek has retreated, revealing swiftly flowing black water swollen with snowmelt. The landscape alternates between woodlot, wetland, and farm field. On the north side of the creek, long, brown grasses have been pressed by the snow, molded into haphazard mounds. Occasional tufts spring up like unruly hair. On the south side, cultivated fields are furrowed with turned earth. Melting snow reveals soil as dark as bitter chocolate, leaving lines of white frosting along the tops of the furrows as if the land were an immense Viennese torte.

This parcel is bounded by busy thoroughfares. A freeway to the north draws development away from the city the way a rival queen draws bees from a hive.[2] The constant hum and buzz of traffic surrounds me like an angry swarm. The high-pitched whine of speeding tires and the low, throaty growl of truck engines resound off the raised roadway, the sound amplified over open land with operatic intensity. The implication is clear: development has sprawled across the exurban landscape. Although no houses are visible here, the horizon is a ceaseless blur of traffic.

A briefly deafening roar accompanies another blur just inside the wood to the south. A long plume of splattering mud follows the disappearing snowmobile like a rooster tail. The trail, elaborately marked with miniature street signs, parallels the creek. In the unseasonable warmth, its entire length is a dark, treacly ribbon of churned mud. Though controversial in Wisconsin and many other places, off-road motor sports—dirt bikes and ATVs in warmer seasons—are growing in popularity.[3] Supported by the enthusiasts themselves as well as some in the tourism industry, they are decried by environmentalists for their destructiveness—made baldly apparent by this mud. Here, as in many parts of the state, they have been accommodated. As the racket from the snowmobile's engine gradually recedes, the persistent sound of everyday traffic reasserts itself.

Lone Oaks

Surrounded by tidy plantings, the elegantly appointed sign at the entrance triumphantly proclaims, "Lone Oaks." Looking down from its commanding height over unbroken, rhythmic waves of bright, new cedar shake roofs no evidence of a single tree is visible. The streets are wistfully named "Wildflower Lane" and "Willow Wood Drive"—epitaphs for a paved landscape. Stub ends of future streets project from either side, the subdivision poised to grow new tentacles.

River Heights North subdivision, Menomonee Falls. The berm of a storm water detention pond divides the subdivision from swampy, river lowlands.

The fate of a currently thriving nursery to the north is clearly sealed. Like a drawn bow the unfinished asphalt edge that points at its heart is already named "Autumn Drive." Bulldozers are scraping old cornstalks and topsoil from the fallow field to the south. Only to the west does development halt, along a moat and berm that divides Lone Oaks subdivision from swampy river lowlands. The long strand of open water discourages access to the wilderness beyond. Pictographic "no swimming" signs seem absurdly superfluous given the brackish surface and modest depth—and the fact that each backyard sports a play structure and swimming pool.

A small frog waits in the water, as still as a stone. Then, faster than my eye can detect, it snatches a dragonfly out of the air. Crumpled wings and bent tail protrude from the frog's mouth as proof. Life requires death; it is the natural cycle. Human endeavors, too, require that we build on what we destroy. Studying nature demonstrates that, although *change* is inevitable, *progress* is a human conceit. The seedling that sprouts from a moss-covered log is not superior to its fallen forbearer.

Romantic Landscape

A carefully mulched and impeccably maintained pathway parallels a beautifully engineered stream, surrounded by expertly sited groupings of native and imported flowers, tall reeds and grasses, and elegant trees. Deliberately casual, it rambles through an enclosed, sunken dell. Precisely positioned steppingstones cross the stream, as do plank bridges crafted of new lumber sporting the greenish cast of chemical preservatives. A small marshy spot provides contrast: it looks just wild enough to accentuate the artificial nature all around it.

The stream flows into a large pond surrounded by clumps of shrubbery interspersed with well-proportioned and rhythmic splotches of color. Looking up from this ingeniously calculated "idyllic reverie," I am suddenly confronted by a curved wall of glass projecting out from a mass of dark masonry. This building, which so dominates the landscape, is the reason this Romantic vision has been created.

"Improving" the natural landscape for private edification is hardly a revolutionary concept. From Roman villas and Japanese Zen gardens to Frederick Law Olmsted's designs for Milwaukee's parks, the earth has been rearranged endlessly to suit aesthetic tastes of particular times and places. But there are increasingly fewer places — especially in urban settings — where the land can be experienced in unadulterated purity.

There are trade-offs when creating a counterfeit nature. As I stroll along on fragrant wood chips, I note that the rippling of the stream and gentle waving of tree branches throughout the dell is accompanied by an omnipresent hum from the generators and pumps that aerate the crystalline water and allow it to flow in its closed-loop system. Although this complex is situated next to the Menomonee River corridor, its waters remain isolated from the ecosystem and do not mingle with the water in the river. It is quite lovely, as its designers intended, but it is essentially an outdoor terrarium. A large berm, inadequately camouflaged as a natural hillside, separates the synthetic landscape from the relatively wild one beyond. The river cannot be seen from here.

The Illusion of Distance

A steady breeze ripples the large lake, corrugating it with violet ridges.[4] The evening sun galvanizes the serrated edge of each ripple with polished chrome. The water's movement plays tricks with the eye, an optical illusion in which the wide expanse is simultaneously a flat, linear pattern and a real, deep space. Oddly, staring steadily into this indigo depth makes its oscillating pattern pop forward. When I blink and glance around it lies back down, snuggled within the contoured hills, speckled with ducks and geese.

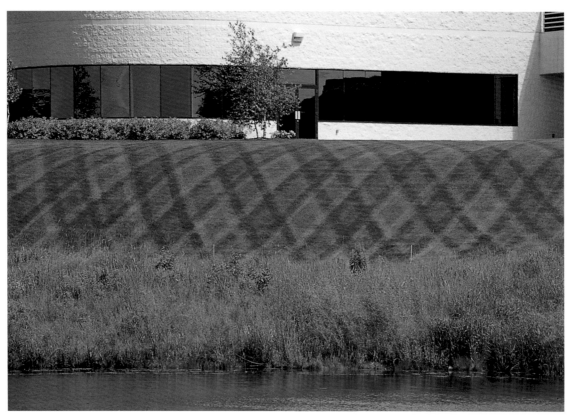

Germantown Industrial Park. "Improving" the natural landscape is hardly a revolutionary concept; we have rearranged our environments endlessly to suit practical needs and aesthetic tastes of particular times and places.

The wide, grassy dike that created the lake prevents its impounded waters from spilling into the wild, swampy woodlot below. The grass has been mowed but not recently; the track down its center is faint and overgrown. To the left, at the base of the dike, lies a wide ditch. Its long ribbon of stagnant water hasn't moved in so long that waterlogged leaves and a blizzard of winged maple seeds seem glued to the surface in an abstract collage. In the shadow of the dike and low hanging branches, the colors are muted and dismal.

I turn my attention back to the lake; the shore starts to shift and move. At first it seems like another optical illusion, but it is wildlife reacting to my presence. A mottled brown lump of earth with the girth and shape of a loaded garbage bag sprouts head and legs, becomes a very large snapping turtle, and slides into the water. Then, without a sound, a heron vacates a tangle of brush in which it could easily have remained undetected, had it but held still with its natural predatory patience.

Along the shore ahead a flotilla of agitated geese glides out, squawking irritably. Each one pauses and turns, in sequence; then, like a practiced drill team, they all pivot simultaneously and paddle purposefully to the far shore. A hundred yards more and a

second heron takes flight, as silent and peremptory as the first, in sharp contrast to the vocal geese. It disappears into the sun's blinding glare on the water.

I don't see the beavers, but they've left their unmistakable calling cards—young aspen and box elders—toppled at regular intervals. They may be safely burrowed beneath the small island not far offshore.

The woodland on the left tapers off to a fallow field and then to a cornfield, as yet unturned. At the bend where the dike curves around the west side of the lake I disturb a pair of deer picking amongst the stubble. They are no surprise to me, white-tail deer being very common in the watershed, but my presence is an outright shock to them. The only cover is below the dike, directly in front of where I stand. Utterly exposed, they bolt in a wide arc across the field toward the woodland. The speed of their leaping gallop is breathtaking, and I realize with a jolt that I've always encountered wild deer in a woodland or marsh, but never before in the open. The setting sun casts their coats in rich tones of freshly minted copper and the tall grasses over which they bound in bronze.

The dike now leads toward a conspicuously bald mountain. Being treeless the landfill looks more mountainous than it is, but in fact it *is* relatively big for around here. Now capped with four feet of "compacted clay," part of this landfill is the repository of an esti-

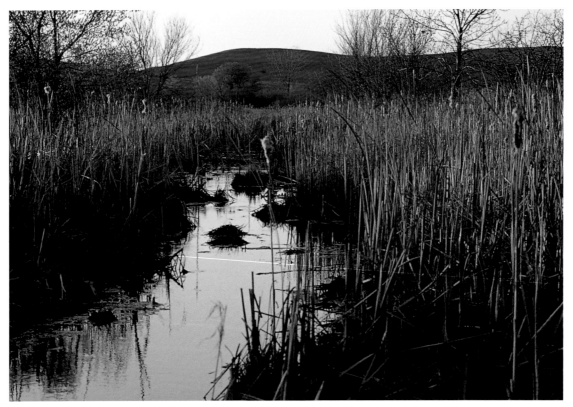

Landfill, Orchard Ridge, Menomonee Falls. The illusion of distance enables us to live in a society that creates such a mountain.

mated 150,000 cubic yards of *hazardous* waste, along with staggering amounts of every-day garbage. Its hideously barren appearance belies the truly pernicious quality of the potential threat, for, as large as it appears, the impact of this mound on the local ecosystem is more akin to an iceberg than a mountain. The greatest threat is to groundwater. The U.S. Environmental Protection Agency has documented contamination under and around the site with benzene, toluene, vinyl chloride, zinc, nickel, arsenic, and cadmium.[5]

A narrow wetland of cattails, shrubs, and isolated trees surround the drainage channel that continues past the end of the lake. Directly ahead, a large nude ridge looks deceptively like a mountain range because a lack of detail normally indicates seeing across a great distance. Seeing it in true perspective makes it seem paradoxically flat, like a crude cardboard cutout of distant mountains. I try to blink it away, as with the lake, but this reality doesn't change.

The illusion of distance enables us to live in a society that creates such a mountain.

Transparent

Although narrow here, the river is slow and has surrendered to winter. Much of its surface has the appearance and rigidity of fossilized bone, and I can walk on it the length of the park. In places, the ice is both snow-free and transparent. It feels alarmingly like stepping on a pane of glass—or on the water itself—but it holds my weight without a creak. Fish swarm underfoot. Lots of them. Most are two to three inches long, but larger ones, up to seven inches or so, dart swiftly away at my approach, taking refuge under the opaque ice near shore. A school of smaller ones moves more slowly, but they are stirred, threatened by my shadow. As well they should be. From above, the clear ice creates a window into an alien, monochrome environment. From a fish's perspective it is a danger zone. Like all wild creatures they shrink from exposure, blend with their surroundings: gray-umber fish on a gray-umber background of silt-covered stones.

From this vantage the meandering river feels exposed amongst surroundings that are increasingly cultivated, fabricated, and systematically ordered. Wendell Berry writes, "domestic order is obviously threatened by the margin of wilderness that surrounds it."[6] The Menomonee River corridor contains a narrow margin of wildness nearly consumed by such "domestic order." Unlike the fish that define their existence within its confines, the river is not camouflaged. It stands in full view like an accusation, while we consume its wild essence. A highly desirable location, houses continue to be built along the river corridor in order to enjoy the view: nature is reduced to scenery. But the more "domestic

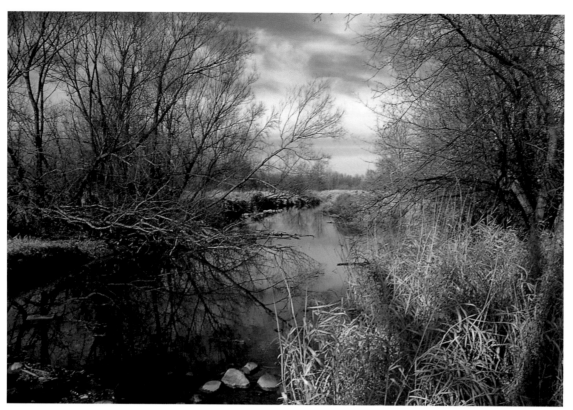

A wild but unprotected environmental corridor, Menomonee Falls.

order" we create next to the river, the smaller the margin of wildness remains—and the narrower and more privileged the view. From atop the river the view is a picture-less frame of shingles, siding, and glass.

The natural corridor is as exposed as the fish, transparent and fragile as ice.

A New Crop

Spring floods have overspread the river banks, saturating the earth and coating everything with a fine layer of silt. Natural, expected, and healthy in the wetland, flooding here helps to minimize more serious flooding downstream, where it threatens homes and businesses. The entire scene is mud-colored and dull. Even a warm glow of morning sun doesn't brighten the drab tones. Nothing except birdsong lifts the pall of dreariness from the landscape, and even that cheerful chatter is punctuated by penetrating, robotic beeps from construction vehicles out of sight to the west.

This is one of the wildest stretches of the Menomonee, where trees remain unpruned, logs lie where they fall, meadows are unmowed, and driftwood piles up against the sides of rocks and tree trunks. Even the upland reaches of this gentle valley

appear largely free of human endeavors. The hillside sloping up to the west has been tilled but not for many years. In its fallow state, it has become a lively habitat for birds and animals, and a hiker is treated to incomparable views of a natural landscape spreading wide and open from horizon to horizon.

When I reach the open expanse I stumble with alarm upon a small, chilling detail: a series of stakes bearing bright-orange plastic streamers, planted in a field. And I imagine the harvest to come from this crop.

The Birds

"*Sweet, sweet, sweet, sweet . . .*" The four repetitious notes, clear as a bell, are followed in rapid succession by a series of more varied ones, some musical, some buzz-like. I am inclined to think they are the work of several different species, but my friend Karen assures me that we have been blessed with the "unmistakable" quality of the song sparrow. However, these are easily mistaken or missed entirely by those of us who lack an ability to identify birdsong. Karen is an experienced birder, and with her I understand the wild in ways impossible alone. Usually, the sensation of sound is simply there like the forest breathing; its beauty washes over me in my woodland treks, welcome but undecipherable. Karen brings my attention to songs that I would not otherwise *hear*.

Because it maintains small territories in a variety of habitats, the song sparrow is one of the most common varieties. The tune of a field sparrow begins with leisurely, delicate, but slurring notes that gradually speed into a loose trill and then ascend to a high pitch. Less common than their more eloquent cousins, they are an indicator species of a healthy habitat. The uplifting reassurance this provides is short-lived, however, as the grinding sounds of earthmovers across the river abruptly drown out the birdsong. This basal accompaniment, with lulls and crescendos, forms a brutish counterpoint to the delightful songs we hear. Next, as if in protest, is the simple, yet distinctive cry of the willow flycatcher: "*FITZ-bue! FITZ-bue!*" Beyond it we catch the fetching, eponymous "*tsit-tsit-tsit, sa-VA-nah*" of the Savannah sparrow. A meadow bird, most likely it has been driven off its accustomed territory in the dry grasses that are being bulldozed into dirt.

In the wooded bottomlands, we hear the repetitious monologue of the red-eyed vireo, high in the canopy, impossible to see. It seems to be saying, "*How-are-you, I-am-fine, here-I-am, over-here, over-here,*" over and over. Its monotonous conversation fills the void when other birds pause their chatter. The loud, dry rattle of a kingfisher gives way to the rich gurgling of the house wren, its sound rising in a musical burst before falling off. Then the split, rasping "*chack*" of the common grackle alternates with catchy

double phrases of an Indigo bunting proclaiming, *"fire, fire—where, where—here, here."* A brown-headed cowbird provides an almost comical variation with its bubbly and creaky *"glug—glug—gleeeee,"* and the goldfinch seems to be asking for a *"potato chip—potato chip—potato chip"* as it darts past our noses.

We also detect house finch, catbird, Baltimore oriole, tree swallow, blue jay, flicker, cedar waxwing, and common yellowthroat. Most of them are in and around the one upland meadow on our route, proof that preserving only floodplain is inadequate protection for many of these species.

A distressed *"scree"* draws our attention overhead as a red-tailed hawk is sent packing by several harrying crows. The day's bird count comes to twenty-three species if we include the ubiquitous mallards and the Canada geese that fly far overhead, their guttural honking audible long after they disappear from sight. My mind continues to echo with birdsong as we wend our way home through city streets, rejuvenated.

Drought

A great blue heron flies off as soon as I enter the marshy lowland of Mill Valley. It isn't long before a hawk also departs from its perch atop the dead tree, regal in bulk but rigid and unresponsive, that rises from the undulating waves of reeds around its base. The river is uncommonly low. It is rockier, and there are bars of sand and gravel where none existed before. Also revealed, sunken into slowly coagulating riverbed mud, are numerous tires of different sizes.

Constricted to ever smaller and more sluggish pools, water striders jump about the still surfaces in such numbers that it looks like a steady light rain is falling. But the air is dry with drought even in the early morning; the normally dew-laden grasses are dusty; the path that should be soggy is as hard as a sidewalk.

I climb the bank and make my way to the adjacent upland meadow. For reasons altogether different, its open spaces are also shrinking. To the south, out of the shadow of the forest of tall beech, poplar, maple, and oak, an aggressive stand of box elders has sprung up rapidly. Sumacs encroach from the north. Small explosions of hawthorn and buckthorn pop up in the middle. That there's a meadow here at all testifies to the clearing that once was done for pasturage or tilling. Without another cutting—or fire—the meadow will eventually be subsumed completely by the forest, and the rich variety of plant and animal communities that depend on this particular habitat will be forced to move elsewhere, most likely much farther away from the urban region.

Riverside Park, Milwaukee. A summer tanager is a rare but welcome sight outside its normal range of warm, Southern climates.

The transition from meadowland to forest is part of a complex web of natural cycles, of course, and in an otherwise healthy ecosystem would be unremarkable and of little concern. But in fast developing areas dry meadowlands are among the most endangered habitats, since they require neither expensive filling nor logging and are beyond the reach of floodplain protections. Even without the threat of bulldozers the life of the meadow is being cut short by a proliferation of invasive species: buckthorn overshadows native crab apples and currant bushes, while wild grape smothers both. The grape leaves in turn are curled and yellow, moth-eaten and afflicted with tumor-like parasites.

As I turn to leave I am confronted by a tiny wolf spider, no wider than the blade of grass on which it sits. Despite the monstrous threat I may pose, its aggressively reared-back stance lends its minute presence all the ferocity of its namesake. The meadow has a protector. I don't know whether to chuckle or sigh.

The Danger of Extinction

A large factory crowns the bluff overlooking the river. But when I plunge down into the valley I leave the factory, and seemingly all of society, behind. Once on the river bottom

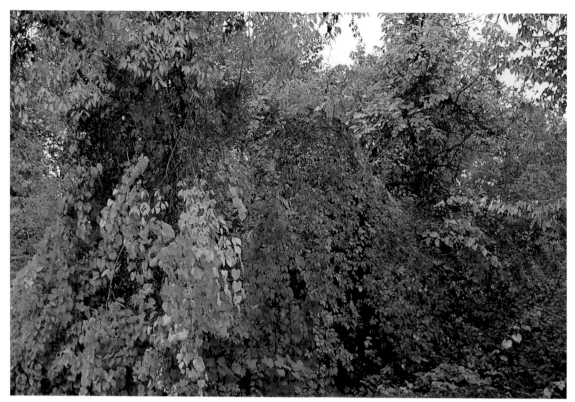

Colorful, invasive species in intramural skirmishes, Menomonee River Parkway, Wauwatosa.

I am enclosed within a dense forest. The dominant species are gigantic black willows and all-too-prolific box elders, but there are plenty of others, including majestic maples, oaks, and beeches. Now, before the buds have opened, the light is filtered by interlaced branches overhead. The forest radiates with a mystical glow, layered upon the forest floor and the great spires of trees in shifting, transient patterns like those cast through the stained-glass windows of a cathedral. It evokes an almost involuntary reverence as I proceed along a path that shifts from expansive nave to cloistered aisle.

The river is wide and full with spring run-off, but a coincidence of toppled trees provides a crossing to the wilder side. Two trees fell precisely across two narrow spots where the river splits around a small island. After negotiating an obstacle course of awkwardly protruding limbs, I gain the farther bank.

The west side of the river is more difficult to explore. There are no trails, and it is swampy, with sloughs full of standing water. The ground is uneven, and the way is impeded by numerous downed trees. From up ahead comes the beast-like grunting and groaning of some large machine maneuvering in a tight space, accented periodically by the loud, percussive crack of snapping tree trunks. In quick succession, I imagine a great rhinoceros mired in quicksand and then the furious panic of an armored dinosaur

trapped in a tar pit. But when I reach the actual scene there is neither tar nor quicksand, and it is not the "beast" that is in danger of extinction. A tracked vehicle is hunkered down in the center of a dense lot of second-growth trees. Methodically, it clamps huge jaws on the end of a hydraulic arm around a cluster of tall, thin trunks. Then, with a great tearing sound, it pulls them from the earth, roots and all, and tosses them aside like so much kindling.

The sight is awesome and revolting. Here is immense power; the power to create and to destroy, the power to transform an entire landscape. And I know that I am the beneficiary of this power. My city and my home are manifestations of it, but ambivalence burns in my heart. I cannot suppress a stinging sorrow. Why here? There is plenty of agricultural land just over the ridge; no need to bring sprawl down here to the floodplain, to compromise the environmentally sensitive riparian corridor.

Farther upriver, where the land is open, the work has progressed much faster. Hedgerows that once divided fields are now neatly stacked piles of timber and brush. Some have been reduced further to heaps of wood chips the size of the two-car garages that will soon replace them. Great, wide swaths of rich, brown soil have been scraped open through the grasses. The earth looks raw, exposed, wounded. Red-winged blackbirds flit from one brush pile to another in agitation, finding nothing familiar, nowhere to rest.

Top and bottom: Lilly Creek subdivision, Menomonee Falls.

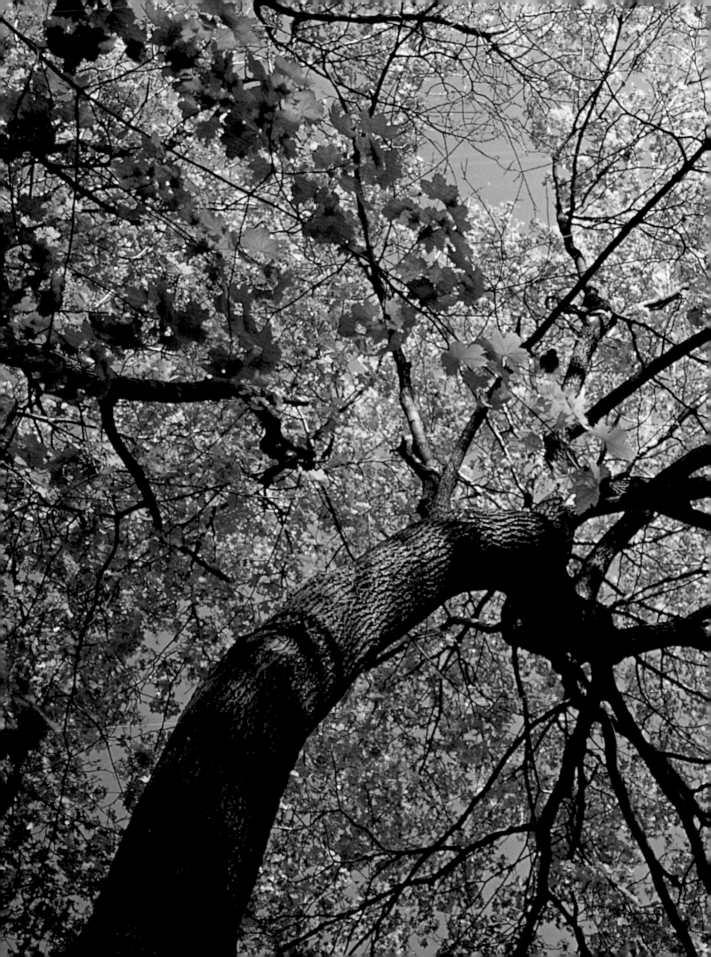

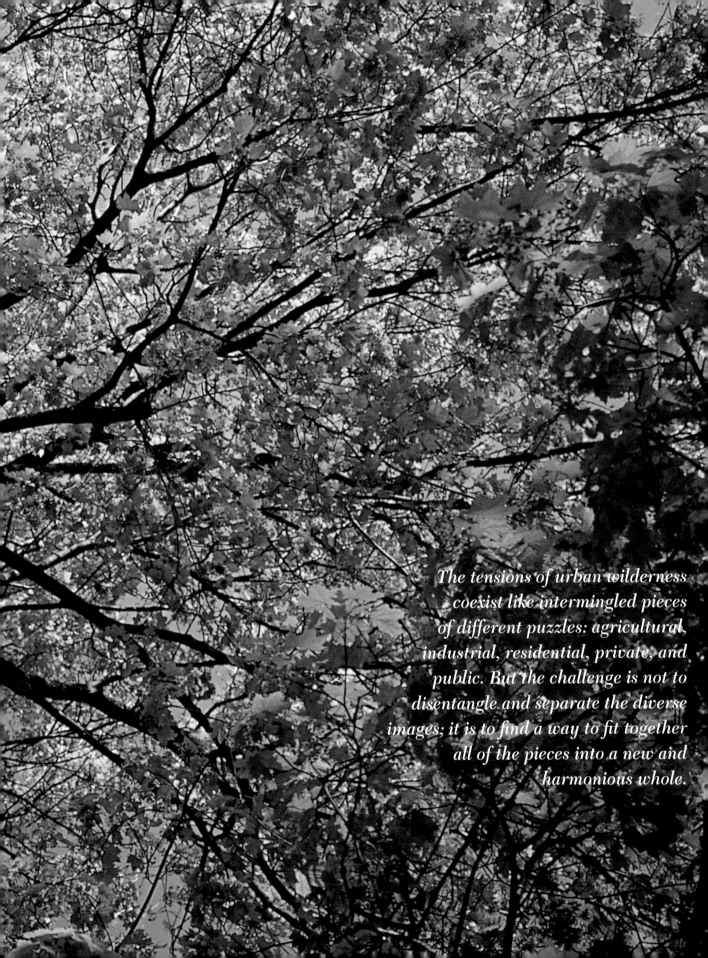

The tensions of urban wilderness coexist like intermingled pieces of different puzzles: agricultural, industrial, residential, private, and public. But the challenge is not to disentangle and separate the diverse images; it is to find a way to fit together all of the pieces into a new and harmonious whole.

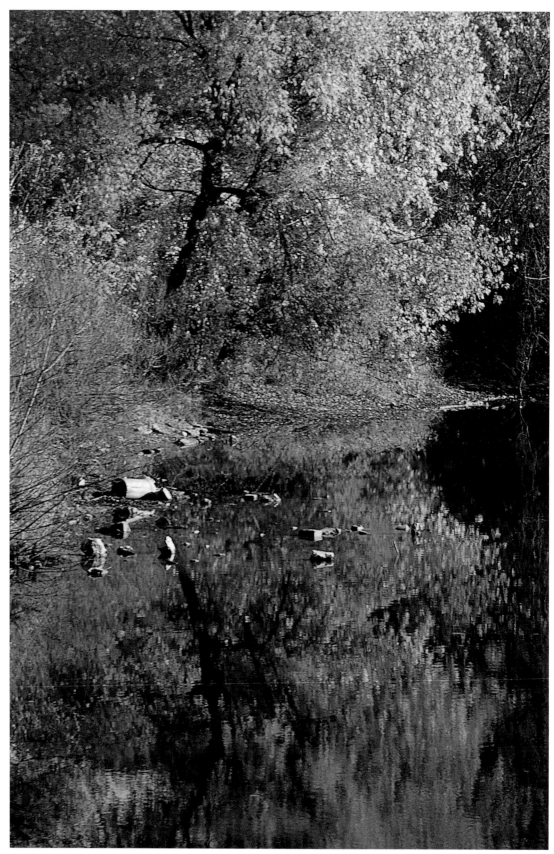

Menomonee River, Frontier Park, Butler; previous spread: environmental corridor, Milwaukee.

Until the end of the nineteenth century, wilderness in America was closely associated with the frontier, defined by Frederick Jackson Turner as "the edge of expanding settlement."[1] Turner is credited with the famous conclusion, based on the U.S. Census of 1890, that there was no more frontier in the United States. His statement profoundly affected the public perception of wilderness and contributed to an increase in demand for its preservation. A century later Richard Louv asserts, "Americans have passed not through one frontier, but through three." He identifies the "second frontier" as a "romantic attachment" that "existed mainly in the imagination," but which resulted in a powerful wilderness lobby, "the creation of great urban parks," and what he calls "suburban manifest destiny." The "third frontier," crossed between the last two generations, he refers to as "electronic detachment," which is the propensity for today's youth to experience nature vicariously, if at all.[2]

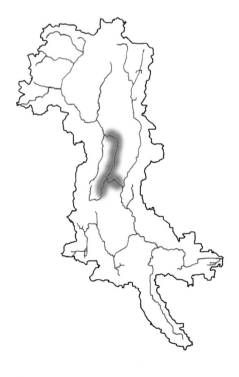

When I refer to "frontier," I speak of actual places in the watershed, ones with associations to the various meanings of the term used by Louv. Frontier is literally the name of a park in the village of Butler, which happens to be situated where the Menomonee River crosses the border from Waukesha County to Milwaukee County. And there is also a stretch to explore, a relatively wild river corridor that runs for three miles along the line—or frontier—between the two counties.

Nature Trail

A nature trail in Frontier Park, padded with wood chips, follows the bend of the river on the bottomland of its north side. It takes all of five minutes to stroll from end to end. In the middle, a dump of tree-trimming detritus diminishes the aesthetic experience. Adventurers who require a greater challenge can find it across the river.

Walking west along the south side the riverbank abruptly becomes very steep. Despite the difficulty of the terrain, a distinct trail rises and falls along the most accessible route. Tract houses perch against the top of the bluff directly above. The view from there, out over the steep gorge, must be beautiful—unless the view includes the sprawling industrial buildings just above the floodplain and beyond. Here below, the foliage closes overhead like a fabric of dreams—dreams that can contain the concept of a frontier.

There was no sign at the east end, but, coming down off the hillside where the land opens out gradually, there it is: "no trespassing" facing the other way. Was it placed there by park officials—to prevent a liability from walking up the hill—or by property owners desiring protection from pleasure-seeking adventurers? At first glance the littered slope seems to justify the sign, but an overturned garbage can and a half-buried, broken grill below one of the houses indicate that some residents may be equally culpable.

Near the confluence of Butler Ditch and the Menomonee, I find a stagnant pool where the river has carved an overflow channel. The water, incompletely covered with newly fallen leaves, has an oily, iridescent sheen. Perversely, it is quite stunning and beautiful, silvery purples and blues contrasting with the matte yellows and ochres of leaves. As I lean over to photograph I make quite certain that I don't step in it.

Frontier Park

I step gingerly onto the ice. It gives a bit under my weight and creaks like old floorboards. Clearly, at one time it was both rigid and safe: snowmobile tracks run down the center of the wide river as far as I can see. But the tracks, now slumped and softened by a recent thaw, are not reassuring. I stay along the edges, near the bank.

A large pond at the eastern end of Frontier Park is flanked by playing fields and tennis courts, but the western portion has been left in a wilder state. I manage to cross the river and turn away to investigate Butler Ditch. Here, the numerous signs of human traffic along the Menomonee end abruptly. They are replaced by even more numerous animal trails. Most are small—raccoons, squirrels, various birds, and many, many rabbits.

An oily sheen on a stagnant pool, Frontier Park, Butler.

In a few places, deer have ventured onto the ice. At one spot, running straight across the creek, a hard-packed, narrow furrow is incised deep below the surface of the snow: the rabbits' commuter trail.

Unlike the main river where large stretches of open water have appeared, here there are only occasional holes in the ice. Clusters of tracks leading up to the edge surround each hole, drawing my attention to the ground. A wealth of wildlife persists on the harsh, frozen earth. But when I raise my eyes to the bluffs that surround the river bottom I am reminded how vulnerable it is. The irregular perimeter of the floodplain is lined with a palisade of fenced parking lots, commercial buildings, and piles of industrial goods. There is a stacked row of immense tires for mammoth machines designed to create more pavement, buildings, and material goods; perhaps even to push more "fill" over the bluffs and down into this cloistered vale. The evidence bristles all around: Frontier Park owes its existence to a caprice of geography, to the fact of floodplain. No high ground is preserved.

Atop the bluff, big-box industrial buildings march away in every direction, relieved only by asphalt tracts for workers' vehicles. I look in vain for trees that could soften the edges. Blank brick corners of buildings jut like ramparts at the brims of the slopes. Unlike the houses across the river they haven't been designed to take advantage of the view.

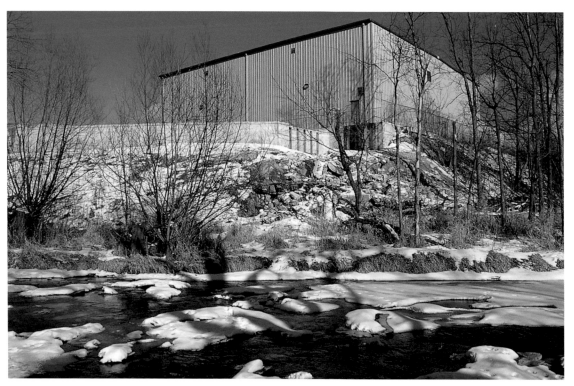

Menomonee River, Frontier Park, Butler. Frontier Park owes its existence to a caprice of geography, to the fact of a floodplain. No high ground is preserved.

As I make my way back down into the ravine the wilderness spirit washes over me with an almost physical sensation of release. I sense, then see a hawk above me in a tree. Our eyes meet, momentarily, as it surveys my passage through its domain.

Many Natures

Despite bright spring sunshine, there is a persistant chill in the shade of tall red oaks. On level ground, once mowed but now given over to nature, the nascent understory remains thin. Between grey trunks in the distance a bit of shadow takes on shape and flits from tree to tree, pale blue as if a scarf cut from the dawning sky were being swept along the ground in a breeze. A steady rhythm draws it closer. The scarf becomes a headless, legless torso in a pale blue shirt. Then a face appears above the shirt, framed by black hair pulled back tightly in a long braid. Finally, the runner's legs, encased in grey nylon pants, are distinguishable against the gray of the trees and brush.

In the cool morning calm under the majestic but gnarled oak canopy, the lone figure with an easy grace seems almost divine, like Artemis coming to light up the woods. She rounds a bend, bringing her closer. The soft padding of rubber soles is now audible, and

she becomes human. Her eyes flicker in my direction in suspicious appraisal, then shift quickly back to neutral impassivity. Passing, she studiously ignores my presence while glancing away to ascertain the proximity a large black Labrador that has been ranging in and out of the brush.

A metallic disk gleams in her earlobe as she goes by. Despite its prosaic function, my imagination is rekindled. As she recedes she is transformed again, now into a character from a futuristic tale. Robotic brain implants maintain an enclosed envelope of awareness around her mind as her body paces on through towering trees. A virtual world trumps the real.

Nature is as much a fluid mental construct as a physical fact. We have many natures. I find myself continually reassessing which nature I want to inhabit.

Freeway

Wisconsin's busiest stretch of freeway, US 45, parallels the Menomonee River. However, as I whip along trying to keep up with traffic, I note the inaccuracy of the term "parallel" here. The road's newly repaved six lanes are flanked on both sides by a football field's width of concrete shoulder, mown grass, graveled run-off ditches, and chain-link fence. It cuts an undiscriminating slash across the landscape with no regard for the tremulous

Butler Ditch, Frontier Park, Butler. A wealth of wildlife persists on the harsh, frozen earth.

Menomonee River Parkway, Wauwatosa. The floodplain opens into a broad wetland with so wild an aspect that it speaks in a nearly audible and primitive voice.

convolutions of the river meandering alongside. It is a numbing negation of nature. One dares not slow for the view when crossing the river. Cars and trucks close in all around. We are urged — no, forced — to travel along the river corridor at great speed, already stressed: focused on the car ahead or the day ahead, tuned in to the radio, tuned out and oblivious to the alternative, restorative world that lies within sight. Are there others, compatriots in cars beside mine, who notice the blur of trees that differentiates the river's environs from the blur of homes and industries?

Farther along concrete sound barriers bring alienation from the surrounding environment to its logical conclusion, effectively putting blinders on drivers and passengers alike. The freeway has become a tunnel and the landscape obliterated. America's vaunted freedom of the open road has become constricted to compulsive compliance. Once the healing potential of open land is banished from sight, it will eventually fade from awareness. Consciousness makes us responsible. How far down this road will we go before we forfeit our consciousness completely?

I slow at the exit and leave the expressway. With relief I drive at a leisurely pace through the trees along Menomonee River Parkway, designed in an earlier time with deliberate intent to counteract the impulses embodied in the freeway.

Pieces of a Puzzle

Once again "urban" intertwines with "wilderness" in unforeseen juxtapositions. I'd expected a short stretch of steep, rocky slope, a trashy hillside dumping ground that would be difficult to traverse. After carefully descending the precipitous, loosely graveled railroad embankment, I quickly discover a deer trail near the water's edge that leads easily to an enchanting lowland meadow in a wide bend of the river. Although a low stone and concrete levee braces the riverbank where it is most vulnerable, rising water would overflow it, inundating the meadow completely. What I take to be a doghouse, now crushed on one side and settling gently into the soft earth, must have fallen victim to such a deluge. Faded barn-red paint has peeled up in places to reveal stark white underneath. It was well cared for before being swept from its foundations. Walking around I discover a circular opening about a foot in diameter. There is no other entrance. Probably it was a chicken coop; now it is a quietly disintegrating vestige of a vanishing agrarian past.

An even stranger artifact disturbs the sylvan character of the scene. Centered in the grassy lea of the riverbend is a kind of charcoal grate atop a steel pipe, similar to those found at picnic areas in parks. Though a mere two feet tall, it stands erect and sturdy, a commanding presence in the clearing despite its rusty and corroded condition. But, since it doesn't appear to have been used as a grill, its purpose is as baffling as its oddly precise positioning.

Guarded by the twin bulwarks of a massive railroad bridge and a divided four-lane overpass and dominated by the steep escarpment, this stretch of riverbottom feels remarkably remote. It is, therefore, especially surprising to find a snug dwelling hidden in a secluded dell between industrial sites above. A path leading down to the water and an overturned canoe are testaments to the owners' appreciation of their riverfront location. It is further testament to the magnetism of nature that, despite its remoteness, the residents feel sufficiently besieged to have posted "no trespassing" signs prominently at the edges of their private enclave.

The tensions of urban wilderness coexist in this place like intermingled pieces of different puzzles: agricultural, industrial, residential, private, and public. But the challenge is not to disentangle and separate the diverse images; it is to find a way to fit together all of the pieces into a new and harmonious whole.

Retracing my steps, I spy the soaring form of a red-tailed hawk, nearly large enough to pass for an eagle. A second, smaller one wafts across its path on an updraft. Both peer intently into the unruffled grasses of the meadow, then silently pass on by, continuing in opposite directions.

Living Together

The bridge over the river is being widened to four lanes. I wait in a line of cars backed up behind a concrete mixer, its huge barrel upended, twirling, as a thick sludge of aggregate slides down its chute and spreads across the leveled and graveled ground, filling all interstices, encasing reinforcing steel. Beyond the orange-striped cones on the shoulder, down the steep declivity, the river flows, mute. A dog park has been established here on the east side of the river. Two Dobermans and a Great Dane splash in the muddy shallows. The owners stroll casually on bare ground in the shade of young maples. The dogs race to scramble up the steep bank. One teeters a moment, then recovers, claws scraping deeply into the raw earth. They stop momentarily to shake out their wet fur, then dash off down the denuded shore.

The west bank of the river is profuse with tall grass and overhanging shrubs that would provide cover for fish, fowl, and amphibians if not for the presence of dogs. There are no trails cutting through the wide field of cattails and tall reeds beyond. I stare out at this scene wistfully as I sit, breathing in exhaust fumes.

This paradoxical concept of pollution and recreation within an urban wilderness is just one example of many dualities that characterize the human condition. We are both communal and territorial. But while dogs mark their territories with scent and birds

Granville Off-leash Dog Park, Milwaukee.

mark theirs with song, only humans mark their territory by so transforming its character as to make it uninhabitable by other species. We are fortunate to live in a city with a wealth of natural areas that can provide an invitation to wildlife. When we have begun to redress the exclusionary effects of territoriality, an already communal urban culture can be enriched by an urban wilderness.

We must make roads, but we also must make parks. And when we build roads or parks there are further choices: neither road nor park need be focused on single-minded utilitarianism. Gratefully, the line of cars inches forward. I pull over and park on the wild side of the river, tramp down into the shoulder-high grass, and relish the relief it brings.

Brief Encounters

The colors in the upland wood have muted to a late autumnal monochrome. A thin overcast weakens the light, further flattening the scene. Against this somber setting the exuberant red of a small woodpecker is a spark of jubilation. The telltale *rat-a-tat* directs my attention, but the colorful bird refuses to hold still, flitting from tree to tree with uncanny alacrity, as if it moves by telekinesis rather than ordinary flight.

The track peters out as I wander into a meadow in the early throes of a skirmishing transition to woodlot. Young poplars, hickories, and maples are besieged by advance platoons of burdock and buckthorn. The wildflowers have withered. Brittle brown stalks, bereft of blossoms, snap with every step.

A well-established but long unused track leads down to the Menomonee's riverbottom. Buttressed by rubble and sizable chunks of concrete, the slope it braces was used as a dump, the sorry fate of so many backcountry roads when there was backcountry to despoil. Rusting debris is scattered along the base of the rubble. The floodplain beyond opens into a broad wetland with so wild an aspect that it speaks in a nearly audible primitive voice. Though trackless and damp, the low-water conditions of autumn make it passible. The wildness of the place is marred by detritus of recent vintage, with brighter hues and more durable materials. The old rusty remains seem almost natural by comparison. And, although this is flotsam deposited randomly by receding floodwaters, without malice or intent, it nevertheless represents carelessness and irreverence.

Wildness returns in the guise of an apparition. A large, dark form bolts from hiding amidst a heap of moldering deadfall. It careens around a log and scoots between clumps of tall grass. It doesn't fly. Its form and manner identify it as a wild turkey, but it is an unusual shade of pale gray, almost lavender, with a whitish head. Very large, it scurries

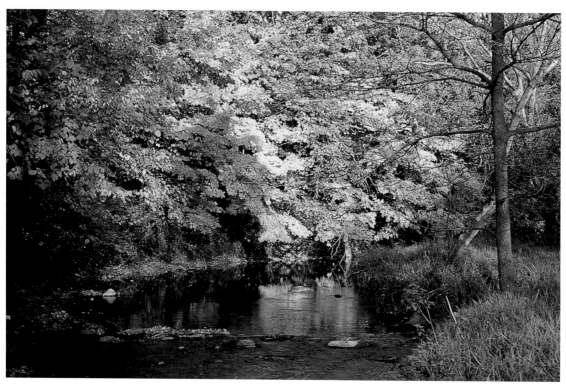

Riveredge Park, Menomonee Falls.

noisily through dry grasses, threatened not by the accumulation of colorful, noxious debris, but by my inadvertent assault on its refuge. I leave, chastened by its fear but heartened by its presence.

Wildest Dreams

Like few other places in the watershed, here in a wedge between highways, between the suburb and the city, the river twists and turns like a snake writhing to elude a predator's grasp. One meaning of "wild" is "free of constraints," as in "one's wildest dreams," which involves allowing the imagination free reign. Then it can "run wild," unencumbered by the reservations of civility, logic, or reason. This stretch of river has a wild character that surpasses my wildest dreams.

It isn't an *easy* place to be. There are no trails. One cannot go for a relaxing stroll. I plow through chest-deep grass, climb over or duck under fallen trees, scramble around eroded gullies, crawl through brush, all the while pushing aside nettles and burdock, stumbling in hidden holes and sinking in mud.

Luminist painters notwithstanding, wilderness is not inherently scenic in classical aesthetic terms.[3] Here, a venerable cluster of giant trees is now upended — thrown with

unimaginable violence across the river. Its base still knotted together, a great mass of soil rears high overhead. Torn roots intertwine like a fistful of worms, simultaneously clutching and surrendering with convoluted gestures. Backed up behind the broken trunks, an incoherent mass of driftwood and debris demolishes all sense of the placid river flowing beneath.

And yet this place along the river can be seen as beautiful. There can be a kind of purity to the ugliness of nature that makes it palatable in contrast to human-made ugliness, which possesses a conceptual repellence that goes beyond visual aesthetics. For example, an old dump lies partially hidden in a ravine behind a fallow field above the river's bluff. Among the more typical rubbish is the wreckage of gasoline pumps, their inner workings exposed like the uneaten entrails of a butchered animal. Numerals stare from small square slots, like unclosed eyes on a corpse, registering a price fixed for eternity, a symbol, perhaps, of the debt we owe the earth by extracting its precious oil to burn.

Wilderness in its purest sense refers to a place untouched by humankind. An urban wilderness may be a place that has been neglected long enough to have acquired its wanton temperament and donned its disheveled attire. A place, it's possible, of peace and beauty. In your wildest dreams.

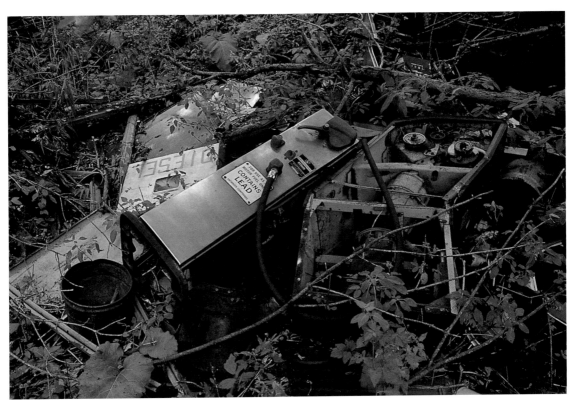

Unauthorized dump, Menomonee River Swamp Natural Area.

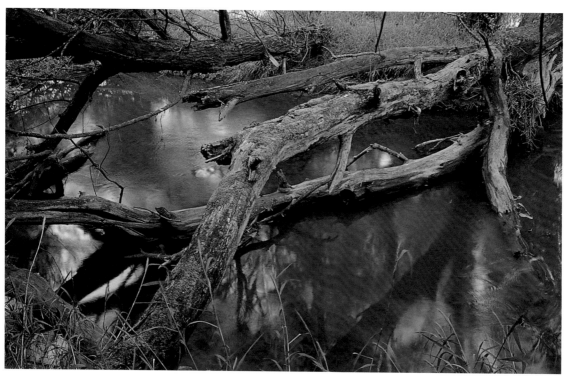

Menomonee River Swamp Natural Area. Like few other places in the watershed, here in a wedge between highways, between the suburb and the city, the river and its trees twist and turn like a snake writhing to elude a predator's grasp.

Definition of Wild

The riverside wood opens into a cutover area under high-tension wires. Run-off from an unsheltered, gravelly slope has gouged deep ditches across the path. Some of these channels have been filled rudely with smashed wooden palettes and sawn posts. This was not done for the mountain bikers who frequent the trail.

The path widens and forks as it enters a deeper wood. I choose the fork nearer the river, though as I proceed the land rises steadily. A large area has become a dirt-bike course, with criss-crossing trails, banked curves, and groomed jumps. Despite this obvious human interference, an uneven terrain, cut with deep ravines, and a heavy tree canopy hung with thick vines makes it seem wilder and wilder.

Reaching the crest of an escarpment I look down into the broad hollow below with a mixture of wonder and dread. If "wilderness" means "pristine land, untainted by society," then I am nowhere near it; but, if "wilderness" means "untamed, even savage conditions," then I have discovered the "heart of darkness" in metropolitan Milwaukee. Distrusting my senses, I climb down the steep slope, clutching tightly at branches as if their stability will also ensure sanity.

Up close the scene at the bottom appears more surreal than sinister. It has a campy air

of post-apocalyptic devastation splattered with carnival colors. The rusting hulk of an ancient Gremlin is nestled into the ground, hood and doors ripped from hinges. The original color is long forgotten, concealed by successive layers of pink and chartreuse paintball splotches. The topmost layer is moist and vivid. I glance around nervously. This is the indisputable domain of renegade paintballers. No one is visible. The rotting guts of several other unidentifiable cars decorate the scene at strategic intervals, radiators and engine blocks exposed, batteries tossed aside, hoses and wires protruding from all angles. Doors and side panels have been propped here and there against living trees and fallen logs. These redoubts are reinforced with river rocks, driftwood, plastic mesh fencing, and long strips of sheet metal. Though I am appalled by the wanton disrespect for nature, there is a place deep inside of me that holds a spark of childhood delight. From my own youthful war games I recognize a dormant instinct to assess the territory quickly for maximum tactical advantage. Its virtual remoteness makes this an ideal setting for clandestine conflict.

The river encircles the "battlefield" in a wide arc. Stands of huge willows and cottonwoods, along with smaller box elders and hawthorns, anchor a bit of higher ground in the center of the oxbow. Floodwaters have cleansed the ground repeatedly, scouring away the soil, exposing underlying rock, and leaving twisted tangles of debris wrapped around the upstream sides of trees, boulders, and bulky metallic carcasses alike. War games aside, this would be a truly wild and dangerous place after a thunderstorm.

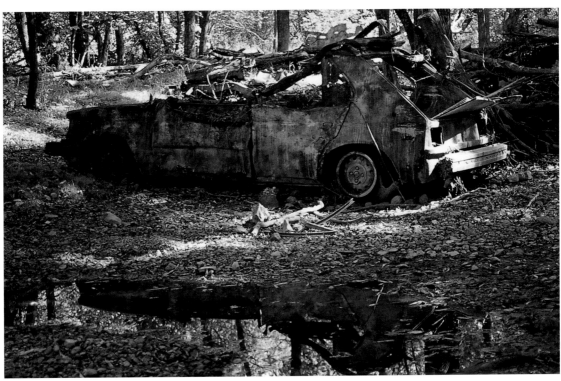

A burned-out AMC Gremlin, Menomonee River Parkway, Milwaukee, the domain of renegade paintballers.

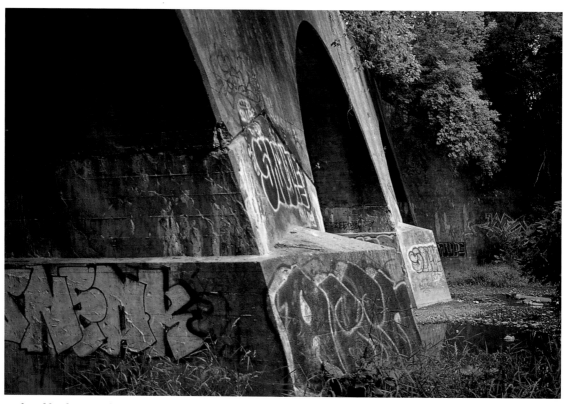

Railroad bridge over the Menomonee River, Milwaukee, the "frontier" where the Menomonee River crosses from Waukesha County to Milwaukee County.

The secret of this place's remoteness lies just ahead. The river emerges from gargantuan triple arches under the massive concrete wall of a railroad bridge rising higher even than the bluff down which I scrambled. Inside the tunnel, under one of the arches, I meet the perpetrators. I had imagined teenagers out for a bit of a lark. I find the truth more chilling. There are four men, dressed in camouflage, ranging in age from thirty to fifty or so. They don't appear to be having *fun*, bearing grim expressions and nasty-looking, short-barreled weapons. In the dimness, I make out several opened ammo boxes and numerous small pink and yellow balls, along with beer cans in the dirt and graffiti on the walls. Most incongruous is a complete set of bleachers propped on a sandbar like a reviewing stand for the military exercises outside. How it came to be here is beyond my imagination.

Distracted, the men look up at me. I wave briefly and politely say something banal. They go back to loading their weapons.

Next to the railroad embankment is a slope slightly less steep, which explains the presence of the abandoned cars, if not the bleachers. A remaining mystery is yet to be solved: how can we learn to appreciate the wildness inherent in the land and not debase it with barbaric impulses and the ruined machinery of civilization?

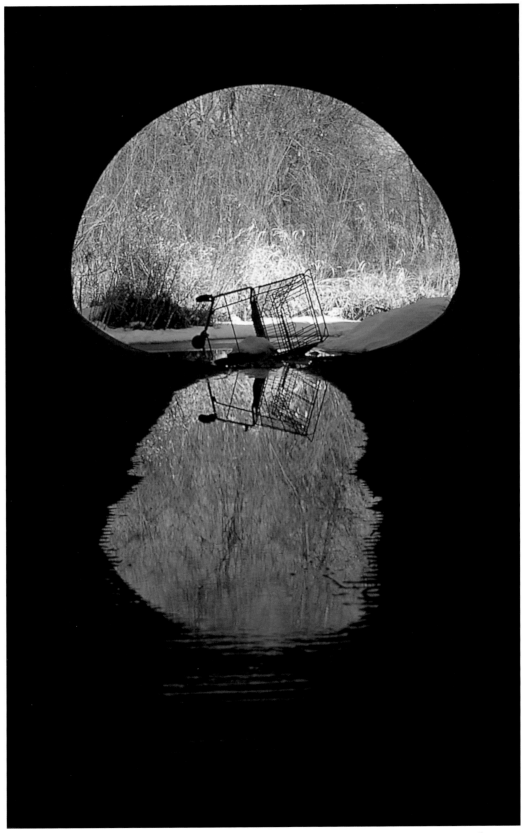

Culvert, Butler ditch, Butler. The "third frontier" is the propensity to experience nature vicariously, if at all.

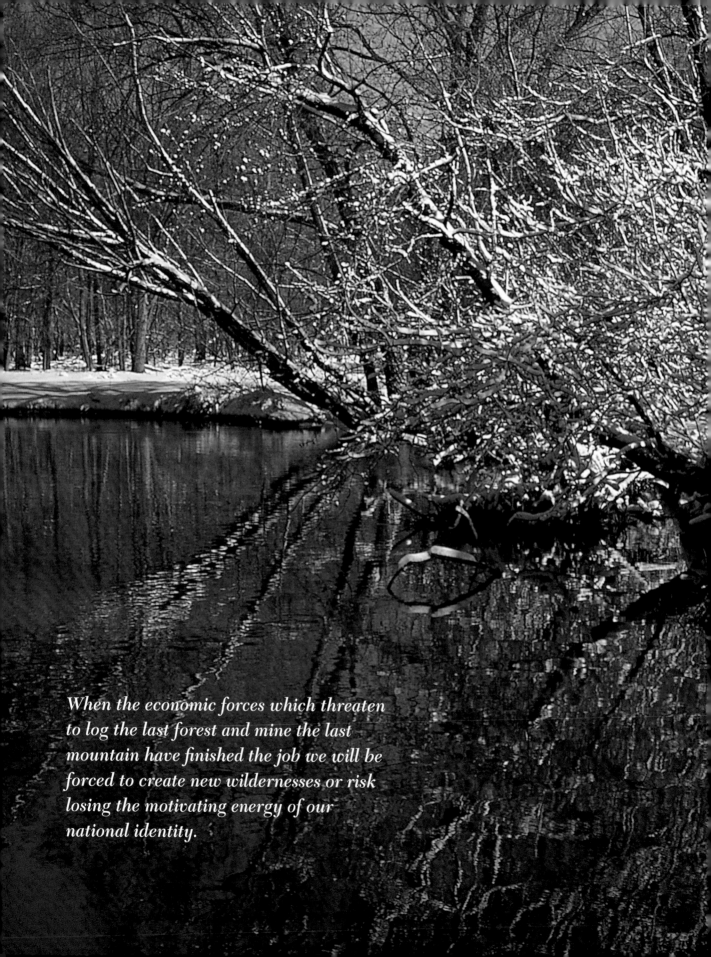

When the economic forces which threaten to log the last forest and mine the last mountain have finished the job we will be forced to create new wildernesses or risk losing the motivating energy of our national identity.

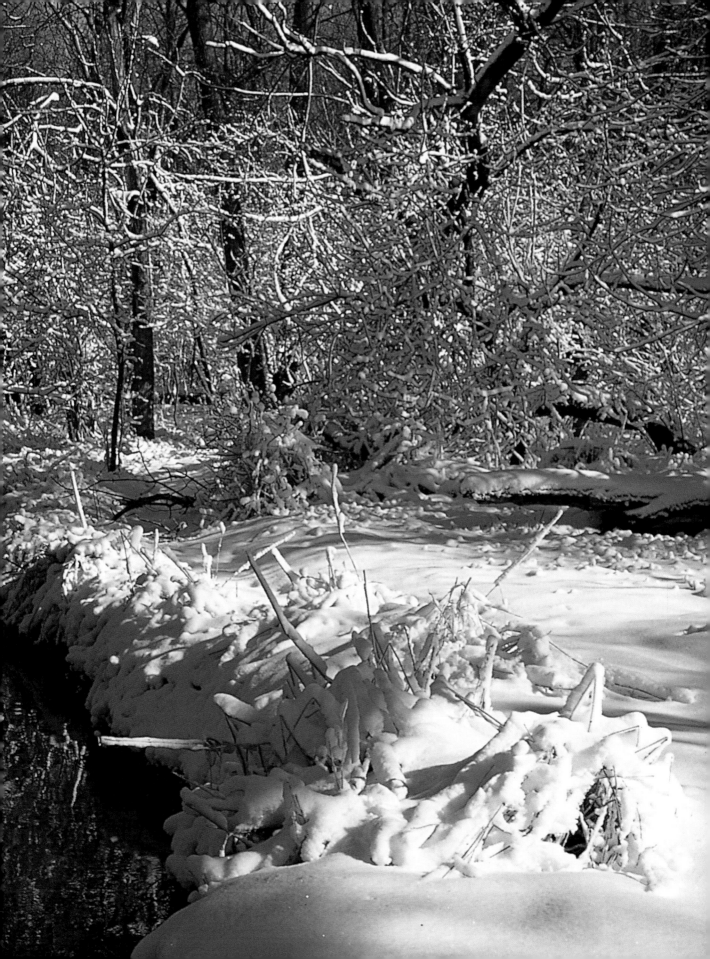

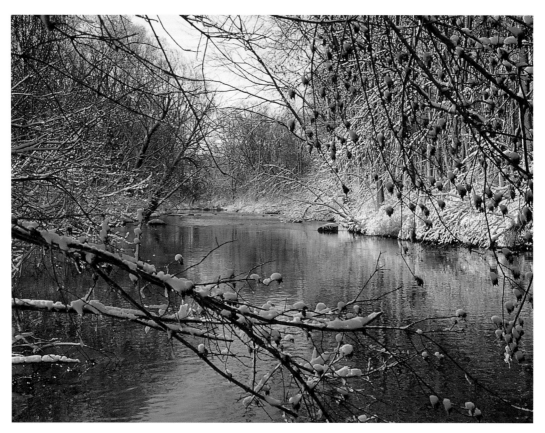

Top: wintry scene, Menomonee River Parkway, Wauwatosa; bottom: sledding, Curry Park, Wauwatosa; previous spread: Menomonee River Parkway, Wauwatosa.

T HIS IS WHERE WE EXPERIENCE THE PARKWAY, a primary element in the enviable system of parks that makes Milwaukee a particularly inviting place to live. The parkway as an urban phenomenon in the United States was conceived by landscape architect Frederick Law Olmsted (1822–1903) and developed in Milwaukee County by Charles Whitnall.[1] Olmsted's revolutionary concept was to design a "new combination of urban and rural elements that . . . would permit urban residents to make full use of the opportunities of the city while enjoying elements of space, sunshine, and fresh air."[2] A parkway, characteristically long and narrow, would enable a city's inhabitants to experience a variety of "natural amenities" in a multitude of ways, putting particular emphasis on both foot and vehicular traffic. Whitnall's brilliant interpretation of Olmsted's ideas utilized river corridors as the basis of the county's park and land-use plan. Both men believed that experiencing nature is essential to healthy living, and, in historian John Gurda's words, Whitnall's "park loop would literally surround Milwaukeeans with nature."[3]

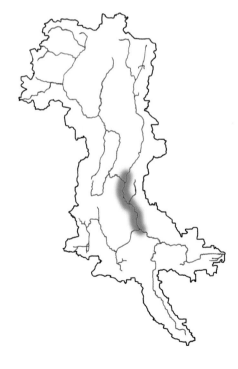

The Menomonee River Parkway weaves its way through much of the City of Wauwatosa and parts of Milwaukee. Just one of several river parkways that make up Milwaukee County's "park loop," it is also but a small segment of the watershed. But the parkway is at the heart of the watershed in more ways than one. It is centrally located, and, more importantly, it sees the heaviest recreational use of

any part of the watershed. In good weather, people flock to it in droves, traveling along its drives, paved paths, and unpaved riverside trails in many more ways than either Olmsted or Whitnall could have imagined. Despite this intensive use, anyone willing to leave the beaten path can still touch a kernel of wildness at the heart of the river that helped to create one of the most important cities on the Great Lakes.

The Bikers

A group of five twenty-somethings on bicycles, decked out in intensely hued spandex, travel in tight formation like Blue Angels on wheels. They slow obligingly enough, following the etiquette of the trail, until they can pass me. Then they resume a furious pace over uneven ground, weaving in and out of trees, maintaining control and formation.

The east side, with its paved bike path, sees much more constant use. But on this cool, gorgeous fall day, there are an unusual number of people out on the rugged west side: this is the realm of the mountain bike, albeit unauthorized. There is a trail accessible enough for parents who bring their children to learn lessons in off-road riding. There

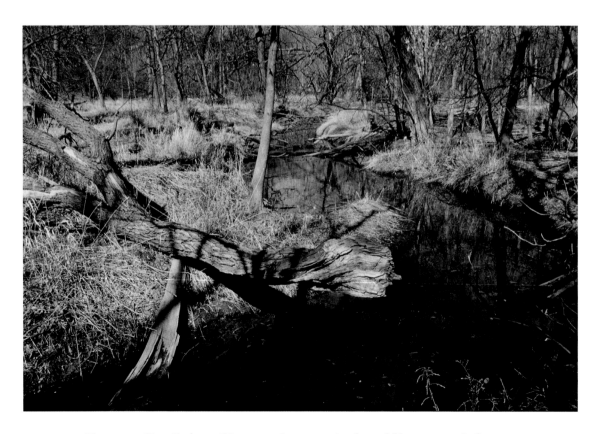

Menomonee River Parkway, Wauwatosa. In autumn, it takes a deliberate mental effort to imagine remoteness, but this imagined wilderness is no useless fantasy.

are also alternate routes that can challenge the veterans. Some are steep enough to invite daredevil plunges, some run through low-lying riverbottom where mud sucks at deeply treaded tires. We come seeking a ribbon of wildness, each in our own fashion, and find it here, sandwiched between the hustling freeway and the placid parkway.

Instinct

Why does a beaver choose *this* tree? Why *this* particular stretch of river—one of the few places not lined with sheet piling or concrete that is wide and straight? The evidence is incontestable: two large birches stand a few feet apart, nearly cut through, telltale gouges and teeth marks tapering in to the cut, piles of fresh, fragrant chips encircling each. But even if these birch trees weren't still standing in defiance of the beaver's industry, they would barely ripple the water before being swept downstream—if there were water into which they could fall. The river is frozen solid from bank to bank. Perhaps a large beaver—they can grow up to four feet long and weigh seventy pounds—could push a floating log this size on a somnolent summer day, but the ice dispels that image.

And, though an enticing idea, can Milwaukee County support a family of beavers? Their predilection is for aspens, which are present in the watershed but not abundant. The unlikelihood of a sustainable local population makes the presence of one or more rogue beavers the more remarkable. They are evidence of a viable natural corridor that allows them to migrate from more suitable northern regions. The opportunity for the local human population to witness them argues for the preservation of these continuous corridors.

Beavers represent a historical reality that was all but lost before the decline of the fur trade in the early 1800s, when much of the state was still true wilderness. Unlike the world they inhabit, beavers' instincts and activities have changed little in 200-plus years of dwindling habitat. Beyond these girdled trees a smaller one was successfully felled. It lies across the ice, not quite reaching the other side. Farther upstream the concrete span of the Hampton Avenue bridge creates a parallel symbolic of the unequal competition between two species with a similar impulse: to alter the environment to suit their needs.

Not far from here the Environmental Protection Agency has ordered that a three-mile stretch of river be completely rerouted in order to mitigate the effects of long-term toxic pollution from an abandoned industrial site upstream. A beaver still lives along the river in Milwaukee and, although this time its efforts have fallen short, its instinct is

Little Menomonee River Parkway, Milwaukee. To venture into the wilderness is to invite danger, for wilderness is, by definition, uncontrolled, unpredictable, and indifferent to human sensitivities.

intact. Which instinct will drive our own species: the one that impels us to consume the land or the one that seeks to restore it?

Flirting with Danger

A week of below zero temperatures has made it possible to walk *on* the river from Capitol Drive all the way to Hampton Avenue: a rare opportunity. It's well over a mile and uneventful most of the way. Areas of open water around rapids are easily avoided. About halfway back I approach a swath of ice-bound debris. I am trying to get an unusual angle for a photograph. Maneuvering here is risky—sticks and frozen flotsam protrude from the ice, making the surface less secure—but a dram of risk now and then has a definite attraction.

To venture into the wilderness is to invite danger, for wilderness is by definition uncontrolled, unpredictable, and indifferent to human sensitivities. Scarcity, along with living in a society increasingly alienated from it, has heightened the appeal of wilderness. Enthusiasts of "extreme sports," such as rock climbers who disdain safety harnesses, are indulging in an adversarial relationship with nature that is no longer an unavoidable

aspect of survival. For intensity and scale the urban wilderness will never compete with remote, glaciated massifs. But even here those so inclined will create opportunities to heighten the experience of the wild with a surge of adrenaline. A degree of recklessness—or lawlessness—often factors in.

I am not immune, though my flirtations with danger tend to be fairly sedate, quite legal, and certainly respectful of the natural environment. I listen carefully for the subtle creaking that indicates weak ice. But this time there is no warning: I step over a clump of snarled driftwood and suddenly—with no sensation of having fallen—I am standing in water up to my thighs. Simply, calmly, I think, "Oh, I have to get out of here." It isn't even cold, at first, just startling. If I remain wet, of course, the cold will catch up with me. Quickly. Being this foolish in the backcountry of Alaska or even the North Woods of Wisconsin would result in mortal peril. Within minutes hypothermia would set in and But not here in Milwaukee. I know that I can outrun hypothermia, for my wilderness ends a half-mile down the parkway where my car waits.

Moods

As I leave behind the paved parkway trails I cling to the river as one clings to the possiblity of a better future for one's children. Ice stretches from bank to bank. On top of the ice, pitted and scarred with the effects of semi-thawing and refreezing, are scallops and looping patterns of mud, as if French curves had been laid out in a rhythmic paisley. I come to a spot where there is no ice. Opaque black water seems to descend like a bottomless abyss, open to the depths of the earth.

The sky is heavy and the light dull. The birds are strangely silent. All around me, suddenly, a flock of tiny chickadees hangs like solemn ornaments in the trees. Just as suddenly they are gone. Mourning doves separate from unseen perches, whistle through the branches, wings thrumming like an exhalation of night. A murder of featureless crows studiously ignores me from the leafless crown of a huge hickory. One by one they drop and glide without a sound like torn pieces of sky briefly flickering, revealing the unlit vacuum of space.

Finally, the mood breaks. A woodpecker starts a lively drumming on a hollow tree. Across the river another adds a lower counterpoint. Their upbeat duet continues until one departs with a chipper cry. A barred owl hoots. Its haunting, chimerical call seems to usher an unseen congregation to prayer. Infinitesimally, the wintry landscape warms. The overcast, which has been growing steadily deeper, starts to shift and thin, like the

shaking of a shroud. At the horizon, the sun looms briefly, searing and salvific. For a moment sky and trees are gilt in regal majesty. A red-tailed hawk simply floats, serene, ethereal. Its motionless wingtips catch the last gleaming spark of day.

The Quality of Scenery

"Preserve open green space" has been a rallying cry in our community and in many others across the nation. But scratching the surface of "green space" reveals a variety of meanings and intentions.

I'm walking on a very large tract of open green space. It contains stunning vistas, delightful variations in topography, and a lively diversity of vegetation. A picturesque watercourse, laced with wooden bridges and punctuated at intervals with romantic ponds having just the right proportions, cuts a dramatic diagonal across the entire parcel. Olmsted's brilliantly conceived theories concerning the quality of scenery in landscape architecture find a good home here.

No fewer than seven golf courses either border on or span the Menomonee River on its short journey from headwaters to estuary. No one would ever confuse a golf course with wilderness, certainly, but it is surprising how completely segregated this one is from

Curry Park golf course, Wauwatosa.

the river. The rolling, pastoral landscape of the country club stands in sharp contrast to the belt of wild lands along the river. A steep bluff creates a decisive edge for about half the length of their common boundary. Fairway layouts and a tree border effectively eliminate sight lines toward the wild lands below.

The other section of common boundary slopes gently down toward the floodplain. Here is an opportunity to exploit the natural beauty of the river and enhance the aesthetic experience of being on the land. Instead, a large, pungent mound of composting residue from grass-clipping and pruning operations forms a visual barrier.

Wildlife, emboldened by off-season abandonment of the course, make no such distinctions. As I traipse about, respectfully avoiding the greens, four huge deer stroll confidently across one of them in broad daylight, indifferent to the failed camouflage in this setting of their seasonably lusterless gray coats. When I get upwind they suddenly swivel in shock, raise their white flags, and relinquish the field, bounding over sand traps.

With proprietary nonchalance, an enormous flock of geese has spread itself across the rolling hills like a regiment in parade dress at ease, far from the front lines. They certainly don't expect foreign reconnaissance to come sauntering into view. When I do, they all raise their long necks high as if on command and stand at attention until satisfied that I will not invade their perimeter. Although I am treated like an enemy scout, I feel like a bumbling interloper, AWOL and out of uniform.

Violets and Garlic Mustard

Why are they called *violets* if they are blue and magenta? The forest floor is free of underbrush; I saunter through a thick, flickering carpet of ground-hugging violets. White splotches of trillium are sprinkled here and there. The flowers look like confetti the morning after a ticker-tape parade. Suddenly, I reach a point where there are no more violets of any hue or any other flower, except a tall, menacing stand of deceptively lush garlic mustard. Like so many nonnative plants and animals, garlic mustard was introduced deliberately by well-meaning European settlers who believed it had medicinal qualities, but who understood neither the fragility of stable ecosystems nor the proliferation and often total obliteration of native species that would ensue. Here, the violets and trilliums have been routed in a war of annihilation in which an alien species overcomes native ones, another example of unintended consequences.

Restoration of native species is one of our great challenges. Unfortunately, many of the species now common in our "natural" areas, whether aggressively invasive or not, are nonnative. To the uninitiated many also appear attractive and desirable.

Invasive Species

A path I've walked so many times should be familiar, yet this parkway trail has a strange and slightly ominous character. The whole place has changed beyond recognition. How can it be so altered in just one summer?

The wood was always shaded and cool, with an open, inviting understory. Now it is overgrown, dense, and tangled. American Indians believe that all things possess spirit and that the landscape itself has power, the power to evoke strong emotions, from elation to terror. Usually, I draw energy from the landscape, and walking along the river I nearly always feel nurtured, invigorated. But not today. The trail is narrow, close, and dark—suffocating, even threatening. My habitual saunter is uncomfortable. As if loitering in a poorly lit alley at night, I feel impelled to move, to escape.

Buckthorn has grown to fill all available space, clogging the forest, eliminating landmarks and scenic views, creating unfamiliarity on a well-traveled path. Buckthorn embodies the term "invasive weed." It doesn't simply overwhelm native species; it is visually aggressive. Long, woody branches with small, dark leaves reach out in all directions, grabbing for space. Bearing no actual thorns it nevertheless manages to appear menacing, as if it did.

The path drops down to wetter bottomlands, where the canopy is denser and the rich, dark soil is slippery from last night's rain. The thicket of buckthorn yields; the damp ground is largely bare, making it *feel* less oppressive, despite the dimness.

Farther on the vegetation shifts. A familiar stand of hawthorns, which, unlike the buckthorn, bristle with the long spikes that give it name, appear reassuringly benign by contrast. Most hawthorn species are native, but even the exotic ones are less prolific, less prone to drive out other species and reduce the biodiversity that is so important to a healthy ecosystem. But now, at ground level, pale garlic mustard sweeps across the forest floor like static fire. Since it doesn't tower overhead, it feels less oppressive than the buckthorn. But at this point in the summer it is uglier. The slender stalks, with delicate bright green leaves topped by pretty white blossoms, are transformed into stringy, brittle spears of dull ochre. At the apex of each stalk stands a cluster of sharp, flower-bereft prongs.

A single stalk of garlic mustard has no power of intimidation. However, it seldom appears singly but more commonly in regiments, marching lockstep in tight formation, trampling everything in its path like a vast, insatiable, pillaging army. And it is all the more hideous for being an army of corpses: while the surrounding foliage remains a vigorous mid-summer green, skeletal garlic mustard rattles dryly, its liver-colored leaves mottled, leprous.

Top: invasive garlic mustard and dame's rocket, Greenfield Park, West Allis; center: invasive purple loosestrife and algae blooming in drainage ditch, West Allis; bottom: River Heights North subdivision under construction along the river corridor, Menomonee Falls.

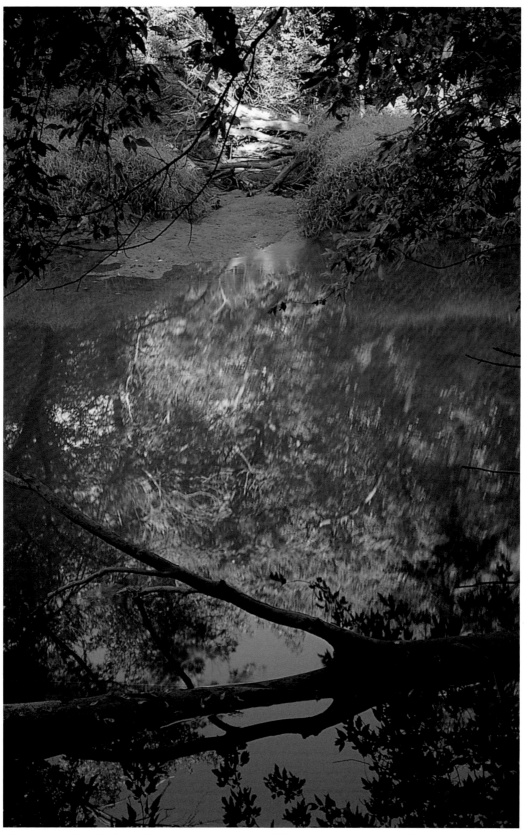

Menomonee River Parkway, Wauwatosa. For anyone willing to leave the beaten path it is still possible to touch a kernel of wildness at the heart of the river.

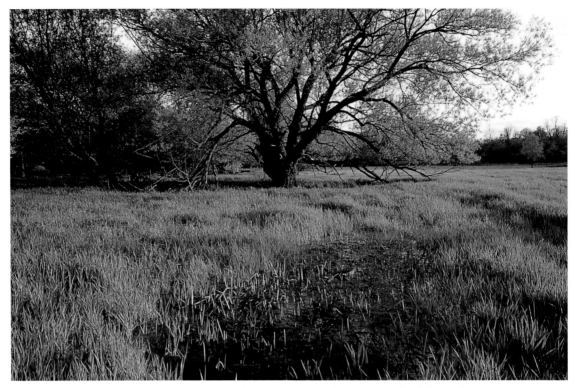

River Heights South, Menomonee Falls. This lush environment can be experienced only by wading.

Nonnative species are destructive because they are free of the checks and balances inherent in a stable ecosystem. Whether brought deliberately into new habitats for some intended benefit, like flavorful garlic mustard, or introduced inadvertently, like the infamous zebra mussel (and even more rapacious quagga mussel) that hitchhiked on ocean-going vessels bound for the Great Lakes, we are ultimately responsible for the consequences of our actions, appetites, and economic values. We must live in the landscape that surrounds us. Whatever we make of it will be our home. If we don't think of ourselves as belonging to *this* place, we may be tempted to alter it, to recreate some remembered place or utopian ideal. Then, no matter how attractive or ugly we make our environment, *we* will have become the invasive species with all of the attendant consequences.

The Tao of Wilderness

Last year an unusually dry summer made it easy to navigate both banks of the river. Hikers and bikers trod hard-packed paths through tall, burned grasses and spiky, dun-colored garlic mustard. This year, the east bank has been abandoned. The land dips into

marsh. There are no trails here now. This lush green environment can be experienced only by wading: literal immersion. One must leave behind suburban paths and become a solitary explorer in soggy seclusion. I struggle to the center of the slough, knee-deep in water, invigorated by the wild aspect of the landscape. Startled by my inexplicable intrusion into their accustomed refuge, three deer stare briefly, then bound off into wooded recesses. As the splash of their disappearance fades a profound stillness ensues. My feet slowly settle in the gurgling mire. A primordial spirit pervades the scene. I want to preserve the power of the moment. Instead of recording it with my camera I simply breathe it all in.

The Tip of an Iceberg

I step carefully near the bank, wary of the river's treachery. A tall crop of reeds hides the edge like a booby trap. Many a time I have been within a hair's breadth of tumbling headlong into the water. My acquired caution serves a second, even more rewarding purpose. Suddenly, at my feet I hear a loud bass *plop*. Despite its being securely hidden below the overhanging reeds, I have come too close for someone's comfort, and the party responsible is clearly larger than the usual bullfrog. In the clear water, a dark form stands out plainly against the sandy river bottom. It is about three feet from nose to tail and looks for all the world like a gigantic mouse. With a seemingly effortless motion, it swims upstream about two feet below the surface, stirring up mud in symmetric swirls as it goes. A faint glow of some unnaturally orange, rectangular object is revealed briefly by its passing. Then the mud resettles, allowing the illusion of unspoiled nature to resume. The creature stays safely underwater until it is out of sight around the bend. Never having seen one in quite that fashion—normally the tip of a nose is all that I glimpse as it glides through the water—now I know why they are called musk*rats*.

The sight of a wild animal in the watershed, be it a deer, coyote, or muskrat, seems at once so magical and coincidental that I am convinced many more must be nearby, unnoticed. Even a large deer could easily go unseen if only it would hold still. Like this muskrat deer seem to trust distance more than camouflage. Generally, it is a departing jump that reveals their presence. As I watch them disappear I stand accused by their distrust. I accept my guilt by association while I marvel at being able to witness their existence. For wildness is not magic at all, but evidence of a *conditional* reality. Each sighting is a confirmation, the tip of an iceberg, proof of the value to maintaining biodiversity of preserved natural lands.

Grass

The floodplain has become a maze. In late June, the grasses have reached a magnificent height, looming well overhead in full bloom. Even on a trail rammed hard by regular mountain-bike traffic I have to part my way through it. At eye-level the stalks rise majestically out of their sheaths, and a sea of golden tassels glows in the morning light. The meadow is soft, luminescent. I can almost *see* the absorption of sunlight; its nourishing energy suffuses each tiny spikelet radiating out from the stalk. The blades flit like rakish scarves tossed by the wind.

The most enchanting discovery comes quite simply by brushing against the stalks and pushing them aside to negotiate overgrown pathways. Each brush shakes loose a delicate cloud of fine mist from the panicle, or cluster of flowers. Before long I am dusted with the blessing of pollen. It is like walking down the aisle of a gloriously illuminated cathedral with an entire congregation of priests shaking censors over me as I pass. A holy spirit pervades the air, shimmering like sunlight through smoke.

In the wilder fringes of parks, away from cropped lawns, a remarkable and often surprising diversity of grasses can be detected with careful observation. In this riparian meadow, as in so much of the watershed, the coarse, nonnative reed canary grass is predominant due to its size and abundance, but here and there other varieties make a stand.

Timothy is the easiest to identify because of its similarity to its cousin, the cattail. It has a distinctive single flower that shoots straight up out of its sheath. Unlike the cattail, however, which remains rigid like a plump, burnt sausage, timothy grows long and limp like a tapering candle left out in the summer sun.

Grass can be far more than a comforting exterior carpet stretching wall-to-wall in the neighborhood. The tall grass meadow is oceanic in its movement, so much more animated than an inert lawn. The progress of a breeze plays across the meadow like the open, unchecked expressions on the face of an innocent child. Contrapuntal rhythms are added as the breeze eddies around trees: the entire meadow dances, dips, and sways.

Reed canary grass, Menomonee River Parkway, Wauwatosa.

Accommodation and Lamentation

Nature's normal variations have been given greater amplitude by last night's gentle rain. The impressions of yesterday's bicycle tread marks in the mud of the trail look nearly as fresh. Indeed I take them for fresh until I get to the meadow and determine that the ranks of grass which have closed over the path are undisturbed. In contrast to yesterday, I am quickly soaked when I push through them. The simple act of following the path takes on a biblical air, almost a parting of waters. It is worth the discomfort: here is treasure! The sprightly lift of the grasses has been dampened, making them less susceptible to the vagaries of wind. Instead the scene is so jewel-encrusted as to make a baroque monarch jealous. Each leaf and every blade of grass sparkles with innumerable, tiny prismatic pearls.

The visual effect has a countervailing sound track that lends it poignancy. The refrain issues from the creek hidden beyond the woods-rimmed meadow, but it seems to rise like a burp from the very belly of the earth with a guttural, penetrating intensity. Sounding like a cross between the pluck of a crudely fibrous string bass and a thump on an upturned crock, each intonation is followed immediately by a softer echo like a huge

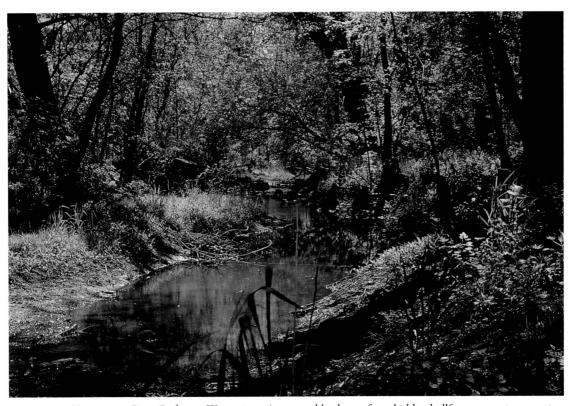

Menomonee River Parkway, Wauwatosa. An unearthly chorus from hidden bullfrogs seems to emanate from the very ground at this time of year.

Menomonee River Parkway, Wauwatosa.

peach pit dropped into a deep, empty barrel. The first THUMP/thump is followed by successive ones farther away, establishing a trenchant rhythm. I imagine members of a baleful but fervent jug band stretched out along the creek, each vying for the lead in a preternatural audition.

The glade through which the languorous creek trickles and pools is peaceful and nearly idyllic. The unearthly chorus seems to emanate from the very ground. The sylvan character of the scene is marred only by the gray-black complexion of the water, the single clue that its source is street run-off, and this is still an *urban* wilderness. Although the bullfrogs' soulful serenade creates a mood of lament, I am cheered by their presence, which signifies adaptability and persistence. But I am not so tolerant. Though thoroughly saturated from the grass, I walk back around, not wanting to immerse my feet in the putrid water. Cheerful optimism and concern, accommodation and lamentation, all are appropriate responses to the contradictions of the urban wilderness.

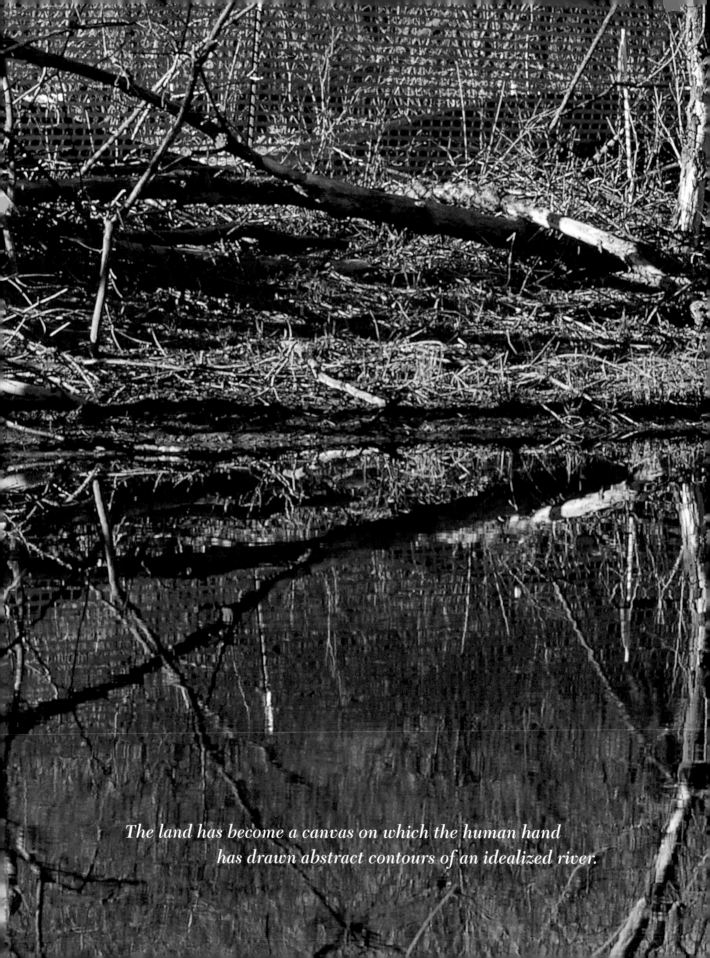

The land has become a canvas on which the human hand
has drawn abstract contours of an idealized river.

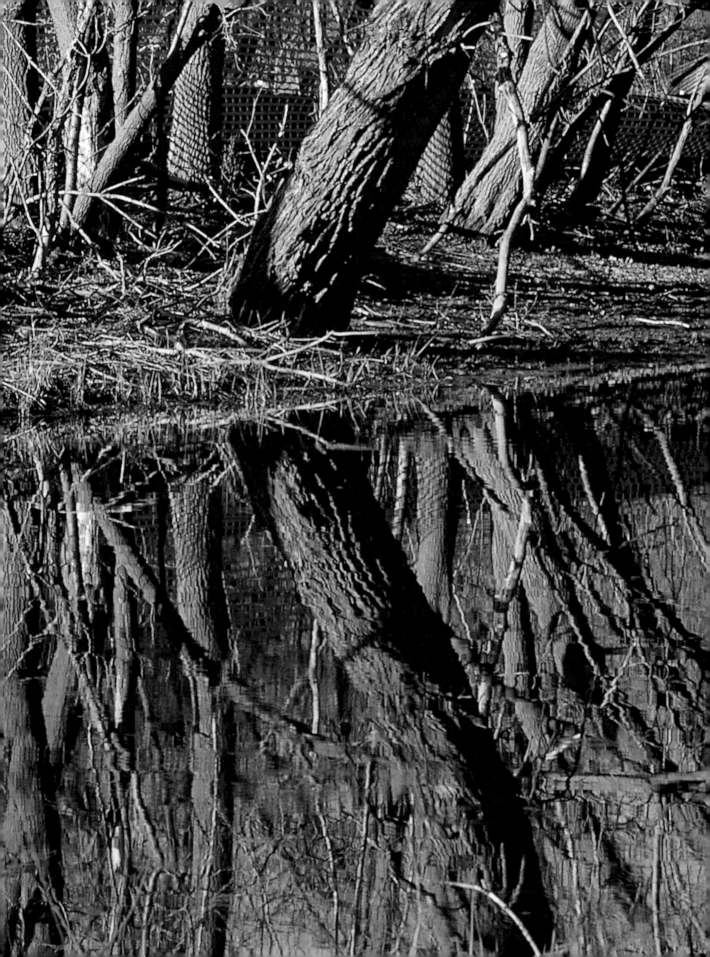

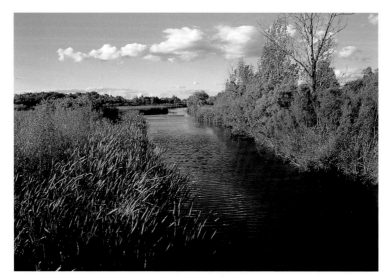

Top: Little Menomonee River Parkway, Milwaukee; center: fencing and logging, Little Menomonee River, Milwaukee; bottom: bank buttresses, Little Menomonee River, Milwaukee; previous spread: Little Menomonee River Parkway.

As an explorer of what is already known I am staking a claim to unusual territory, another paradox for the urban wilderness. Gary Snyder identifies one of the "key problems in American society" as a "lack of commitment to any given place." In our highly mobile culture, "neighborhoods are allowed to deteriorate, landscapes are allowed to be strip-mined, because there is nobody who will live there and take responsibility; they'll just move on."[1] The Little Menomonee River might have been such a place: a river in name only, this small stream was straightened in the nineteenth century to maximize adjacent agricultural land. In the twentieth century, the lower half of it was contaminated so badly by a wood-preserving facility that the entire floodplain reverted to virtual wilderness. In the bureaucratic words of the Environmental Protection Agency, "Potential health risks exist for individuals inhaling volatilized chemicals or ingesting or coming into direct contact with the contaminated sediments, soil, groundwater, or surface water."[2]

But today we have reached a point when "moving on" is no longer feasible. All over the nation cities are discovering they can no longer ignore polluted rivers. Milwaukee has decided to make a commitment to this place and to rehabilitate a river. In this chapter are the stories of the Little Menomonee River, both above and below the offending facility. Designing a river can be a hopeful act, but it is like a story without an end passed on orally from one generation to the next: perception and interpretation often determine "reality," and control, ultimately, must be relinquished to the flow of both time and the river.

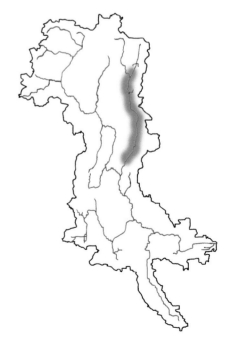

The Edge of the Suburb

The logic of the city exceeds its bounds. The wavering watercourse bisects one square mile of the grid that enmeshes the countryside with a surveyor's precision. In the city of Mequon, this tiny "river" is no more than a narrow creek—a narrative digression from the epic story of suburban sprawl. Rick Bass says, "when we run out of country, we will run out of stories. When we run out of stories, we will run out of sanity."[3] Today, feeling the need to boost my sanity, I set out to decipher this one small thread in the story of the watershed.

It is Sunday, and the traffic on Mequon Road is light. The sounds of civilization fade as I move forward down the path of the river. Indeed it is more path than river. Solid ice and deep snow make it the easiest route—first between farm fields, then into the wood-lot at the heart of the section. Someone has been here before me but not today. Yesterday's snowfall hasn't quite obscured human boot prints, perhaps made by another seeker of sanity.

There *are* fresh tracks, of course. Non-migratory animals have gone about their daily routines. Domestic dog prints near the houses at the start of my journey give way to wilder creatures deeper in the wood: the ever-present deer and raccoon and a lone fox. The "path" of the river becomes wilder, too, more arduous with more and more trees fallen across it. Some are too large to clamber over; some are snarls of intertwining branches. I make my way around.

I come upon a stout bridge deep in the wood. Leading away in both directions are a hunter's requisite red circles like insignia spray-painted on trees. Following their trail east leads to a private yard. Here, at the edges of suburbia, a kind of manifest destiny exerts itself. Active use of wild lands overrules ownership—as long as fence builders or bulldozers stay away. The "no hunting allowed" sign is similarly disregarded, as evidenced by the blind at the western end of the same trail. Aldo Leopold once observed, despite the laws of possession, "At daybreak I am the sole owner of all the acres I can walk over. It is not only boundaries that disappear, but also the thought of being bounded."[4]

Just as the density of the brush threatens to become completely impenetrable and just as silence settles all around like a comforter thrown overhead, the wood unexpectedly opens up again. Fields fall away on either side, and Freistadt Road draws its hard line across the land ahead. Geometry and fragmentation reassert control, along with the thought of being bounded. Like a wolf downwind from danger I turn back to the reassuring silence and the snow.

Snout

Ah, the elusive beaver! Or is it a muskrat? Hard to be certain when the only part of its anatomy in view is the tip of a snout. But I've seen plenty of muskrats, and this creature moves through the water with a distinctive attitude, its visible feature held aloft as if in disdain. The beaver slides smoothly through a thick layer of avocado green algae, which covers the surface like a tablecloth. It is intent on the farther shore, but, just before reaching there, it submerges and is gone.

"Beaver" might not have come to mind when I saw the skimming snout, except for the abundant evidence surrounding the lake. Trees, felled and left untended, lie all along the western shore, overgrown and buried in underbrush and tall grass. Neatly tapered, symmetrical stumps, bearing the distinctive scallops of overgrown incisors, mark the sites like gravestones. Here and there, larger trees stand ringed by chips. They've daunted the attacker but are still doomed by the girdling.

It seems wasteful to work so hard at bringing down a tree only to leave it lying. But beavers are compelled to chew by necessity, not simply for utility. It is said that, if they don't, their teeth will grow upwards into their skulls. *That* adaptation seems of dubious survival value, but it helps to explain the rotting timber.

Here, some poor beaver managed to chew its way through a six-inch tree only to have it drop vertically, wedged in the top limbs of an adjacent, larger tree. Perhaps this beaver hasn't mastered the art of directional felling. Undaunted by the wasted effort, however, the beaver has assaulted the offending tree as well. A concentric doily of wood chips decorates the ground around a prodigious gouge in its trunk. I imagine a human reaction—frustration at the initial failure followed closely by a furious, vengeful attack on a tree too large to drag even had it been brought down. Though disheveled by its assailant, it still stands, unmoved and sturdy.

The lover of nature working for conservation in the city can often feel like the beaver, sometimes like the tree.

Frogs

At times, during the summer, frogs seem to be everywhere. Now, in the dog days of August when much of the ground has hardened and cracked, the frogs have withdrawn. They rally wherever there is a bit of moist earth.

They are normally hard to spot, not suffering human intrusion willingly. One after another I hear the small *plop . . . plop . . . ploops* as they disappear from perches along

the riverbank. All I see is a ripple and a cloud of billowing mud. But, today, they are visible in spades. Trucks have plowed through mud, leaving deep, permanent ruts filled with water. Frogs of all sizes congregate along the sides of these long, narrow ponds. Except for the silence they are reminiscent of people in a popular bar at happy hour. The slightest movement scatters them in every direction, like popping corn.

Rush Hour

It begins a bit after 7:00 a.m. The traffic on the freeways is just getting started, but the sky is thick with geese. V-formations criss-cross in every direction. There is no evidence of an overall pattern to this activity despite the orderliness of each individual group. The heavy rhythm of beating wings is punctuated with occasional splashing as a group rises from the lake,[5] but all is nearly drowned by the incessant, primeval sound of their honking. The muted noise of trucks shifting gears on nearby 107th Street is lost, for once, in the uproar. In fifteen minutes, the geese are gone. The sky is empty, the lake unruffled.

Rush hour is over. The city reasserts itself as the sound of traffic intensifies. For this is the city of Milwaukee, not a revered, distant preserve. People happily drive an hour or more northwest to visit Horicon National Wildlife Refuge in order to witness a similar

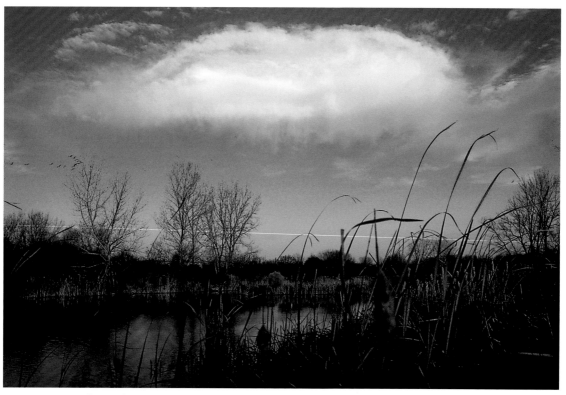

North parcel, Little Menomonee River Parkway, Milwaukee.

phenomenon. During migration season, in the early morning, here in the northwestern corner of Milwaukee, wildness is undeniable. It might be nearly overwhelming to someone caught unprepared, unused as we are to confronting the raw power of nature on its own terms. Here is the unexpected miracle of urban wilderness.

Nearby, earthmovers are scraping the wildflowers off a remnant piece of upland meadow. Soon sewers will be dug and roads paved in, and then houses will follow. People will purchase them and watch the geese from picture windows as if wilderness can be framed and hung on the wall. Except it won't be the same geese. As they do elsewhere, resident geese will stay all winter, accustomed to being fed, so tame as to be a nuisance. The wild geese will assemble at Horicon and other distant marshes, and the city will have lost one more irreplaceable opportunity to experience the power of wildness within its borders.

The Clarity of Mud

"Nature bats last." The phrase comes to mind as I watch my step on uneven ground, trying to avoid tripping in the ruts. A dry autumn has left the land as hard as sandstone, perfectly preserving, as if cast in plaster, both the tiny paw prints of voles and the zigzag tire patterns of three-ton trucks. The earth has the capacity to heal itself—given time. Deeply incised parallel grooves remain in this meadow after many years. Some are quite distinct despite the many small trees that have sprung up in and around them, a few with trunks measuring three inches in diameter.

In Olduvai Gorge, in the great rift region of east Africa that gave rise to early humans, the simple clarity of mud makes million-year-old footprints comprehensible. What will paleontologists of the future make of *these* impressions? Will they remember the dawn of Western civilization's third millennium as the pivotal point when the uncontrolled momentum of the twentieth century finally slowed, turned aside just in time from the precipice of ecological catastrophe? Or will they revile us for the devastation we left as our inheritance? Will their tapping hammers and dust brushes carefully reveal the tread marks of a culture joyriding across the land until the land could no longer support that culture? Or will they be relieved to discover a place that was revered, a haven that was preserved, a culture that had finally learned to live in harmony with the earth?

I come to a recent gouge so deeply embedded that a puddle lingers in spite of the drought. Minute green needles have emerged from the muck. A leopard frog tenses as I approach, then relaxes again as I step respectfully aside and continue on my way.

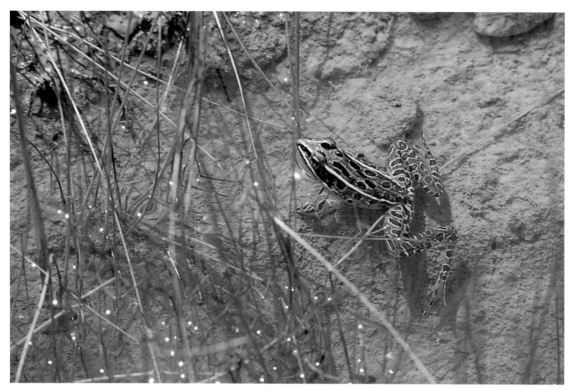

Leopard frog, Little Menomonee River Parkway. The earth has the capacity to heal itself—given time.

Parallel Universe

A previously overlooked segment of the river yields an unexpected wealth of wild land. From the vantage of the Little Menomonee River Parkway, by car or bike, it has always held little attraction. The river side of the road sports a narrow margin of mown grass, which abuts a uniformly dense wall of trees and brush, largely buckthorn; uninviting. But it just proves an immutable truth: wilderness cannot be experienced from a road. One must leave the confines of the car in order to hear its call.

Surprisingly, there is no trail. In fact, there's almost no evidence of human presence. Perhaps this is due to the signs posted every few hundred yards warning of a "possible chemical hazard." (Doubtful. In other places, those signs are dimpled with bullet holes, even trampled.) More likely it's the standing water. Three minutes from the road and I am wading. Within fifteen minutes it begins to look more like a Louisiana bayou than a Wisconsin river corridor.

After a while I hear the implausible roar of a cataract. Incredulous, I work my way toward the sound. The water rushes toward the riverbank, draining swampy surroundings. From a distance, the source of the noise looks like a particularly tenacious logjam, but it is a temporary dam and the reason for the swamp. Recent heavy rains have increased the

dam's natural appearance. Silt-laden, coffee-colored water cascades down the rugged profile of its downstream incline, minimizing the obtrusive glare of the raw, white limestone with which it is made. Its impact on the river's flow is particularly pronounced. The dam is not high, but it has backed up sufficient water to inundate many acres of surrounding land, thereby slowing its progress toward the flood-prone Menomonee.

The roar of the cataract enhances the perception of this place as a virtual wilderness by drowning out other noise. Only briefly does the sonorous rumble of an accelerating jet taking off from nearby Timmerman airfield interrupt the tranquility of the scene.

I continue on. The dim, filtered light of the wood evokes an image of Hansel and Gretel. Almost expecting to encounter a gingerbread house, instead I reach Fond du Lac Avenue. As I step up the inclined shoulder and out into the bright light of mid-day, squinting, I am unnerved. It is as if two separate realities have interposed themselves, and I stand uneasily in the wavering portal between them.

After the peacefulness of the wood the din assaults my senses, and my reverie dissolves into noisome reality. Here is the unremarkable, ordinary activity of people in cars, stopping and starting at this single intersection, one of countless intersections in

Floodwaters, Little Menomonee River Parkway, Milwaukee. An unexpected wealth of wild land begins to look more like a Louisiana bayou than a Wisconsin river corridor.

one of thousands of municipalities throughout the nation. Pettiness interjects itself onto ordinariness when an impatient driver lays heavily on his horn as the light turns green. My eyes and mind dilate synchronously as I return to the dark seclusion of the forest, as if to a parallel universe.

Mirage

In the midst of a slow process of unmanaged reforestation after being cutover some years since, the meadow is full of widely spaced, second-growth weedy trees: box elder and hawthorn. All are of a similar, immature height, maybe fifteen feet. All are equally clothed in the light yellow-green of new leaves. The foliage ends abruptly at a three-foot height, so oddly uniform as to seem measured, leaving "leggy" bare trunks exposed below. They look like an atypically static, brightly costumed troop of Irish dancers with stiff skirts that puff out at the knee. The insatiable deer are certainly responsible, but why they couldn't reach any higher is beyond me.

Reality is playing tricks today. I emerge from the forest onto a large wetland meadow overlooked by a row of neat brick houses on a hill. The severely mown, grassy slope leading down to the marsh is dry and brown. Sun glares off picture windows like klieg lights. Air rising from the hot street shimmers in front of the houses, making them seem unreal: uninhabited facades placed like a stage set, for effect, static and lifeless. No sound dispels this illusion.

Turning toward the marsh again I slog through saturated grass that suddenly seems more real, less dream-like. I spook a deer, then eagerly follow it out of sight of the houses.

Coincidence?

The proprietor of the defunct driving range went all-out before going bankrupt: the entire view from the boarded-up pro shop wears a cloak of eternally green Astroturf, complete with blue imitation "water hazards" and white imitation "sand traps." Actual grass and weeds sprouting through it appear drab against this vast mat of artificial fecundity. Wrinkles and bulges further erode any semblance of reality. In places, the "grass" has been rolled over like a worn carpet, revealing black rubberized fabric and patches of sandy, sterile soil. Nothing moves. Bright-white balls still dot the wide, shallow bowl of otherwise empty terrain as if they spontaneously generate—perfect little Astroturf eggs that pop immaculately from its surface.

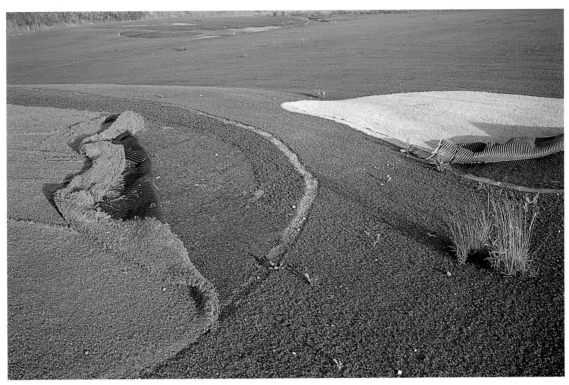

Astroturf, Granville Road driving range, Milwaukee.

Beyond the reach of a powerful drive the range slopes up abruptly to a de facto horizon, obliterating any view of the surrounding landscape. I crest the brow of the hill and look with relief at a field of glorious wildflowers that falls away toward the floodplain beyond.

The meadow is a sparkling, dew-laden lace of delicate fronds with an air of ethereal softness, suffused with the glow of early morning sun. A complex mix of earthy colors — olives, russets, and ochres — is accented with violet, burgundy, and yellow flowers. Mist rises from the river bottom, lending mystery to the woods ahead.

Upon entering I am engulfed at once in a wild snarl of brambles. The forest floor is uneven and requires constant vigilance to avoid tripping and stumbling into unseen holes. Finally, near the river the land becomes flatter. Here, the railroad ties begin to show, lying at first singly and then in haphazard heaps. Although they lie innocently at rest, partially submerged in the earth and littered with leaves, one detail hints at a devilish truth: after many years they remain solid and square. Chemical stabilization has arrested decomposition. Here, urban wilderness takes on a new, malevolent meaning. Here, too, is the reason for undertaking a difficult passage across this odd array of landscapes before reaching the river: I've been circling around the fenced site of a Superfund clean up in-progress.[6]

Discarded railroad ties near the Moss-American Superfund site, Little Menomonee River Parkway, Milwaukee.

The federal Superfund was established in 1980 to mitigate the effects of uncontrolled or abandoned hazardous substances. The primary culprit in this case is creosote, which is the preservative used in making these railroad ties. The fenced compound was once a chemical treatment facility. Although the factory is long gone, contamination remains in the soil and groundwater. Until very recently it continued to leach into the Little Menomonee River.[7] There are no fish in this tributary for five miles downstream, where it meets the main stem of the Menomonee and its toxicity is diluted by the increased water volume of the larger river. The "possible chemical hazard" signs posted along its entire length are largely ignored. Too many things have been ignored for too long in this part of the watershed.

When I finally reach the narrow river there is an old levee beside it. A faint trail runs along the top; undisturbed leaves and branches lie across it. When the levee flattens out into a swamp, the trail disappears.

The water is a murky gray-green with no detectable flow. Its depth is impossible to discern until I come to a spot where it runs more rapidly down a short, rocky decline. The rushing water *seems* perfectly clean. As it washes over the sandy bottom the stones glint with a clarity that resembles any other stream. Then the water drops into

the next stagnant pool and is immediately gray and opaque again. Where it eddies it has a metallic sheen.

I make my way to the railroad bed that forms the northern edge of the fenced site. Gazing south from the river trestle the scene looks more vacant than dangerous. The river curves briskly away to the east as if deliberately swerving to avoid the invisible hazard, but the site itself seems no more than a flat, boring, deserted field. Weeds grow in desultory patches. There is a large, paved lot on which sits a single, disengaged semi-trailer. The site is mostly empty gravel. One pair of rails ends abruptly in the middle of the field.

The words "Superfund site" elicit a kind of potent dread that is deceptively missing. How can such harmful pollutants be so inconspicuous? No wonder it was ignored for so long. At the far edge of the site are the fence and trees that screen the driving range on which I began this bizarre journey. Truth is an elusive concept in a place of such jarringly discordant realities.

As I leave the bridge I step around very real, very thick, dull-black globs of creosote that exude from the wooden structure. I struggle back through trackless thickets that seem uncommonly wild yet are strangely quiet.

Moss-American Superfund site, Little Menomonee River, Milwaukee. How can harmful pollutants be so inconspicuous?

Designing the River

Not long ago, there was a river here. Now a wide, level clearing runs as far as can be seen through bifurcated woodland. This ribbon of smooth, dark soil marks the low point between hills to either side, on which are massed the front ranks of urban development. It is manifestly a place where there *should be* a river, but it has vanished. I stand atop the old riverbed that is now buried with tons of clay and topsoil, tamped flat and hard as a new road. An actual gravel road runs alongside the entire length of the missing river.

There is no mystery here, no divine intervention; the watercourse has simply moved—in the poetic jargon of federal bureaucracy, it has been "dewatered"—replaced with a "new and improved" river. Stumbling in a Caterpillar's tracks I walk a few yards east to where its course now flows between matching banks of burlap netting. The mesh secures pale-yellow straw placed there to stabilize the fragile banks until new vegetation can establish an anchoring root system. It looks like a long, open, festering gash with thin, mottled-gray "blood" running freely down the middle, reflecting the uneven tones of an overcast sky. A second gravel road lines the far side of the new channel, bearing the impressions of huge, lumbering backhoes and dump trucks. Traffic signs are nailed to posts and convenient trees: "One way" and "Yield" and "Wrong Way."

Little Menomonee River Parkway, Milwaukee. Not long ago a river was here.

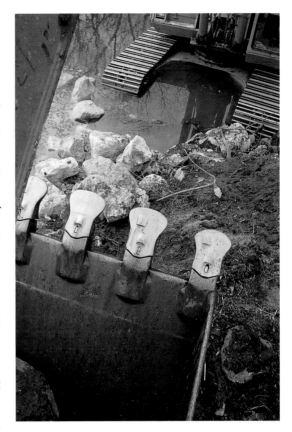

Backhoe in the river, Hoyt Park, Wauwatosa. People have been modifying rivers since the origins of agriculture.

The entire construction site, for that is what this mile of floodplain has become, is clearly demarcated with perforated plastic fencing like the bold outlines in a coloring book. The bright-orange line is the most colorful part of this wintry scene. The land has become a canvas on which the human hand has drawn abstract contours of an idealized river. It awaits nature's regenerative potential to paint it with a representation of reality.

The new stream meanders slightly — a wobble rather than a true meander—but it is more natural than the strict lines and impervious materials of other engineered waterways in the watershed. Who gets to *design* a river? The thought arouses a mixture of fascination, envy, and horror. How do we presume to usurp the power of Creation? Of course, people have been modifying rivers since the first time a Mesopotamian farmer diverted a trickle of the Euphrates. Manipulating the nature of rivers is arguably one of the oldest signs of civilization. It's a relief to see a river designed to be *more natural*, and it is fittingly symbolic that it should happen within the confines of a large American city.

The old river *looked* pretty wild compared to what I see here now. For all its subtle irregularity and biodegradable banks, the new one currently resembles a concrete ditch more than a stream. Gone are the tree roots over which water lapped and gurgled; gone is the shady canopy that kept the water cool; gone are the sedges and grasses that waved as the river passed. But something less obvious and far more insidious is gone as well, if the outcome has matched the design.

I walk on a bit farther to where restoration continues. A huge gouge has laid bare the sediments underneath the old streambed. A pool of putrid liquid lies stagnant at the bottom, marbled with swirling, hideously beautiful patterns of purple and silvery-blue. The soft, earthen sides of the hole glisten. A viscous chemical slime oozes from every crevice, trickles down slowly to join the thickening sludge. A steel cofferdam segregates this toxic pool from the new channel, which flows placidly. Farther downstream a segment of old channel has a similarly benign appearance that masks its contamination.

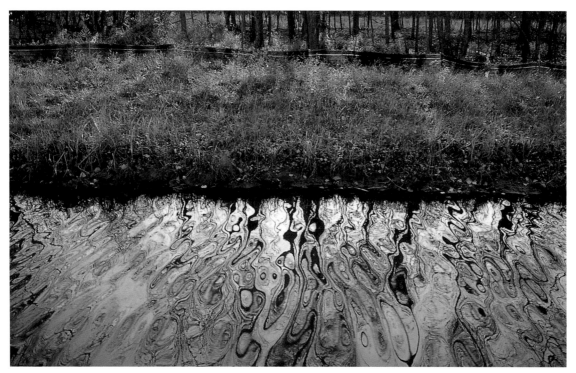

The new channel, Little Menomonee River, Milwaukee. We can reshape the contours of the land, but healing occurs when we believe in what we've done, when the land is allowed to become whole again.

Left untouched the contamination was inconspicuous. Now the solution *appears* more unnatural than the toxicity. Trees cut from the site have been used to shore up the new riverbanks in areas threatened with erosion. They look as natural as World War I trenches. Welcome to the hydraulic engineer's new urban wilderness.

After the restoration work is completed the gravel will be removed and the orange fences rolled up. Then, we presume, the land will slowly heal itself. In the meantime, we must heal ourselves, for the technological fix is only part of the solution. We can scrape away the toxic soil and haul it off to be incinerated. We can remove visible evidence of the evils perpetrated upon the earth willfully or through negligence. We can reshape the contours of the land with our mighty machines and replant trees and grasses. We can, and should, do all of this wherever the earth is injured, but healing will only come about when we *believe* in what we've done. True healing means becoming whole once again.

Collective understanding of the value of restoring this ecosystem is needed in order to make whole the diseased environment. The watershed cannot be whole if we do not feel part of it. If we continue to deal with environmental degradation piecemeal, then mitigation of pollution will be no more effective than trench warfare was in World War I when civilization was witness to a new age of chemical and biological weapons.

Another cofferdam isolates the construction site from the river downstream. Two stout tubes float behind it, looking like long, white sausages. These trap flotsam and back up the colorful residue on the surface. Thick hoses snake out of the pool and connect to a big, square, red siphoning machine. Below the dam free-flowing water disappears into the shadows of a dense profusion of vegetation. But its natural appearance is more than deceiving; it is dangerous.

That is the next section scheduled for restoration.

A fat vole scoots out from under an idle tractor as I walk past. A high-flying hawk wheels, but my presence deters it. The vole slips safely into a crevice between the logs buttressing the new riverbank.

Continuity

A 'possum sits in the middle of the river, perched at the edge of the ice, lapping at the thin stream of open water— a bristly black, gray, and white ball of fur atop the smooth black, gray, and white river that slashes through the brown landscape. Silently thanking the designer of this newer stretch of rechanneled river for leaving a screen of trees close to the river bank, I move toward the animal. My caution proves unnecessary, for, as I move slowly out from the tree cover, the opossum begins to trundle even more slowly across the ice and up the frozen burlap towards shelter. I get very close before it reacts to my presence with a slow-motion grimace that reveals sharp, pointy teeth.

The opossum is one of North America's most ancient mammals, having walked among dinosaurs. Despite its ungainly, lethargic gait and minimal wit, the range of the opossum, originally more to the south, has expanded to include most of Wisconsin. Its most familiar adaptation, "playing dead," has made it a rare target for predators, and so, particularly here in the urban wilderness, the opossum's only "natural" enemies are the automobile and truck. Fortunately for this one, the Little Menomonee River's floodplain is not only wide enough to redirect the entire river, but also long enough for the geographic continuity needed to sustain a population of this slow-moving symbol of temporal continuity.

Fortunately for the citizens of Milwaukee, humans are capable of moving and adapting much more quickly than opossums, and valuable lessons were learned during the first phase of the river's cleanup and rerouting. More than a year has gone by, and this is the second phase. As I walk along the new channel the nearness of the tree line is only one of the obvious improvements. Instead of the "wobbly" impressions of meandering

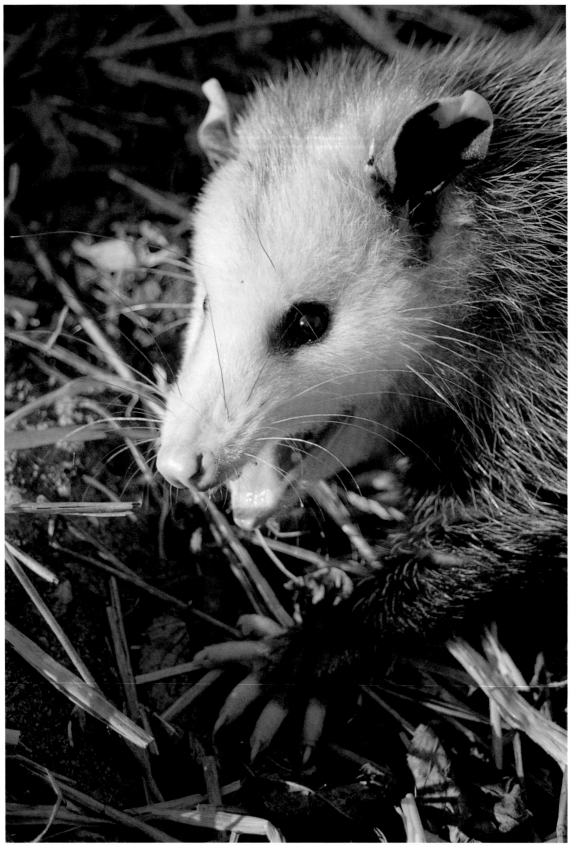

Opossum, Little Menomonee River Parkway, Milwaukee.

noted earlier, the new river now curves dramatically, greatly increasing its ability to slow storm runoff. And, although they currently resemble the tank traps placed along Normandy's beaches during World War II, the cut timbers have been used *in situ* instead of being hauled away. The steel cables that anchor them don't look very natural, but as the corridor reestablishes itself and they are overgrown these impediments that further slow the water will also provide desirable habitat for wildlife.

As I round the next bend I discover a very large great blue heron resting on one of these log constructions. Momentarily totemic atop this pedestal, the heron also symbolizes continuity: being tolerant of a wide variety of diets and habitats these are one of the widest ranging birds in North America, and I see them in every part of the watershed. One thing they don't tolerate, however, is my presence. As it disappears in the distance it veers to follow the newly created curves of a river "under construction" as if it were the most natural thing to do. Which it is.

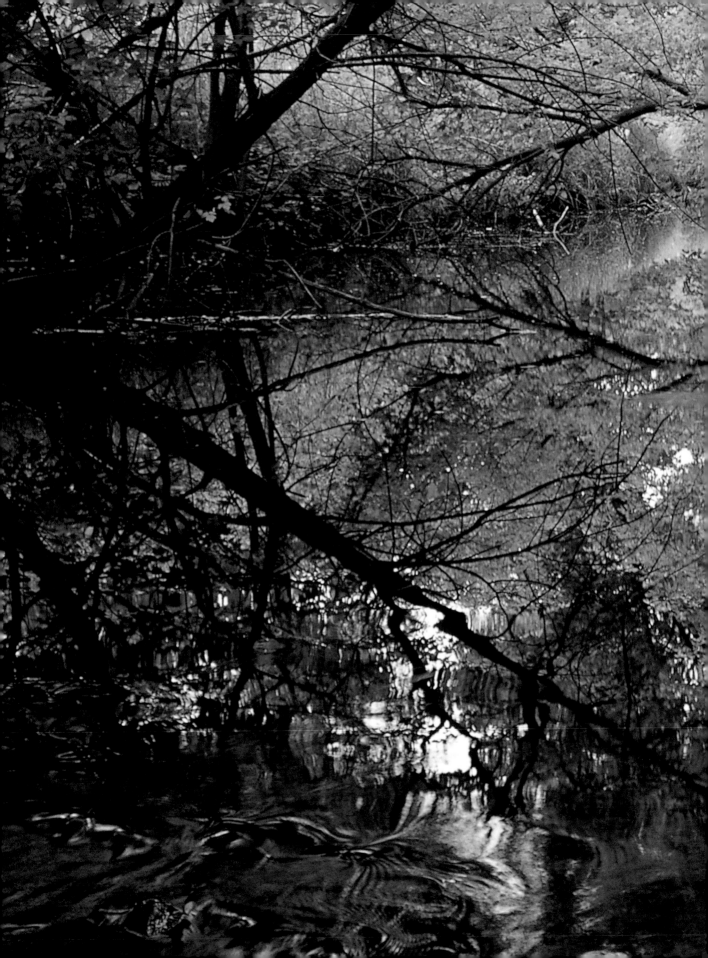

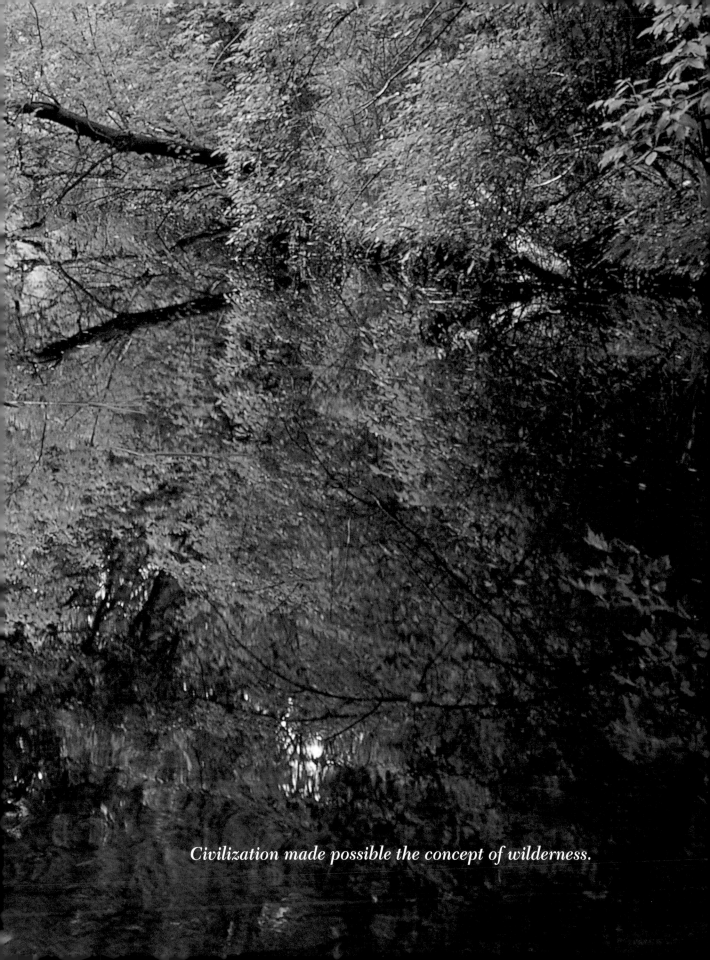

Civilization made possible the concept of wilderness.

Top: crab apple, Hoyt Park, Wauwatosa; bottom: couch, Underwood Creek, Wauwatosa; previous spread: Underwood Creek, Elm Grove.

ONE OF THE PARADOXES inherent in the idea of an "urban wilderness" is, in Roderick Nash's words, "the fact that civilization created wilderness."[1] This is not to say that by altering some places with agriculture and architecture those which remained unaltered—natural or wild—were themselves changed; it means that the newly established contrast with civilization is what made possible the *concept* of wilderness. With the advent of civilization the unaltered environment, which, until that point, "was simply habitat," suddenly became an adversary or a place of mystery; it was somewhere to conquer or avoid, often associated with "the supernatural and monstrous."[2]

This concept was long-lasting and lingers yet, but, as many authors have shown, the meaning of wilderness is multi-layered, culturally bound, and historically malleable.[3]

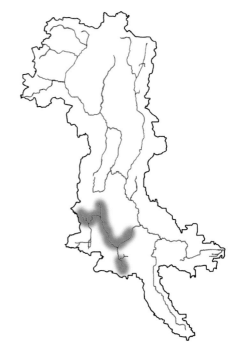

On the map the Underwood Creek subwatershed seems an unlikely locality to explore the various meanings of wilderness as it is entirely contained within well-established suburbs. But maps are abstractions; the creek is not. Underwood Creek has many moods and physical qualities, and, although much of it meanders through private backyards—from which I am intentionally excluded—its multiple personalities are evident enough in a variety of public lands. Small though they are, for the urban adventurer these serve as Aldo Leopold's famous "blank spots on the map": places where we can conceive of wilderness.

Three Types of Park

Driving into Wirth Park I pass a brightly colored but idle plastic playground, a vacant softball field, and a large, empty swimming pool with an accompanying bathhouse. Beyond these are the backstops and fences surrounding several more softball fields as well as a grid of eight tennis courts, all equally vacant. Crossing acres of unoccupied asphalt I park as far back as possible, next to the shuttered day camp buildings, near the trees. This entire area—a sports-and-organized-recreation park—bustles with activity during the short Wisconsin summer, but autumn has brought both chill and quiet.

In the northwestern corner of Wirth is a second type of park: it has been designated "natural," with an emphasis on educational. The woodland has a satisfyingly diverse inventory of hardwoods, including oaks, hickory, basswood, and walnut, but is surprisingly free of groundcover and understory. Something seems amiss. Then I reach the prairie section where it becomes clearer: access is paramount. Woodland and prairie alike are cut with extravagantly wide swaths identified as "nature trails." The shadowy forest, uncut grass, and wildflowers are a welcome relief to the relentlessly mown lawns elsewhere, but the expressway-style "nature trails" seem a bit over-improved. Trail-marker posts made of flat white plastic look exactly like those used to identify buried pipelines. (Who requires markers to follow *these* paths?) Standing taller than the grasses, they are visible everywhere across the field like exclamation points shouting, "Notice me!" "Notice me!"

At its farthest corner the prairie narrows between two separate tracts of woodland. The "expressway" turns back past more trail markers to boardwalks, lawns, and pavement. But untracked wilds visible through the gap call the incompletely civilized soul toward a third type of park. Although this one is not so designated, a wilderness park is a place where, in William Cronon's words, "we find ourselves surrounded by plants and animals and physical landscapes whose otherness compels our attention," a place which elicits a sense of wonder. And we delude ourselves, he says, "if we imagine that this experience of wonder and otherness is limited to the remote corners of the planet, or that it somehow depends on pristine landscapes we ourselves do not inhabit."[4]

My sense of wonder, easily stimulated, drives me forward. I find a trail, though it is faint. Cattails and tall grasses are trampled by wildlife and weather. Fall dryness makes penetrable an area that would be a quagmire in spring. Following a deeply rutted deer path, I stay near the watercourse, both fascinated and repelled by the purpling oil slicks along its grassy edges.

A wedge of wetland narrows between two converging railroads. Track beds made of raised gravel frame a scene rich with textures, colors, and types of flora. The dominant

autumnal hues range from golden swatches of foxtail grass through every variation of ochre, umber, and sienna, to bright brakes of red osier dogwood. Here and there, patches of duckweed remain vibrantly green.

I step aside to avoid crushing a nest in the grass, although I know it has outlasted its function and that the blackbirds will build new ones next spring. The skillfully woven cup of grasses and twigs forms a small, circular hollow as empty as the swimming pool. Parks exist at the whim of the public, and they serve many functions. We build pools and softball fields—despite the fact that they sit idle a greater proportion of the year than they are used—because we value those functions. We also preserve natural areas not only for obvious functional reasons, but for inherent values no less compelling.

In July, the pool is decked out with bright blue and yellow umbrellas and filled with screeching children while the prairie is decked out in more subtle hues—the blue of spotted knapweed and yellow of wild parsnip—and rings less stridently with songbirds' chipping and trilling.

Now the umbrellas are folded in storage, the flowers shriveled and brown. The warblers and wrens have migrated to warmer climes, and the children pursue mostly indoor activities. But the wilderness doesn't pack up for the winter or fly south. The land lives on. Fall is not a dying but a climatic expiration of breath, a pause, a resting before the great gathering of strength that comes again with the inhalation of spring.

Semiotics

A sign that reads "Nature Center" hangs on a fence at the elbow of a street that hasn't yet elbowed its way inside. Curiosity piqued, I wonder about the designation. Although there is an opening in the fence for pedestrians, when I enter there are no trails, no other signs, no structures, nothing that is normally associated with a "nature center." There isn't even an informal path. Pushing aside the ten-to-twelve-foot tall cattails soon makes it obvious why: one would need hip waders to go more than fifty yards or so.

My inclination is to interpret the sign as expressing the central importance to the community of this vital wetland at the headwaters of a short tributary to Underwood Creek. For here I am, immersed in a very raw nature, up to my knees and over my head, surrounded by housing subdivisions in the center of a large suburban enclave. Identifying this place as *central* could symbolize its value as an anchor for healthy watershed ecology. At the center, nay, at the very *core* of our civil community is the land—the biotic community—that belongs to everyone, and to no one, and which sustains all life.

Underwood Creek primary environmental corridor, Brookfield. At the center of our civil community is the land—the biotic community—that sustains all life.

But upon further examination the designation seems tenuous, if not downright interim. On the far side of the marsh the last remaining farm field next to it bears a "for sale" sign. A dead end street points toward it, poised like a hunting dog panting to be let loose. Is a "nature center" something more substantial than a puff of wind, a chimera? The name doesn't have the determination of a "nature preserve." The latter denotes land which is truly valued for its inherent qualities, as opposed to land consigned to a hollow, semiotic purgatory because it hasn't yet acquired sufficient economic value to justify the expense of development.

Even setting aside the ecological argument there is evidence that maintaining natural lands within a community increases property values.[5] And one need not look far to find significant numbers of people who hold dear the quaint notion that a bit of wild here and there helps to balance the omnipresence of civilization. In fact, when wilderness and civilization are placed side by side, the inherent worth of wilderness is nearly always admired. The ability to see and touch the wild spirit of creation, even in brief moments, ignites in the human soul a spark of vitality, for now we can gaze across this green expanse of "nature at the center." If we choose, we could forge a pioneering path into its trackless depths—or merely allow that thought to settle in our awareness.

Nowhere to Go

Near the headwaters of the south branch of Underwood Creek, one of the most maligned tributaries in the watershed, a remnant of nature can be found. Three sources converge along the eastern edge of Greenfield Park. Two are sterile, concrete-lined drainage ditches, running between the wooden fences residents have erected to shield themselves from a visual abomination—and to protect their children from storm runoff that is dangerously accelerated by the channels. The third source is inviting. It trickles through a luxuriant wooded area between the park boundary and a public golf course.

The wood is damp and densely overgrown, almost tropical in its lushness, but there is something peculiar about it: the thick vegetation has an odd uniformity. Soon it becomes clear that most of the profuse, beautifully rich greenery around me is comprised of invasive bishop's weed. Farther on a few tall pink blossoms of dame's rocket manage to bob above garlic mustard, one invasive species trying to subdue another. The flowers appear to be treading water to keep from drowning.

The rivulet leads through the weeds to a cyclone fence that surrounds the golf course. Running parallel to the fence is the inevitable trail. Close to the city, trails are made wherever there are woods, no matter how narrow or seemingly insignificant. The presence of trails signifies how highly prized are urban natural areas. The size of the

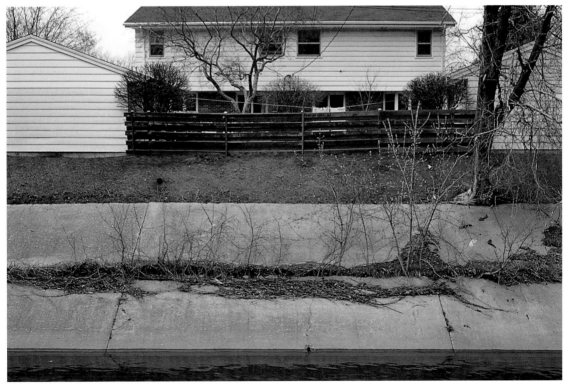

Underwood Creek, Wauwatosa.

place does not matter, for the spirit of wildness has neither scale nor boundary. Thich Nhat Hanh, the Zen master, puts it thusly: "This spot where you sit is your own spot. It is on this very spot and in this very moment that you can become enlightened. You don't have to sit beneath a special tree in a distant land."[6]

Perhaps it is pursuit of such a mystical experience that explains the curious phenomenon I discover next. The trail leads in both directions along the fence. Although not wide, it is well enough traveled to keep back the weeds in moist soil. Turning toward the creek I go no farther than about forty yards before I am surprised to reach a completely dead end. No cache of discarded beer cans or any other debris indicates a den of iniquity. There is nothing except damp earth and nowhere to go except back.

This is unique in my experience of urban parklands. Trails either lead *to* a particular place or pass *through* from place to place. Regular, repeated use is required to establish a trail. An occasional explorer is insufficient. Trails blazed to dead ends peter out and soon become overgrown from neglect. Though I'd like to report that on this spot in this moment I became enlightened, this trail's purpose remains a mystery. Perhaps it is someone else's special spot.

Teaching Tool

Underwood Creek divides just south of here. The west branch wanders through rolling, forested hills. At least it was forest at one time. Attractive wooded lots conceal the houses and mask the fact that they consume more land—because they are less densely developed—than nude lots built on cornfields. The north branch of the creek—too straight to be natural—originates in a beautiful marsh. The only public access is from the local high school.[7]

The school's relationship to the wetland is contradictory. On the one hand the natural ecology of the marsh is valued as a teaching tool. A small amphitheater nestled among the cattails allows it to be used as an outdoor laboratory/classroom. Picturesque paths wind through a meadow. Boardwalks make it possible to inspect the wetland without getting wet.

On the other hand a limb of the marsh has been amputated from its body. The raised bed of an access road runs along the west edge of the property at the very lip of the creek. Effectively a dike, it separates a remnant expanse of living marsh from its bloodstream. The impact is clear: cattails and dry grasses to the east have browned prematurely. The continuity of wetland and stream is broken. The abruptly demarcated rectangle of land seems reduced to real estate, perhaps a land bank for future development.

Education in the United States has become a disconnected system of isolated disciplines just as the land itself has been divided and subdivided. But teaching ecology as an isolated discipline is a contradiction, and the result is a subtle but overwhelming subversion of the central tenet of ecology: the need to see systems as integrated, with every part connected to the whole. David Orr warns, "All education is environmental education."[8] His point is that the lessons we learn in school affect how we regard and treat the world in which we live. Here in the divided marsh, the facts on the ground counter the pedagogy of the outdoor classroom.

The Unseen

The pond in Greenfield Park has not so much shrunk as settled. The skirt of its shoreline bears a wide hem of driftwood, dried mud, and algae that can be lifted like an old felt pad. The small pond is fed continuously from the larger lagoon above and across the park's drive. With a deliberately delightful melody the water trickles several feet down over cement rocks that have been sculpted into nearly natural contours. Though

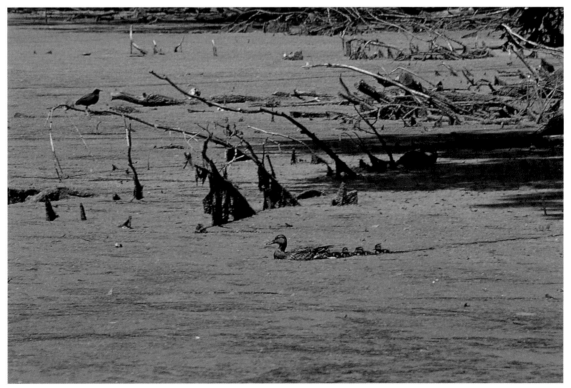

Greenfield Park, West Allis. This small pond, veiled in algae and neglect, harbors its circumspect wildlife. Slowing down sufficiently to see what normally goes unseen helps to release the tensions of a fast-paced urban lifestyle.

there is no outlet, the constant inflow is insufficient to raise the level of the pond. Its stagnant surface is thickly matted, even wrinkled in places. Algae hangs in dried drips, like crude, hand-made paper, from protruding sticks exposed by the receding water.

In naturally occurring quantities, algae is a vital part of any freshwater ecosystem. It forms the base of the food chain and helps to maintain a healthy balance of dissolved oxygen. But this kind of overabundance has the opposite effect. Decaying algae depletes oxygen, thus depriving other aquatic plant and animal species that require it. Excessive algae growth is often caused by nutrient runoff into waterways from fertilizers used on lawns and farms.

Leaving the lawn that slopes down from the drive I walk around to the far side, which remains in a wild state. In a fragrant wood of mixed cedar and birch, the mystery of the disappearing water is solved: though unexpectedly dry, the earth near the pond is soft and peaty. It gives underfoot like stiff foam. Across the way, where the drought-browned lawn comes right to the edge of the water, the ground is rock hard, but most of the pond is surrounded by this spongy soil. I walk across a low, swampy spot without squeezing a single teardrop of moisture from it.

An American bittern—generally secretive and hard to spot because of its pattern of tan, brown, and white camouflaging stripes—emerges from protective cover high in the tree canopy. It swoops down and lands on the single stump that sits like the hub of a broken axle in the center of the pond. This bird is bulky, with a wrestler's muscular sturdiness and a short, thick neck. Its piercing yellow eyes scrutinize my position, daring me to move. Satisfied, it shifts its attention to the green surface of the water and, with a ruffle of wings, hops closer to the edge. Then it waits.

Every now and then it glances down and, almost casually, dips its short, sharp beak. When it raises its head there is in its mouth a brief gleam of silver, which then disappears with no discernible gulp. The bittern hops to an adjacent rock and methodically continues the ritual. Mostly, it glares fiercely around.

A nearby boulder, covered in ragged tears of algae like anti-aircraft netting, suddenly slides below the surface. Astounded by its size I castigate myself for not detecting it. How often are we unprepared to notice what we don't expect to see? This entire pond is a bit like the turtle: not so much unnoticeable as merely unseen. It is Sunday and hot. Hundreds of people must be using the park, mostly around the lagoon, at picnic areas, and in the popular "Cool Waters Family Aquatic Park" that replaced the old swimming pool. The festive noise fluctuates but never ceases. On its perch atop the stump the bittern, uncharacteristically, is in plain view of traffic passing by on the drive. But, although alert, the bird is unconcerned with any of that.

The bittern's calm is understandable. The whole time I've been here no one else has ventured anywhere near the pond. Like the turtle the pond simply goes unnoticed: a bit of wilderness left to itself. While this is healthy for the plant and animal community, the health of the human community might be better served by paying greater attention. According to Richard Louv, "A widening circle of researchers believes that the loss of natural habitat, or the disconnection from nature even when it is available, has enormous implications for human health and child development."[9]

Backing away slowly so as not to alarm the bittern, which still commands the center of the pond with resolute aplomb, I reflect upon my own mental health. This small, soft place, tucked in the corner of the park and veiled in algae and neglect, harbors its circumspect wildlife. It makes the city whole. Slowing down sufficiently to see what normally goes unseen helps to release the tensions of a fast-paced lifestyle. As I pull away from the curb I glance back at the pond: the bird is nowhere to be seen.

Multi-colored Woods

A white cement sidewalk runs down the middle of a thirty-foot-wide strip of closely cut lawn atop a berm that curves away to the left around a depression full of cattails. Reminiscent of a freeway cloverleaf, in the center of which is allowed to grow a bit of uncropped vegetation, it looks natural in the way that an unshaved armpit does. Two red-winged blackbirds flit among the cattails, and I hear the rasping croak of a solitary frog. The tiny wetland is circumscribed on my right, opposite the berm, by a thin stand of aspens through which one block of a condominium complex is visible. Another block is out in the open at the far end of the sidewalk.

There is a solid rank of trees along the outside of the berm like a castle stockade. For the residents this wall of foliage is valuable as a scenic backdrop to the view from their windows. But a wall of any sort lives in dualistic ambiguity: it can be seen as protection or rejection depending on which side you *want* to be on, or whether you want to live in a divided world at all. For the adventurer the trees are an invitation to explore what is beyond.

Beyond I find a good reason to have a stockade of trees around the condo cloverleaf: an active railroad. I climb over it and down through thick undergrowth to the water's edge. Underwood Creek is well named at this point. A wide variety of trees and shrubs of all sizes stand tall and bend low over it, creating an extraordinarily beautiful cavern-like glade. A soft but intense light, more yellow than green, filters through gently ruffling

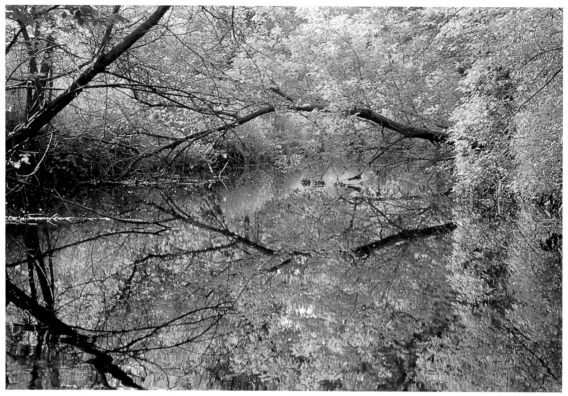

Underwood Creek, Elm Grove. The creek is well named at this site.

leaves overhead, which are mirrored in the creek below. As I step into it ripples fracture the mirror into myriad fluid facets. It is both explosive and calming. Instead of wading in a creek it feels like swimming serenely inside a bottle of champagne!

When I climb the far bank there is a change in color so dramatic it looks as if I have stumbled into a nightclub instead of a wooded glen. The "room" is lit in lavender and blue. The "floor" has been decorated with a lavish display of wildflowers, spread in every direction. Wandering amongst them through the trees is like going from room to room and finding them all the same until they are transformed once more, this time into a grandly columned ballroom in which identical place settings and tablecloths match even the carpeting. Then, as in *Sleeping Beauty*, the thirteenth witch shows up at the ball when I recognize the sinister significance disguised by the magnificent color coordination: exotic dame's rocket blankets the ground.

Pink and white blossoms in roughly equal amounts blend in the dim forest atmosphere to create the lavender light. And, yes, it is as invasive as the other plants that are amassed in similar great quantities nearby—the garlic mustard, the bishop's weed, and buckthorn—choking out the native species like a thicket of thorns binding an enchanted castle. But it is bewitching. It's hard to be upset with a weed as spectacular as dame's rocket.

On the other hand it isn't the shallow thrill of sensation that motivates me on my various quests, that turns me away from the sidewalk and toward the woods. If I could but be the noble prince I would part the encircling thorns, to kiss awake what is wild and true.

Enter at Your Own Risk

I go to "discover" the real Underwood Creek today. Its tormented proxy is all too familiar—the soulless corpse of a creek lying exposed in an open, concrete tomb. I've heard tantalizing stories about the natural, living creek, one that managed to escape rechanneling. A culvert links the schizoid identities of the creek with a tenuous thread. The formidable dike of a raised railroad bed effectively severs the obedient, straight-and-narrow stream from the unruly wild one beyond its pale. Another concrete channel conveys a trickle of water into the mouth of the culvert; this one, however, has been breached and very nearly vanquished by encroaching weeds. Tall canary grass, cattails, and giant ragweed grow from a long hummock down its center, while well-established roots of substantial trees grasp and crumble its canted walls. A few black ash, green ash, and a lone cottonwood stand amongst the more aggressive box elder, Russian-olive and

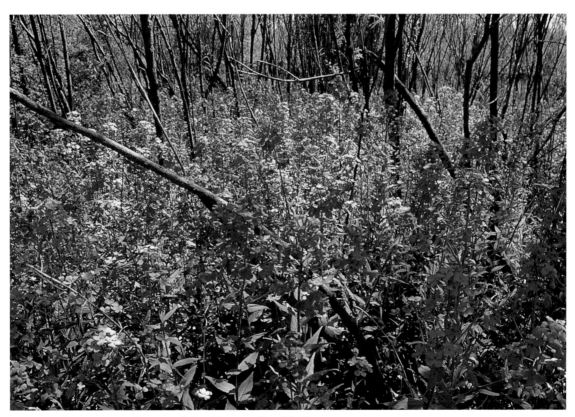

Dame's rocket, Dousman Stagecoach Inn Museum, Brookfield.

honeysuckle. Here is some sort of vindication: if there have to be invasive species let them crush the concrete channel!

After a hundred yards the concrete ceases entirely. The creek trickles through a narrow place so completely neglected as to be nearly savage in its wildness. It isn't a casual stroll. Briars tear at my clothing. The only path is a deer trail, which frequently leads blithely into logs I find either hard to climb over or duck under, and it seems as if deer must pass right through like cartoon ghosts.

After crossing 115th Street the corridor widens into a wetland and a path appears. Rather than following the creek itself, which is satisfyingly twisted, it parallels the mown perimeters of residential properties to the north. Walking here seems an intrusion on backyard privacy; the wilderness shrinks before patios and banging doors. I wave politely at a man standing over his grill. He stares but doesn't reciprocate.

At a fork a fainter trail veers into woodland more convincingly wild. Unlike Robert Frost, I plunge in without hesitation: this "road less traveled" disappears altogether in places, forcing me to part encroaching overgrowth to rediscover its direction. Crossing the creek on a logjam of driftwood and debris brings me to a distinctly darker world, reminiscent of forbiddingly fantastic lands such as King Kong's jungle island or a hobbit's Middle Earth. "Enter at your own risk" is spray-painted on a tree in crude script that is a

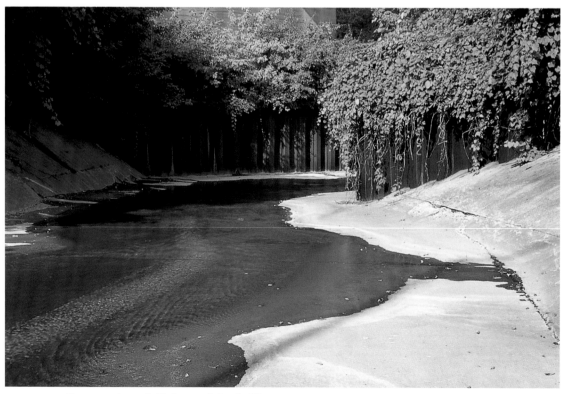

Concrete channel, Underwood Creek, Wauwatosa.

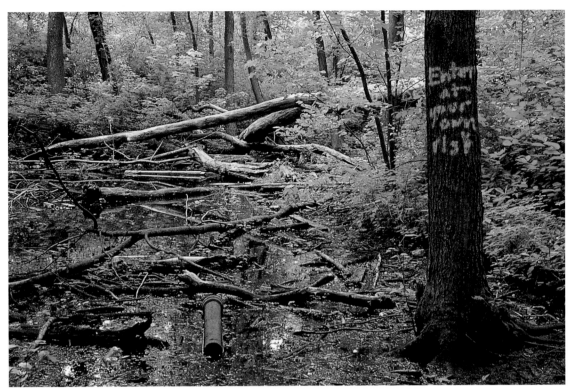

Original channel, Underwood Creek, Wauwatosa.

shade of green eerily harmonious with surrounding foliage. Standing water and rusting iron resting in muck around the tree make the inscription seem ironically redundant. My boots enable me to penetrate this secret domain, more cautiously now. The water spreads and deepens. The muck sucks at my soles. The mysterious hideout, if there ever was one, never materializes. Neither do trolls. I find only stripped, white hulks of water-bound trees, an inadvertent swamp created by the railroad dyke and diversion of the fraudulent creek. The only demons here are fabricated.

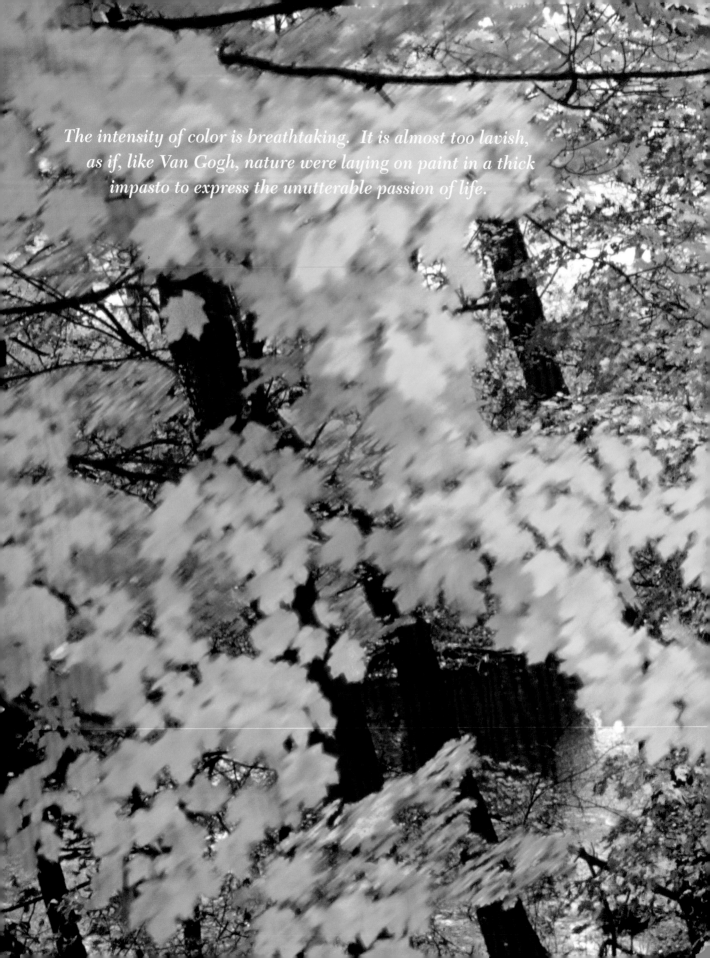

The intensity of color is breathtaking. It is almost too lavish, as if, like Van Gogh, nature were laying on paint in a thick impasto to express the unutterable passion of life.

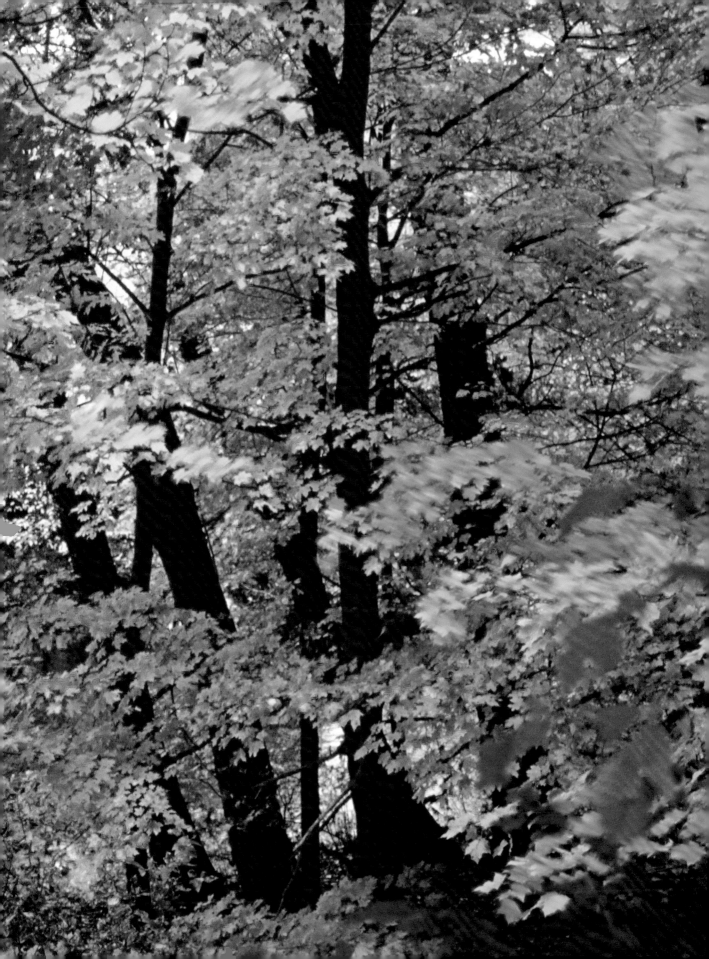

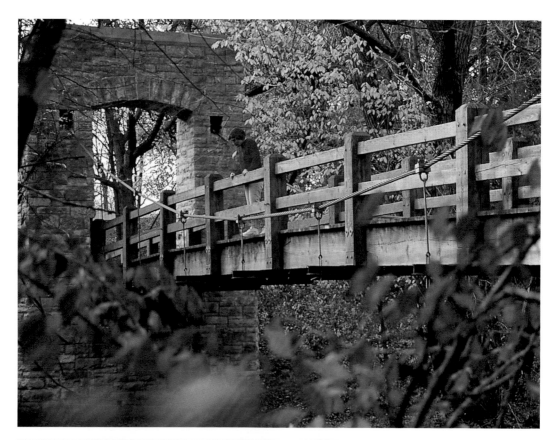

Hoyt Park, Wauwatosa: top: suspension bridge; bottom: tree harvest; previous spread: autumn colors.

THESE STORIES DESCRIBE A SEGMENT OF THE WATERSHED in which several tributaries merge with the main stem of the Menomonee River, a literal confluence of waters. Because of its situation at this point in the watershed the city of Wauwatosa has been subjected to unusually severe flooding in recent years. In 1997 and again in 1998, the city and other parts of the Milwaukee area suffered back-to-back "100-year floods." These floods are so named because the statistical probability of floodwaters rising to such a high level is one in 100: it should only happen once every 100 years. The problem of flooding has been exacerbated by the channeling of tributaries (described in the next chapter). Some of the proposed solutions to the flooding problem have also fallen largely on the city of Wauwatosa. In this chapter, I also reveal a confluence of issues facing the watershed that resonate most profoundly in this place where the rivers converge.

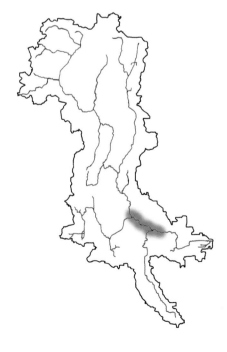

Philosophically, it is here where waters join that we find the most powerful example of the confluence of meaning between both wilderness and wildness and urbanization and wilderness. For if Thoreau's famous pronouncement is correct—"In wildness is the preservation of the world"—then we would be wise to examine the kind of world we expect to preserve. In one of its many guises wilderness is uncontrolled nature—the opposite of civilization—but the more we attempt to control nature the more we discover limits on our ability to do so and the more serious the consequences. A new equilibrium is needed: a confluence of values inherent in civilization and in wildness.

Wide-Angle View

We tend to find what we are looking for, but we also tend to overlook that which we are not seeking. The scrupulous scientist understands this. A wise photographer does, too. A wide-angle lens provides a broad view of the landscape. A broad understanding of society sees it whole, including river, forest, and city. Switching lenses to zoom in on an insect, flower, or paw print involves more than changing subjects; it also requires a change of perception, of one's understanding of nature and the relationships within it. For example, the renowned biologist Edward O. Wilson studies the ecological importance of the microscopic realm of organisms in the soil, a topic about which few people are aware. Our society, with its omnipresent stimulation, emphasizes bold strokes and dramatic gestures. But, like photographers, we must all carry different lenses—and make an effort to vary our points of view.

I stand in the middle of the river and crouch to see the delicate, lacy pattern of an ice shelf cantilevered from a round rock an inch above the gurgling stream. Black water swirls around hundreds of round rocks, each with a sporty knit cap of white snow. Near the river's edge the rocks congregate and the snow coalesces into a solid sheet of ice. The ice holds an unbroken blanket of snow that spreads up and over the banks and into the woods beyond, binding them together in visual unity. Dark vertical accents, the trunks of hundreds of trees rise out of the white blanket, divide into branches that divide further into a lacy pattern of twigs against the solid white of an overcast sky.

March

This time of year can dishearten the explorer. A walk through the woods feels like walking in a dissection of nature's corpse. In the aftermath of winter, the river corridor is a great, serpentine skeleton, revealing its fragility in the sterilized ecosystem of the city. Barren trees stand like bones stripped of flesh, and everywhere through them the proximity of the city imposes itself. Unconcealed debris and a paucity of imagination alike await cleansing floods and blossoming foliage.

In March, the earth reveals all wounds. Neither snow nor new growth covers the scars that remain from recent and even very old abuses to the land. I walk beside deeply etched tracks and step around discarded tires. From broken bottles to broken foundations the human imprint is apparent everywhere. Unresurrected plants are the dullest shades of brown and gray, having lost the blush of rich sienna, the glimmers of autumn gold; they are paler than the raw umbers and charcoal grays of winter, set in contrast to the white of snow.

March holds the dregs of the year, the bottom of the cup wherein we can read the fate of the land. The saving grace of March is that its drabness is illuminated by a brilliant equinoctial light.

The first crocuses are blooming today.

Spring Flood

Spring in Wisconsin is so long in coming that by May the pent-up energy in budding trees is ready to explode. The fresh yellow-greens of newly opened leaves seem to glow from within as if the life bursting forth cannot be contained within corporeal confines but must emanate into the atmosphere, filling the air with its energy.

As I walk in riparian thickets the sun filters through quivering leaves, catching flickering facets. Breezes create evanescent cascades of shimmering sparkles. Little fat birds warble in the trees with carefree abandon, lending buoyancy to the already animated scene. The attenuated winter finally dies both around and within.

But, well before the swelling of buds, the bursting forth of cabin-bound people signals the changing season. The trails along the river are host to the first and most exuberant of spring floods: walkers, joggers, cyclers, roller bladers, dog owners, families with strollers, camera buffs. On the paved parkway paths, alongside the watery one, the stream of people is nearly constant. Witnessing this human flood, who can question the value of accessible public land?

Clean Sweep

The easternmost tip of Hoyt Park narrows to a wedge that drives into the heart of the old village center in Wauwatosa. It was a neglected and overgrown haven for wildlife until recently when a bike path and bridge were constructed through it. Despite the scarcity of wild areas this was a worthwhile sacrifice. Though less wild, a greenway remains, and a valuable recreational route has been made continuous. Use of the park has seen a dramatic increase. And, truncated though it is, a little area nestled into an s-curve in the river remains quite wild.

What is most immediately apparent is an intriguing lack of ground cover. There is the usual tangle of brushy plants in the understory, but the earth itself is mostly bare. It seems to have been swept by a gigantic broom that somehow managed to clean the floor without rearranging the furniture. The corrosive cleansing action of regular flooding is

responsible—as opposed to the occasional flooding that is common throughout low-lying portions of the watershed. Grasses and flowers that grow profusely elsewhere are here either thinly dispersed or clotted together in defensive clumps. Today all are lying prostrate like strands of residual hair combed across a balding pate. The parallel rhythms of the bent grasses and the scoured character of the gravelly soil clearly reveal the ravaging of the river in flood. Here and there, a wisp of torn plastic has been woven into the fabric of debris that clings to brush and tree trunks, but there is none of the usual flotsam that settles on the land as floodwaters slowly abate. Wilderness has asserted itself, erasing nearly all trace of human presence.

As if to exult in its power the river has thrown up a gargantuan accumulation of twisted and jumbled logs against large cottonwoods that anchor the bend in the curve. Entire trunks, some three and four feet in diameter, lie braided together with smaller debris. The water surges impatiently against the obstacle, then slides downstream. On the landward side a rocky tunnel has been gouged beneath the root systems of mighty trees that line its path. Gnarled roots arch across open air like a flayed skeleton. But for the logjam that buttresses the fragile earthen barrier, the river would trade its circuitous route for this more direct one. Some day it will.

Human efforts to stem the abrasive action of the river seem puny and ineffectual by contrast. As it rounds the second curve the water undercuts the steep railroad embank-

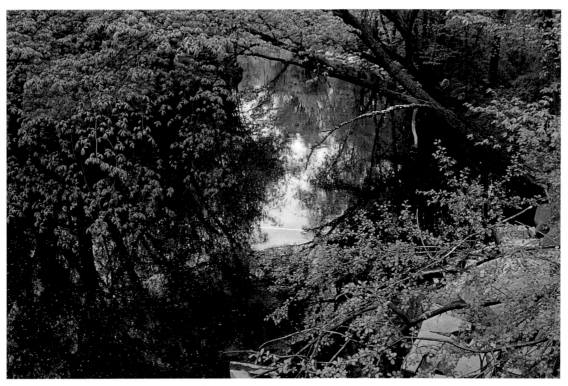

Menomonee River, Hoyt Park, Wauwatosa.

ment on its south side. Slabs of broken concrete have been pushed down the slope to prevent further erosion. Fortunately, the s-curve serves as a natural safety valve, allowing flood surges to cross over in a straight line, mitigating the need for more intrusive solutions such as a retaining wall made of poured concrete.

Passion

As I walk down to the river the tree canopy closes overhead, and I feel like I am entering a bright, green cave. The intensity of color in late spring when the leaves have just burst into fullness is breathtaking. It is almost *too* lavish, as if, like Van Gogh, nature were laying on paint in a thick impasto to express the unutterable passion of renewed life.

Twilight

Downwind and downstream, for once I see her first. Dusk has brought us both to the river, she to drink the water and me to drink the cool light quickly fading out of it. The large doe bends her neck to the swiftly flowing stream. I haven't moved a muscle, but suddenly she jerks her head up and stares straight at me. Reassured by motionlessness she cautiously lowers her head again. Then, with no more provocation, she startles once more and locks me with the same suspicious stare. No longer trusting my immobility she trots up the bank and into the wood. A second, larger deer follows—one I hadn't noticed. And no wonder, for even now that I know where they are—they have halted just inside the nearest screen of trees—when they stop, they vanish. In the gray light of dusk, amid the gray of tree trunks, their winter-dulled coats are perfect camouflage.

We stare each other down for a few minutes, although I am staring into formless shadows. When they shift in agitation they reappear like phantoms. They know my shape doesn't belong here on the riverbank, but, more curious than afraid, one edges closer, head cocked slightly, still staring as if trying to detect my thoughts. She bounds off again—though I haven't twitched a finger—and then stops and disappears once more like the Cheshire cat. Only the smile of her tail reveals that she hasn't continued into the gloom.

Each time she creeps back she seems more curious and less fearful; however, there is clearly a line she will not cross. Wondering how long the approach-avoidance game might last and tiring of the disappearing act, I finally relieve the suspense: I take a step. Without so much as a snort of acknowledgment, they're gone. Two swift crunches of

dead brush under hoof, then nothing. Suddenly it is night, as if all residual light has been sucked into the vortex of the forest by their brusque exit.

June Blizzard

It is mid-June, the summer solstice approaches, and, following a disappointingly chilly spring, the weather is finally warm. Yet it seems to be snowing! Poplar seeds, borne on light, cottony wisps, float gently in the still air beneath the forest canopy. In one day, every leafy surface in the undergrowth has acquired a fluffy, dust-like mantel that would take years to accumulate in an undisturbed attic. Webs strung fastidiously between grasses have lost their invisibility. The ground is white all around, and here on the path it looks so much like drifts of snow that an unchecked urge compels me to stroll through and watch it swirl around my feet.

Rounding a bend three young teens come barreling down the path on bikes. As I step aside the first cries out, "Whoa, watch out!" Whether he meant to warn me or his friends, or whether his outburst is a startled reaction to a near collision, is unclear. They all blast on past, not slowing, not seeing the wondrous storm that billows up in their wake. No matter. School is out and summer an inviting door they are just beginning to open. As the cloud of cotton settles again I wish them many exciting summers to come. Some June day, when they are ready to slow down, the cottonwoods will still be snowing. Maybe then they will venture into the woods and discover them.

Bonding with Nature

Wauwatosa's Hart Park is one of the most thoroughly developed and heavily used parks in the Milwaukee metropolitan area. It has tennis, basketball, and volleyball courts; a baseball diamond; and a playground. A 20,000-square-foot building hosts a senior center as well as special events. An acre or two of parking doubles as a fairground on festival days and staging zone for fireworks on the Fourth of July. The park's football stadium seats 5,000 people and is home field to two high school teams and two semi-professional teams, the Milwaukee Marauders and the Milwaukee Momentum. The loudspeaker can be heard throughout the large park grounds and for many blocks beyond. Milwaukee County's regulation ten-foot-wide Oak Leaf Bike Trail passes through, paralleling the Menomonee River.

It is an unlikely place to look for wilderness, but some come here and find it. Across from the athletic fields is one of the steepest, highest, and longest stretches of bluff in

the entire watershed. The path up the crest of the bluff from the bridge is hard-packed despite the softness of the soil to either side. The reason becomes apparent when I have to step aside to allow a mountain-biker to pass. He grunts — either with gratitude or mere exertion — as he goes by slowly, legs spinning quickly in low gear. The park and all other signs of civilization are concealed by burgeoning foliage all around, still more yellow than green and glowing with the vibrancy of new life. The river sparkles through the trees, now a long way down.

At the point where the crest levels off a voice comes bellowing up from below. The thick, horizontal root of a red oak tenuously braces the cliff edge, which is dangerously undercut beneath it. A thirty-foot section of the bluff has relaxed its grip on the earth and slumped into the dark waters to be swept away. I peer over the edge to see four teenagers struggling to climb the precipitous slope, urged on by a fifth person acting as coach at the riverside. His bellows consist of equal parts barked command, taunting exhortation, and incisive obscenity. The boys hurl jovial imprecations right back, along with gobs of mud, undermining the leader's earnestness. But they press on, painstakingly, making slow progress on the slippery slope.

The appeal of mountain-climbing is well documented, most famously in the ever-increasing numbers attempting the "ultimate ascent" of Mount Everest in the Himalayas — despite horrific accounts of spectacular failure and death. We judge our lives by our aims as

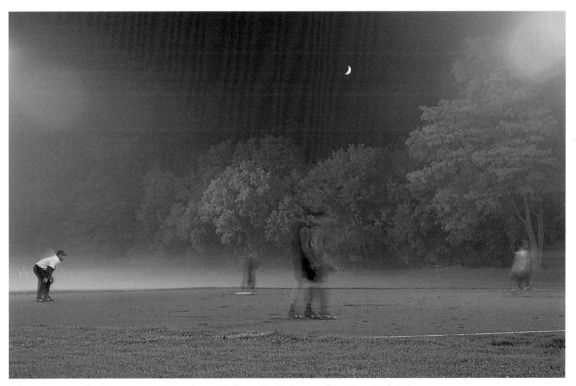

Moonrise over the Menomonee River beyond the softball diamond in Hart Park, Wauwatosa.

much as by our accomplishments. The capacity to strive in the face of adversity is valued by some individuals almost as much as success in achieving a goal. Others of us require constant prodding, particularly when confronted with gratuitous discomfort or challenges of dubious value.

"Come on, you sissies! Move it! Move it!" resounds from the riverbottom. The boys grab at the mud with their hands. The clinging mud makes their boots swell to elephantine proportions, and their faces and clothes are spattered. But, despite the continual complaints and the condition of their clothes, they are enjoying the adventure.

The first to reach the top hauls himself bodily over the oak root, rolls to a squat, and then stands, breathing heavily. A triumphant grin lights up his face when he sees that he's had an audience, and he's eager to know what I think of his exploit. His grin broadens as he hears the expected congratulations for a hard-fought climb, then collapses into quizzical concern when I add softly, not wishing to deflate his beleaguered pride completely, "You know, this is worsening an already serious erosion problem."

After a brief hesitation there is a new gleam in his eye. Then, as if I've just slipped him a trump card, he swivels and calls out over the cliff to the others, lording it over them with this newfound piece of intelligence. Far from being upset with me for diminishing their achievement, the four boys adopt a superior attitude. When the leader finally gains the top they all round on him, lashing out with mock severity at his "stupidity." The "coach," who turns out to be little older than the other boys, sheepishly apologizes as if I were the injured party.

Then, in an attempt to reestablish his flagging authority before it is torn to shreds, he sets off down the path, barking out new commands. The four form an unruly pack and follow at his heels, tearing leaves off low-hanging branches as they disappear down the trail in search of more character-building opportunities to bond with nature.

Choke Point

The sonorous gurgle of water rushing under the footbridge is chillingly subtle like the low, throaty growl of a disturbed wolf. I imagine the vicious snarl and snap when it is fully provoked. A river, like a wolf, is untamable. Any attempt at taming transforms it entirely. Here on this bridge, at a choke point, it is easy to observe the effects of one attempt to tame the Menomonee. The river is squeezed into a narrow channel, walled in concrete; the relationship between natural forces and human activities has been rendered both precarious and dangerous.

Normally, the water slides sedately along the gravelly bottom but not today. After last night's heavy rain the twenty-foot-deep channel is filled nearly to the brim. The vulnerability of businesses built atop the floodwall is all too obvious. I stand directly over it, gazing down: the incessant bulging surge makes the water appear desperate in its rush to escape the confines of the channel. It seems impossible that so much water can flow so furiously. I stare, transfixed. Its energy and power are frightening.

Unfortunately, not everyone is frightened by it. Along with these businesses lives are in jeopardy. The recent drowning of a number of youths in the rivers has precipitated calls for action. As lives get swept away so do emotions and understandably so. Ironically, yesterday's solutions have contributed to today's problems. The biggest culprits are well identified: upstream developments with unchecked runoff and "flood control" channels that increase the speed of a storm's surge and add to the roiling fury below.

I drop a stick over the railing. It vanishes instantly, swept under the churning torrent, carried mindlessly toward an uncertain future. Will we do likewise or learn to live mindfully in the watershed once more?

Demolishing a Neighborhood

The bulldozer operator carefully positions the claws of his scoop at the base of a house's frame where it meets concrete block. With surprisingly little sound the house slowly rises off the foundation, all in one piece. He raises the scoop to its maximum reach in an attempt to tip the house over bodily and smash it. The doomed house teeters at a steep angle but eerily resists. Not for long, however. Efficient and businesslike the operator quickly switches tactics. He shoves the corner, twisting the frame off the foundation, then attacks the side bluntly, punching a great, gaping hole in the exterior wall, exposing empty rooms and flowery wallpaper. Absurdly, I expect to hear screams and see blood, but there is only the mechanical grinding of the bulldozer's tracks, the splintering of wood, and a rising cloud of dust.

The operator backs off as the upper story begins to sag. The great scoop rises high and comes down, crushing the roof as easily as cracking an egg. Window frames and doorframes stretch, skew, and pop, shattering glass that tinkles and shimmers. Within fifteen minutes it is over. The bulldozer sits atop a pile of broken wood, aluminum, and glass. Dust billows thickly around it, obscuring all like a theatrical magician's act. But this is no trick; when the dust finally settles vacant land is all that remains not only of this house, but of an entire block.

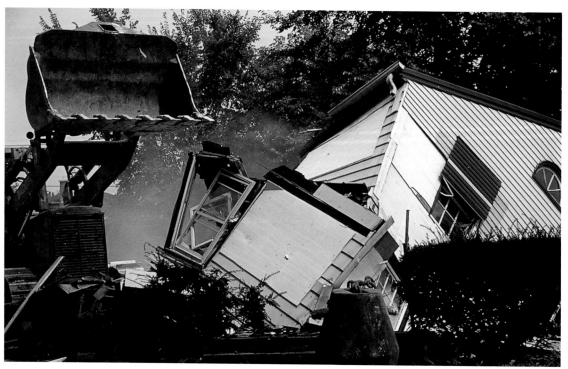

Removing houses from the floodplain, Hart Park Flood Management Project, Wauwatosa.

When this riverside neighborhood was settled in the early twentieth century, these houses were built confidently above the floodplain, but now, after losing basements to repeated floods, it comes to this—devastation, families uprooted, memories erased. The river brought the settlers here, to drive the mill, to grind the wheat, to enable a community to grow in a Midwestern wilderness. Now the wilderness—wild nature—has returned.

Designed in the 1960s when it was considered an effective flood-control technique, channelized streams were intended to drain residential and commercial developments more quickly, but they were never meant to carry current volumes of water. Today, millions of dollars are being spent by federal, state, and local agencies to remove the houses and lower the floodplain in order to prevent additional tragedies. It is money well spent under the circumstances, but it is also a belated attempt to reintroduce natural processes that had been circumvented. Draining of wetlands and filling of low-lying areas have robbed the watershed of its natural ability to absorb the effects of stormwaters. The normal ecology of the region results in a slow runoff to rivers over time, which is slowed further by naturally occurring meanders and the sponge-like effect of wetlands. The application of asphalt has so altered the ecosystem that, after a thunderstorm, it now reacts more like a desert with violent flash flooding.[1]

I walk past the next block of vacant houses. Boarded windows stare like the sightless, unresponsive eyes of corpses. The impassive river glides by softly.

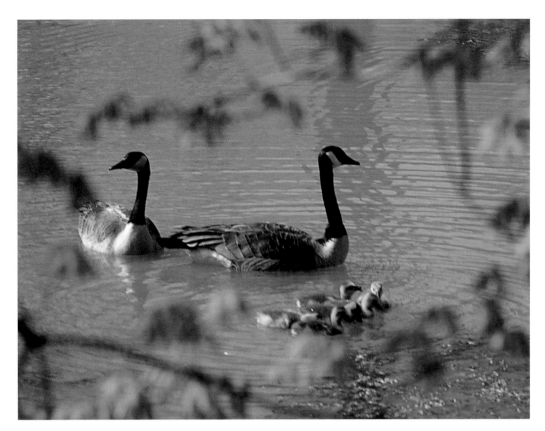

Canada geese (top) and meadow rue and trillium (bottom) in Jacobus Park, Wauwatosa. If Thoreau's famous pronouncement, "In wildness is the preservation of the world," is correct, then we would be wise to examine the kind of world we expect to preserve.

Being in the Middle

Three sets of footprints precede me—two adult, one child-size—lending me confidence on the snow-covered ice. Here and there, the spacing of the imprints widens, indicating a longer stride and increased momentum, followed by skid marks on the smooth, slick surface. A bit self-consciously, after a glance around, I indulge in the simple delight.

Being out on the river provides an unusual perspective. As I saunter and slide down its center the edges are more noticeable. The south side is buttressed with cut stone walls where, during the New Deal, the Civilian Conservation Corps truncated a former oxbow for the railroad. The care and skill involved in that labor are evident everywhere as is the wall's advancing age. Loose and missing stones make the wall look like an unfinished puzzle. By contrast the north side, which has no wall, exhibits dramatic erosion despite recent attempts to shore it up. Large stands of mature oaks and maples hang precariously over undercut banks, roots exposed and tangled with debris. Some lie collapsed in the water, collecting great rafts of flotsam.

Erosion is, of course, a natural process. Watersheds are borne of and defined by erosion, but this unusually severe devastation has been exacerbated by unnatural influences. In the 1990s, hundred-year floods ravaged this region two years in a row. Statistical

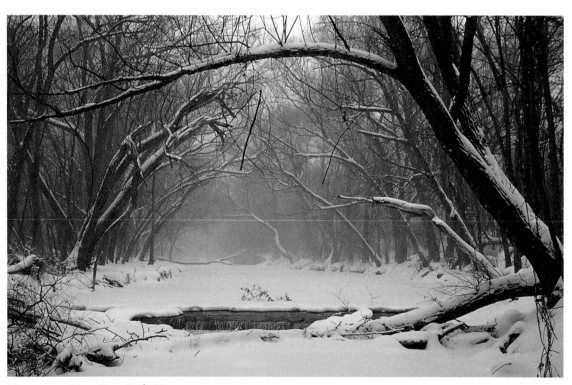

Menomonee River, Hoyt Park, Wauwatosa.

anomaly? Portent for the future? In recent years, widespread development upstream has brought considerable increases in the acreage of impervious surfaces. Above these twisted roots residue from flooding clings to tree branches well above the river bank, and during storms there are violent spikes of runoff.

Wauwatosa, a city caught in the middle, bears the worst brunt of this effect, for it is here where three major tributaries enter the Menomonee. Two of them have been "channelized." This now discredited method of flood control, in which the watercourse is straightened and lined with concrete, produces exactly the opposite of its intended effect when looking at the whole watershed as an integrated system. This strategy takes a naturally absorptive streambed and transforms it into an unrelenting conduit that propels an accelerating deluge toward its confluence with the high waters of the main river. And the "city in the middle" gets inundated.

Hundreds of years of natural erosion control provided by the gripping power of oak and maple roots are now undermined. It is no wonder that the citizens of Wauwatosa have responded with vocal alarm. Being in the middle provides a unique perspective.

Another light-hearted slide across the ice ends with the ominous sound of cracking, and I hurry to the safety of the bank.

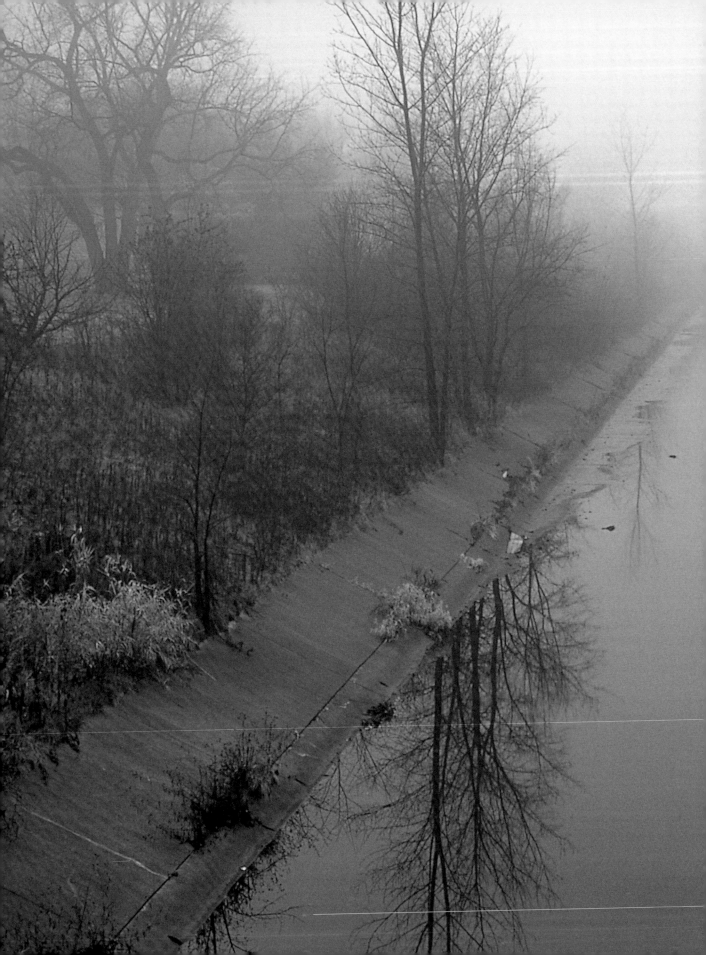

The more we try to confine the river the more terrifying its power becomes.

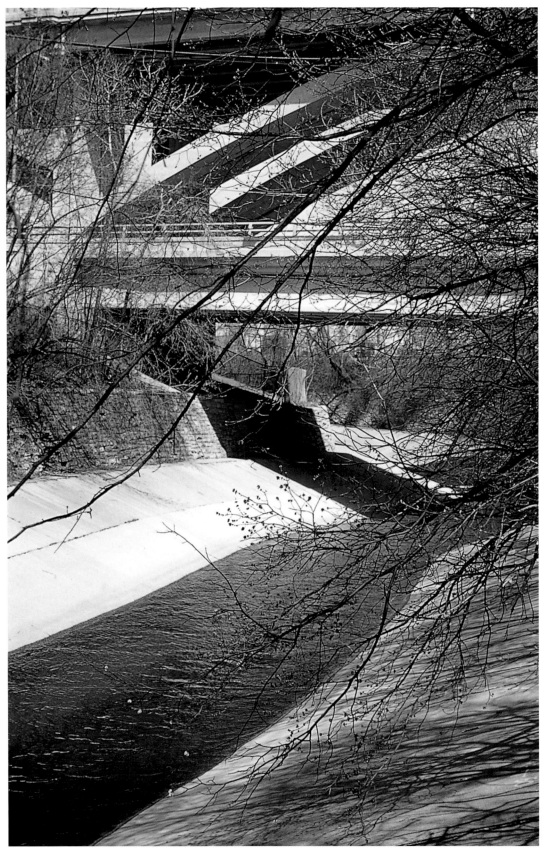

The Wisconsin Avenue viaduct crossing the Menomonee River; previous spread: Underwood Creek, Wauwatosa.

WHAT COULD BE MORE ANTITHETICAL to the contemplation of wild rivers or a natural environmental corridor than to bulldoze a stream into a straight line and fill it with concrete? Perhaps to stop its flow with a dam or to bury it completely in an underground culvert. These are the stories of those sections of the watershed on which such distortions have been imposed. They include nearly all of Honey and Grantosa creeks, parts of Underwood Creek, and even a segment of the Menomonee River itself.

In the words of Page Stegner, "There is a majestic power in the flow of a river that transcends our capacity to conceive and remember — something . . . that both fascinates and horrifies. A river, like all natural forces, is not indifferent or unresponsive to humankind (words which imply intent), it is simply 'not subject.'"[1] And yet humankind often tries to make rivers and streams subject to various demands and desires. The Menomonee River watershed contains concrete creeks that are anything but "majestic," though in their own way they can have the capacity to fascinate and horrify.

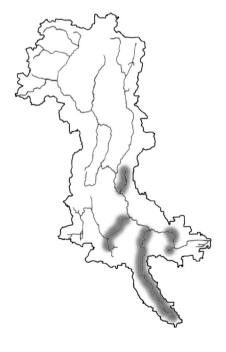

The Prisoner

The downstream section of Grantosa Creek is not lined with concrete like some others; it is, therefore, more aesthetically appealing, but it is no more natural. Bracketed by a divided boulevard it is a stream in a

Underwood Creek, Wauwatosa. Do we design with nature or try to impose our will on nature?

straightjacket: a prisoner. Its gully is free to erode—like moral underpinnings on a penitentiary ward—but wandering is strictly forbidden. Going upstream at 100th Street, as if convicted of some flagrant violation of civic orderliness, it is consigned to solitary confinement, disappearing entirely into a pipe. Grantosa Boulevard continues to wind gracefully on. Its well-tended median implies similar continuity in the buried watercourse. But that is a sham. The water's source lies in another direction; the prisoner has been diverted to an undisclosed location.

The grid of streets, the regularity of the houses and yards, the graded slope of the terrain, the hurried gait of people on sidewalks: nothing provides a clue to the whereabouts of the erstwhile stream. Its free spirit has been extinguished in an oblivion of sewers: out of sight, out of mind.

Finally, in Madison Park, there is a reprieve. The shackles are removed. Paroled, the creek is visible again. Heather, sedge, and wildflowers suggest a natural prairie like the beckoning square of blue sky in the window of a prison cell. The unfettered creek marches rigidly along the perimeter of an unkempt acre, demarcating the line between the "wild" portion of the park and the "tame," which sports a wide variety of courts and athletic fields and many acres of golf.

Continuing upstream the creek is allowed to infiltrate a formidable rank of "luxury" apartments that barricade the north edge of the park. Within the confines of this enclave a compact meander is permitted in a nod to the Picturesque. Privacy is asserted in this momentary "natural" interlude by a "no trespassing" sign affixed to one end of the footbridge spanning the creek. What kind of society builds bridges that are not meant to be crossed? Who owns this water, slipping silently over the stones at the bottom of the dividing ravine?

At its source the creek is imprisoned again, barred behind a chain-link fence. Not that anyone would want to visit this most unnatural source: the flat expanse of Timmerman airfield looms like barren tundra. Water trickles from a recently completed detention berm designed to impound runoff in order to thwart uprisings and riots during storms.

We are no freer of the forces of nature than water is of the hydrologic cycle. Our public policies and our private values come back to us. Like rain they can nourish our soil or flood our basements. We build cities; then we must live in them. Will we build ourselves a straightjacket? Or will we allow our arms to swing? Do we want the sewer as our symbol or the free-flowing stream?

Reversing direction I pursue the trickle of water. After washing the runways of the airport, runoff is discharged from detention to flirt with its true nature in the park. It vanishes into a sewer, then reemerges within the restraints of the boulevard. Finally, Grantosa Creek releases its captive waters into the Menomonee to be swept on, adding its thimbleful to Lake Michigan and, eventually, the Atlantic Ocean. The circle is closed as rain begins to fall on Timmerman airfield.

V. A. Hospital

The grass is dry and brittle, toasted to a drab straw-brown. Nevertheless, in a wide, undulating draw near the V.A. hospital, it has been cropped with military precision. I've never understood the appeal of vast expanses of unused lawn. In a place devoted to human health, why not heed the advice of Frederick Law Olmsted? His stated intention in designing natural landscaping that provided variety in the textures, heights, and colors of vegetation in urban settings was to create "a soothing and refreshing sanitary influence."[2] The features of a natural landscape common in the countryside are especially important to integrate into city planning for visual relief and spiritual uplift. According to Olmsted, "A man's eyes cannot be as much occupied as they are in large cities by artificial things . . . without a harmful effect, first on his mental and nervous

system and ultimately on his entire constitutional organization."[3] In the city, this beneficial natural effect only occurs by human design.

The watercourse emerges from a culvert under the road. It drains a flawlessly picturesque duck pond on the far side, but it is never allowed to emerge completely.[4] The clipped lawn slopes gently down to what clearly could have been (and surely once was) a peaceful wetland. The dell bottom is dominated by majestic weeping willows that should be anchoring a grassy stream bank. Instead they stand aside, almost sullenly, from the travesty of hydraulic engineering that they must interminably witness. Not content with a concrete corset, the entire length of the channel's rigorously curving path is fettered with cyclone fencing as well. Reaching tenderly over the fence, one or two of the weeping willows trails a sorrowful tendril in the sluggish water on the floor of the trough.

The water isn't always sluggish. The fences are well coated with clinging debris, indicating the water's depth and violence when it rises and overcomes the confines of its cement enclosure. Instead of spreading out harmlessly over the surrounding land the torrent assumes a menacing fury as it rages toward the river.

The more we try to confine the river the more terrifying its power becomes. Our futile attempt at containment has destroyed the salutary effect that a natural landscape can have on human health and biotic diversity. But we have the capacity to change! The willows may bow and weep, but they stand steadfast.

Woods Creek, Wood National Cemetery, Milwaukee.

Honey Creek, Greenfield.

Source

Near its beginning there is still a short section of Honey Creek that has been spared the fate of concrete. Two fallow, weedy fields that haven't functioned as farms for quite a while await the inevitable bulldozer. Briefly remote from traffic and houses, a great blue heron starts up as I pass. As always I am heartened by its independence as it recedes from view. But the fragile flicker of wildness recedes as swiftly as the vanishing bird. The source of Honey Creek in Creekwood Park lies beneath the road that forms its boundary. Like the double barrels of a shotgun two storm-sewer pipes protrude from the shoulder of the road. A desultory dribble drips from the lip of one of them. The tragedy of Honey Creek has this appropriately ignominious and symbolic origin.

Detritus of the American Dream

Even in the short portion that runs through Konkel Park, where it is still unlined with concrete, there is abuse. Honey Creek wanders away from the stream of traffic on Layton Avenue just far enough out of sight for people to discard the detritus of the American

Dream without being caught. Besides the usual debris—from ever-buoyant styrofoam to leaden tires—there is evidence of deliberate, even systematic, dumping. A pile of old fenceposts with concrete footings lies in the gully behind Greenfield High School along with plywood, furniture, and an intact water heater. A television lies face-down in a stagnant pool, uncannily resembling a bloated corpse.

Some of the abuse is more industrial in scale. Behind an apartment block an environmental impact fence—the long ribbon of black plastic required on construction sites—has settled into permanency. Left behind long after the project's completion it now sinks slowly into the suffering earth. The land behind a "floral and garden center" looks nothing like a garden. It has been stripped and bulldozed right up to the perimeter of the property and beyond. Despite a bordering scrim of taller trees rubble tumbles down into the surrounding wetland, crushing cattails, dogwoods, and sandbar willows. Widely scattered across the top of the leveled site are piles of old, crumbled asphalt, each the exact size of a dump truck's load. They look like short, truncated Mayan pyramids but without a trace of mystic reverence.

The Range

Across the level crew cut of cattails from the park is a curious sight, but distance makes it impossible to decipher. It looks vaguely like a paddock used for equestrian jumping, but the barriers are crude, either makeshift or in serious disrepair, and the enclave is not fenced. The riddle is easily solved by closer inspection: makeshift by design, the barricades are upended wooden pallets, propped in place with sticks and fifty-five-gallon drums. All are thoroughly splattered with overlapping, multi-hued explosions of paintball impacts. Direct sunlight has robbed the colors of their original intensity. It is deserted, silent, and inert, giving it the feel of a shabby Stonehenge and lacking majesty of scale or sense of order, leaving only the paltriness of decay.

Paintballs are made from soluble gelatin filled with biodegradable lotion, and they pose little threat of environmental degradation. But what of the warrior mentality, the militant emphasis on assault and control of territory, the disregard for the ecological integrity of that territory? How can a battlefield be compatible with a wildlife habitat?

A more urgent concern is not the paintball range but the adjacent wetland, which has been used as a dump for quite a while. A wheel-free truck has rested on its chassis in the muck long enough for all vestiges of paint to yield to corrosion. A formerly overstuffed armchair graces a small island in the supersaturated soil like a throne on a dais. The chair

has erupted, spewing its contents like the frothy pronouncements of a petty king in an obsolescent fiefdom. Most poignant, a rusty swing set stands over the refuse pile like a neglected memorial to forgotten youth. Swingless chains hang slack, trailing in the mud.

Just as disturbing are twin circles of rich, dark loam bulldozed into the cattails. The wetland's value as a sponge for rain—replenishing the groundwater, slowing the spike of floods—is as obvious as the deep impressions my boots leave behind, as is its *un*suitability for human activity. Can it be a coincidence that this assault on the environment is in such close proximity to feigned military exercises?

Historical Society

A wooded vale has been allowed to encircle the Greenfield Historical Society's compound as if to shield it from the contemporary society that encroaches from all sides. The approach is guarded by a crude, zigzagging plank fence, consistent with its period theme. Cars stream past on the four-lane, divided boulevard while the gravel lot stands empty, forlorn. The sign on its door reveals that the humble log cottage is open for two hours every other Sunday.

A feeble screen of trees and a briefly natural segment of beleaguered Honey Creek separate the society from the River Falls Family Fun Center, which bustles with noisy

Honey Creek, Greenfield.

activity. Never mind that this creek has never resembled a river or that the only falls emanate from pumps discharging atop an artificial cliff in the adventure golf course. The contrast between the busy Fun Center, with its simulated rocks and frenetic pace of activities, and the silent historical society illustrates Richard Louv's concern that our children are being raised with what he terms "nature deficit disorder" or a lack of direct experience in nature. "For a new generation," he says, "nature is more abstraction than reality. Increasingly, nature is something to watch, to consume, to wear—to ignore."[5] Along with that, in our increasingly stressful lives, even recreation is controlled and structured. "At the same time, the urban and suburban landscape is rapidly being stripped of its peace-inducing elements."[6]

I turn back to the actual creek. It won't take long to explore the narrow band of woods. But it has a calming effect and provides an unmediated experience, one-on-one with the world during which nothing is consumed.

Exploring the Concrete Creek

A major portion of Honey Creek descends completely underground, disappearing through a monstrous steel grate like the baleen maw of a mechanical whale. For two miles, between the city of Wauwatosa and McCarty Park in the city of West Allis, it is

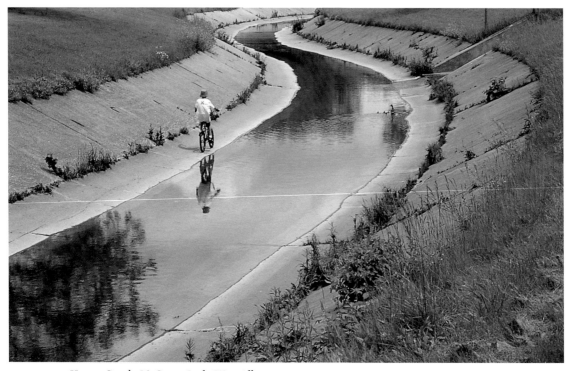

Honey Creek, McCarty Park, West Allis.

nothing other than a storm sewer. Even here in the park, before being swallowed, it skirts around a scenic lake as if in shame, encased as it is in concrete. It slumps into the park lawn as if slinking through, not wanting to be seen. A boy rides his bike beside the creek, which bears more resemblance to a sidewalk than a waterway.

As I walk down the slope into the trough the landscape steadily disappears from view, first the houses and trees around the periphery of the park and then the ball field's fences, the bathhouse at the lake, the people fishing along its nearer shore. Finally, the two lawns flatten on either side, becoming thinner and thinner until they are twin horizons. Then, suddenly, these are also gone. The bottom feels wrong, harsh, and empty.

All that remains is a narrow band of tepid water darkening the middle of a concrete bed with concrete walls topped by fringes of grass. The sun beats down from a white sky, and unremitting heat rises from the white of the concrete. It is an environment totally alien, physically enervating and spiritually debilitating. The natural impulse is escape, to walk right back up to where the world still exists, fresh and green, where there is softness and shade. But I steel myself and move up the channel feeling like a mouse in a laboratory maze.

A high pedestrian bridge connects the two halves of the park partitioned by the channel. From this vantage the thin steel trusses express unrealized hope as they span pointless reality and connect invisible destinations. Ahead the concrete runs on until it bends in the distance. The only differences between this next stretch of channel and the last are the trees that edge close to the rim and a greater propensity for vegetation to break through the concrete. These are welcome variations on the occasional drainpipes and runoff ditches that have been the only interruptions in the uniformity of the channel.

Encounters with anything resembling nature in this harsh environment are but brief breaks in the tedium. A small mulberry tree overhangs the concrete, its branches bulging with so much fruit that it is a zestful counterpoint to the antiseptic channel. The ripe berries, neither sweet nor bitter, remind me of Earth's natural fertility the way the song of a caged bird suggests flight. Fallen berries stain the concrete black, but the blemished surface remains unwounded.

Farther on a family of ducks has stumbled into the channel. Another boy on a bike stops, and they face off across the stream, divided by so much more than water. The mother duck turns and leads her brood out of the trough. The ducklings struggle up the smooth slope, hop the fringe of grass one by one, and vanish.

I take this as a sign and follow, not wanting to think that I have less sense than a mallard.

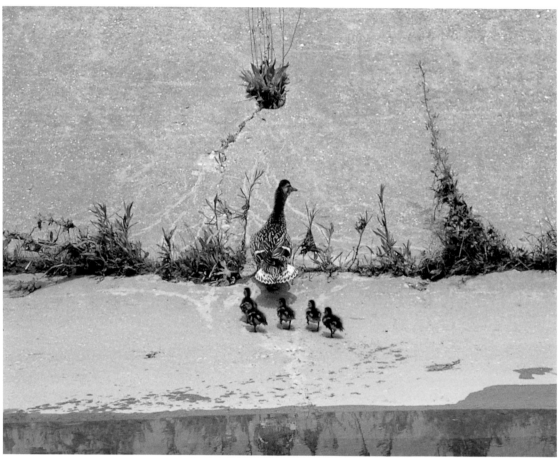

Mallard brood, Honey Creek, McCarty Park, West Allis.

Honey Creek Park

Honey Creek once flowed openly through the park that bears its name like an epitaph. The evidence, though scant, is not subtle. Curving in a gentle arc diagonally through the park is a strip of grass marked by parallel rows of stately elms and horsechestnut trees. Clearly, they once lined an actual, living creek. The bracketed lawn dips in a slight depression, a foot or two deep at the center. The black steel discs of sewer-access covers are punched into the sunken lawn at irregular intervals, evidence that water still runs its course underground, unseen.

The crowning irony is the elaborate, rusticated bridge. Constructed to allow passage across the former creek, it has become punctuation in the sidewalk that continues to carry amblers and cyclists across it and a question mark for those curious about its anachronistic presence. Its massive stone railings rest incongruously on the lawn, grass growing up their sides like a ship moored on solid ground — or a mammoth headstone for the stream interred below.

Skateboarding on the Creek

A group of five boys are riding bikes and skateboards across Underwood Creek, which is not to say they are riding on the other side. This is one of the creeks that might be mistaken for a miniature freeway with a strip of water for a median. The boys have chosen this location because it's secluded and particularly suitable for their purposes. A drainage ditch empties into the creek at this point. The concrete channel has been excavated about eight feet below the level of the natural landscape. Runoff from the ditch falls over a short steel cofferdam, and below the dam there is a wide concrete splash pad with banked sides. The two banked channels meet in a triangular spine. It couldn't be more ideal for skateboarding if it had been designed for that purpose (except, that is, for the very real possibility that stormwaters will tear through the playground with the implacable power of a flash flood).

With youthful inventiveness the normal trickle of water in the drainage ditch has been diverted through a narrow, hand-dug flume which bypasses the cofferdam and spills down the side of the main channel. This bit of impromptu engineering keeps the splash pad dry when it isn't raining. To increase the size and complexity of their improvised course, plywood has been laid across the water in the creek like a pontoon bridge and a runway carved out of the brush on the wooded slope above.

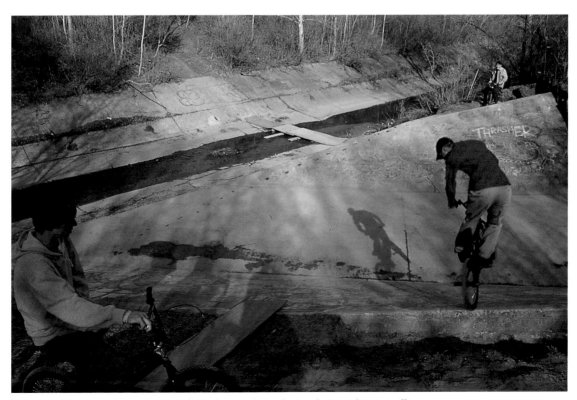

Riding on the concrete creek channel, Underwood Creek, South Branch, West Allis.

One of the boys backs his bike up as far as he can into the brush at the top of the runway. He spurts forward, pedaling fast to accelerate down the earthen slope, then the steeper slope of the concrete, and across the plywood. He zooms up the other side to the concrete pinnacle and is airborne. Twisting the handlebars with a jerk he spins the bike around and tries to land upright in the splash pad. As the group looks on the bike totters, and he has to put down his foot to prevent an embarrassing spill. Still it is an impressive feat. Dignity intact, he yields the court to a skateboarder who waits his turn at the far side of the pad.

Urban wilderness meets urban jungle. The indestructibility of thrill-seeking youth flirting with danger coincides with the mildly antisocial assertion of self-identity and freedom from parental restraint. How enticing! This is a perfect setting for such a convergence of adolescent impulses, and all it took was a misguided flood-management program and the expensive ruination of a creek. Can we find a more potent symbol of our society's dysfunctional relationship with the watershed than these kids, who, instead of searching for snakes and turtles, are riding skateboards on the creek?

Where is Rachel Carson's sense of wonder and the sheer joy of creation with which we are born? Acres of fallow land abut this stretch of concrete channel—room, if we would but build it, for the most natural forms of flood control: a wide oxbow in the creek and a large wetland. Along with this practical benefit would come priceless opportunities for our children to come into direct contact with wildlife in safety. What if we had a Superfund not just to clean up toxic chemicals but to rescue and reclaim physically damaged rivers?

Dam

"Progress" is a slippery concept. It is so subjective that completely opposite activities that produce contrary results can both be described reasonably as progress.[7] This is true for *construction* and its semantic converse, *destruction*. Not long ago a dam was removed from the Menomonee River near 45th Street. As dams go this one was decidedly underwhelming, so do not imagine the Grand Coulee or Hoover dams. Picture instead the tub overflowing and covering the bathroom floor with water before it spills over the doorsill, the sill being the dam not the tub. It had four feet of rise and a dozen of spillway. Its diminutive stature was reflected in its official designation: "drop structure," not "dam." Puny. But you wouldn't know it from the controversy its demolition caused, particularly amongst people who lived downstream. From their point of view it was as if Lake Mead would be released directly into their neighborhoods.

It's not that they didn't have cause for concern, considering the tendency for the river to take such a detour and end up in basements. When it was built the dam was intended to slow floodwaters a bit before sliding into the channelized section of river below. However, rampant *progress* had long ago rendered the little dam useless for that purpose. Runoff from sprawling developments upstream had created such elevated flood levels that it was like using a speed bump to slow an Abrams A-1 tank in full assault.

Not long ago the construction of a dam was almost invariably construed as progress (except by those displaced from inundated land), but the tide is turning and much more substantial dams than this are being removed in order to restore the healthy flow patterns of natural rivers and improve habitat for fish and wildlife. Although the drop structure's intended purpose had been rendered obsolete, its most significant unintended consequence—the prevention of fish migration—never ended. Current sensitivity to the ecology of the watershed deems the destruction of this dam—and concurrent rehabilitation of streambed—as *progress*.

The Struggle

Salmon are lined up in the channel like commuters at a stop light, backs and dorsal fins clear of the shallow water. From the sloping, dry edge of the concrete I can almost reach

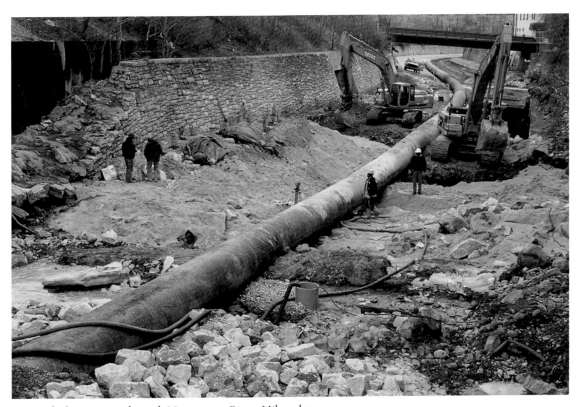

Removal of a concrete channel, Menomonee River, Milwaukee.

out and run my hand along the dark, iridescent green back of the nearest one. Downstream, where the channel is wider and the current is slower, I once saw a teenager step in and grab a nearly three-foot-long fish. Here, in the narrow chute under the Wisconsin Avenue viaduct, their fins and tails move constantly as they struggle against the swift current, but they remain stationary despite the effort.

Every few minutes one of the frustrated fish thrashes wildly in a burst of extraordinary exertion. But it moves only inches forward before falling back into the holding pattern of equilibrium between continuous effort and unrelenting resistance. Only tremendous perseverance has enabled them to reach this far. Eventually, each one tires and limply slides down to where the concrete ends and the river widens and slows over a gravel bed. Bloated carcasses litter sandbars and float in shallow eddies.

On rare occasions, when conditions are right, a particularly strong fish can make it past the upstream end of the concrete channel. With the 45th Street drop structure gone a fish can then continue its instinctive but ultimately futile drive to reach the river's headwaters and spawn, futile because of the much higher mill pond dam in Menomonee Falls. Until recently, it was also futile because these nonnative Pacific chinook salmon were infertile. They were introduced in the mid-1960s in a hugely successful attempt to revitalize the sport-fishing industry and to control another nonnative species, the Atlantic

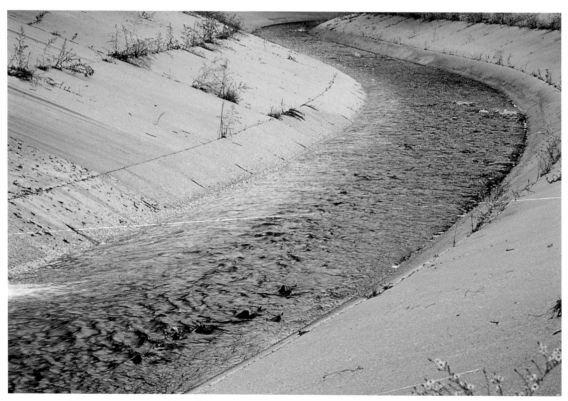

Menomonee River, Milwaukee.

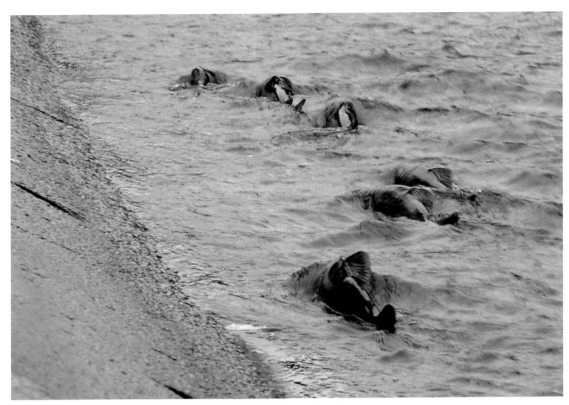

Struggling salmon caught in the channel, Menomonee River, Milwaukee.

alewife, that had infested Lake Michigan beginning in 1949. The alewife is just one of many species that caused ecological havoc in the once-isolated Great Lakes ecosystem following the opening of the Welland Canal in 1829, which enabled fish to bypass the previously insurmountable barrier of Niagara Falls.

With an irony that proves the risk of upsetting natural balances or predicting the effects of doing so, salmon that have had to be stocked yearly now unexpectedly reproduce on their own. The salmon's success has created additional problems. Recent attempts to reintroduce a popular *native* sport fish, the walleye, have met with resistance from salmon fishing clubs because adult walleyes eat young salmon.

The fish in the channel continue to struggle with an unnatural current while we humans continue to struggle with the consequences of our public policies.

Ambivalence

The river drops into the city's industrial valley through a stretch that seems schizophrenic by design. The north side is urban/industrial; on the south side a closed landfill bulges like an overstuffed laundry bag. The contents have been cloaked with a park and

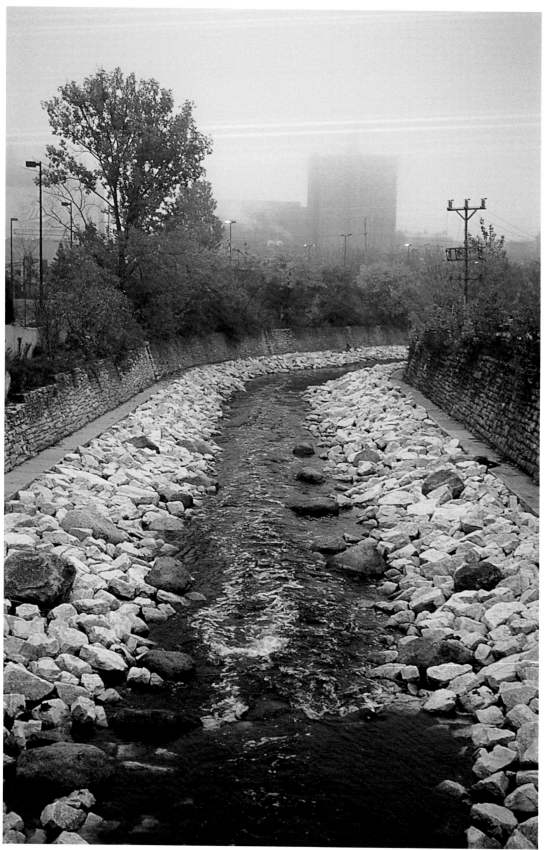

A "restored" Menomonee River, following the removal of a concrete channel, Milwaukee.

a golf course. Along the walled river's edge runs an old dirt road, gated and padlocked at one end but used—occasionally—by mountain-bikers and joggers. There is a steel bridge across the river, which is even more purposefully blocked with concrete barriers. At one time this bridge provided access to the businesses on the north side. Now all have turned their backs to the river.

The south side path, sequestered by the steep decline of the park's slope and a dark canopy of mature hardwoods, is very secluded. Supple box elders arch over it, creating a natural tunnel. It is hidden to all except the adventurous, for there is no visible access from official Doyne Park above. No sign marks the narrow footpath winding its way down. Being here feels vaguely illicit and daring. I observe the talents of graffiti artists who adorn the otherwise blank backsides of industrial steel sheds across the obsequious river, which drops from here into its final stretch through Milwaukee's industrial valley.

The city is a place where nature cannot be taken for granted.
It must be sought and husbanded. If it is not claimed by the public,
it will be lost to "economic development." Here in the city,
we must stake a claim for nature.

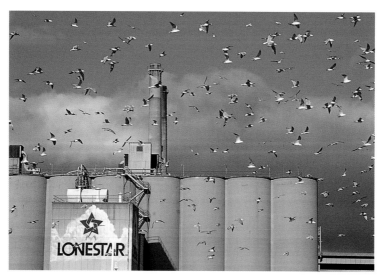

Menomonee Valley, Milwaukee: top and center: Lonestar's silos behind a salt warehouse; bottom: brick rubble and mud; previsous spread: Interstates 43 and 94.

WHILE THE SHADED WOODLAND trails in riparian parks are cool and inviting I consider it just as important to explore the portions of the watershed that have been developed or degraded. It is here that conceptualizing an urban wilderness is most challenging and perhaps most crucial. Like many naturalists and writers I have chosen to live in and describe a particular place. Unlike most I have chosen a city, a place where nature cannot be taken for granted; it must be actively sought and ardently protected. We who value the urban wilderness stake a claim for nature while living in the city.

Dave Cieslewicz argues that we need a city ethic to complement Aldo Leopold's famous land ethic: "A 'city ethic' would change our view of where we belong from the savanna and the forest to the urban neighborhood. If we can view cities as our true and natural home, we would advance a long way toward achieving the land ethic. Respect for land means treading as lightly as possible on it. And what is more fundamental to treading lightly than taking up less space? Cities . . . are not only fine human habitats but also good for nature."[1]

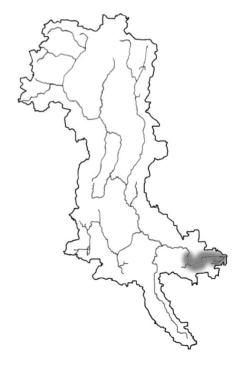

In the Menomonee Valley—once a verdant marsh, then an industrial powerhouse, and more recently a blighted patchwork of pollution and decay—we have an opportunity to create a sustainable city that respects and integrates the urban and the natural. An old philosophical conundrum asks whether a tree falling in the forest makes a sound, but the more important and practical question we must ask is this: if

a tree falls in the city, will anyone hear? If we feel ourselves to be embedded in nature—instead of falsely separate or superior—then we will not only hear, but we will want to plant new trees throughout the city.

Monuments

The constant river runs, a ribbon of life snaking through an exhausted industrial valley that lingers at the point of death. The western end of the Menomonee Valley is dominated by the new $400 million baseball stadium for the Milwaukee Brewers. Its vaunted retractable roof rises like an Aztec pyramid, a contemporary counterpart of an ancient reverential form: the temple-mountain. Spreading out from its base like lava the largest parking lot in Wisconsin consumes the land. The river bisects but cannot conquer the vast, gray acreage, which remains silent, sterile, impermeable, and—except for brief moments when the multitudes arrive to pay tribute—monumentally empty. Parking lots are necessary in our auto-dependent society, but the planners could have been more humane here.[2] Where are the islands for trees in this sea of asphalt? How many parking spaces were gained by sacrificing an opportunity for shade—relief from the oppressive vastness of hot tar?

From massive pyramids to soaring Gothic cathedrals, humanity seems compelled to leave a lasting mark on the landscape. One measure of a culture's ultimate values is where it expends the most resources. Skyscrapers aspiring ever upwards have made monuments of our modern cities. But a less dramatic gesture may better reflect contemporary values: do we want to be remembered as the society that poured the most concrete over the surface of the earth?

Multitude

How could a working railroad yard ever be likened to a wilderness? Trains come and go like animated walls, sliding in and out of view, issuing a constant, abrasive hissing, clanking, and screeching. Monstrous mechanical serpents have been punishing the earth here for more than 150 years, since the time when most of the Menomonee Valley was still a wild rice marsh. Now the barren ground is a vast latticework of woven steel.

As I drive past my eyes are arrested by a sight so preposterous I wonder if it is a hallucination. A curiously repeating row of goose heads rises from behind the raised track bed as if wildlife wallpaper has been pasted to the boxcars beyond. I stop to investigate and am rewarded with an astonishing discovery: the dozen or so geese I expect to find

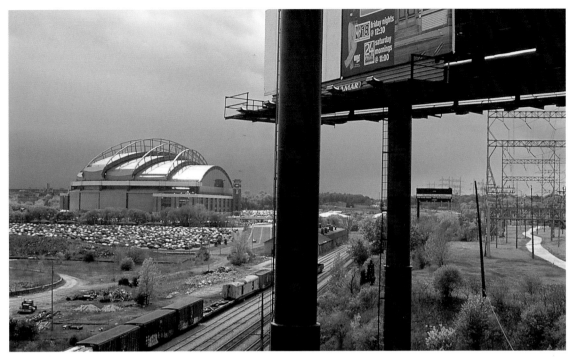

View west from the 35th Street viaduct, Menomonee Valley, Milwaukee. Once a verdant marsh, then an industrial powerhouse, and more recently a patchwork of pollution and decay, an opportunity now exists to create a sustainable city that respects and integrates the urban and the natural.

huddled around a pool of rainwater turn out to be the vanguard of a multitude so immense I can only stare with incredulity. They must number in the thousands. Most are standing still in fairly regular intervals as if in parade formation. They are alert and seem to be waiting for some signal that will allow their platoon to engage in whatever arcane agenda has assembled them here.

They squawk irritably and flutter aside as I wade into the mob, then fill in behind me like water eddying in my wake. Atop a stack of railroad ties the epicenter of activity comes into view. A huge, seething mass of bodies writhes. A steady stream of geese somehow manages to march calmly into the crush like pious and deferential pilgrims entering a packed sanctuary. The object of their devotion is obscured by the tumult. They must be feeding on something, but the barely contained chaos has the implosive force of religious ecstasy. I feel privy to a secret ceremony with ritual symbolism beyond human comprehension, to which I am neither invited nor welcome.

It seems as if this must be an apparition, that these geese are haunting the site from which their ancestors were banished when the marsh was filled. If so it is a fitting vision: where once the waterfowl were innumerable and the first railroad tracks sank in the mud, now a spectral horde engages in a bizarre memorial for the marsh that lies buried and braced with steel.

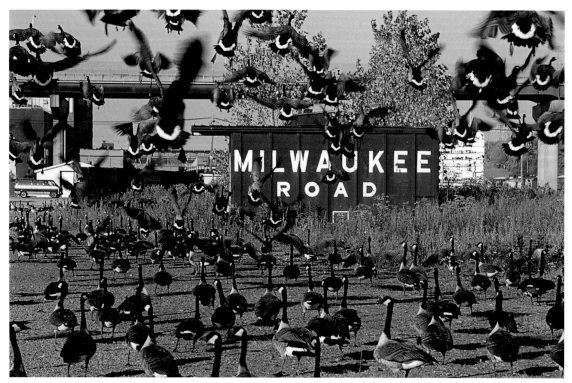

Canada geese, Menomonee Valley, Milwaukee.

Great Blue

As I pick my way down the rocks under the viaduct, with the tall buildings of downtown Milwaukee for a backdrop, *three* great blue herons start up from cover on the near shore. As awe-inspiring as it is to see one, the sight of so many at once is dizzying.

They fly several hundred yards downstream and alight in the upper branches of tall cottonwoods on the farther shore. One takes longer than the others, swooping up and over the thin band of trees that buffers the river. It circles slowly, its slender, widespread wings looking prehistoric in the distance. Finally, it joins the other two, disappearing under the canopy as if sucked up by the tree.

I regain the top of the bluff and proceed toward them cautiously, keeping a steady eye on their position, knowing all the while the futility of trying to get close. Although common along riparian corridors even here in the city, herons have never adapted to the presence of humans, making their appearance a signature of wildness. When I am as close as I dare I start down the bluff again toward the riverside. That's when the *fourth* heron stirs *behind* me, shielded by the shadows near the bluff over which I had passed moments before. With a surprisingly loud, guttural squawk it unfolds immense wings. Its hasty ascent seems awkward, but once aloft it glides with an air of refined grace.

The heron banks deftly, this one heading upstream. It skims low over the water and vanishes behind tall grasses lining the riverbank. Farther on it reappears, swoops upward, cups its long wings ever so slightly, and stalls over the outthrust limb of a dead tree overhanging the river. The magnificent wings collapse onto the suddenly svelte body as if deflated. It stands warily on its perch, long neck alternately stretching and bending back onto itself in a distinct s-shape.

Paradoxically, it is both more exposed and less vulnerable than before. The heron understands instinctually the fragility and impermanence of life. And so it stands in the open, poised, with a clear view all around, ready to flee at the first sign of danger.

The land itself is likewise fragile and impermanent, but wild land cannot raise wings and fly when threatened. The land cannot protect itself. Like a heron perched on a dead tree under a viaduct the virtues of urban wild land have to be open, part of the public consciousness and discourse. If they remain secret treasures valued by only a few explorers, they will not be saved.

The Once and Future Viaduct

Over the years four viaducts have been built to link the south side of Milwaukee to the north side across the great divide of the Menomonee Valley. The highly productive estuary and marsh of pre-European settlement times was gradually filled and became the highly productive industrial hub of the growing metropolitan region. Then it suffered the decline typical of Rust Belt cities. The one constant throughout this history has been the difficulty of crossing over the valley. In solving this problem the viaducts inadvertently made it easier to ignore the plight of the valley itself as conditions deteriorated.

Now the Sixth Street Viaduct is being renovated. Its new design signals a new intention: it will no longer be merely a means of transport across the valley, but also a point of entry into it. Its center will dip down to ground level, physically and symbolically linking adjacent neighborhoods with the valley floor.

A great cavity yawns where the bridge once stood. From the south come the rumbling rhythms of destruction as demolition progresses. Jackhammers chip away at the road deck; acetylene torches hiss and spit; chunks of concrete crack and fall; steel screeches as it tears and crashes to the ground. Simultaneously, to the north a melody of construction is added to the dissonant cacophony: the whine of cranes lifting heavy loads, the staccato percussion of steel hammers on wooden concrete forms, the high-pitched beeping of construction vehicles.

In the midst of it all, in an abandoned grassy field speckled with hardy chicory and patches of thistle, two pairs of rabbits frolic, oblivious to the human clamor all about. When the workday ends other creatures appear: first gulls, then geese, and much later, in the quiet of twilight, a single, small green heron. Life goes on. Like humans, *some* species will adapt to almost any conditions. But living in the city and contemplating an urban wilderness we must ask, "Are those the only species of plants and animals we want to see around us?" And, "To what conditions must we ourselves adapt?"

The new viaduct is intended to stimulate creation of an improved environment in the Menomonee Valley, and a visionary design is attempting to balance needed economic development with reconstruction of native habitats along the river. This can stimulate greater biodiversity and provide a pathway for nature that extends into the epicenter of urban Milwaukee.

Faint-Hearted Crusader

At the bottom of the bluff, near the river's edge, it is possible to imagine being in a distant wilderness rather than in a narrow corridor between landfills and brownfields in the

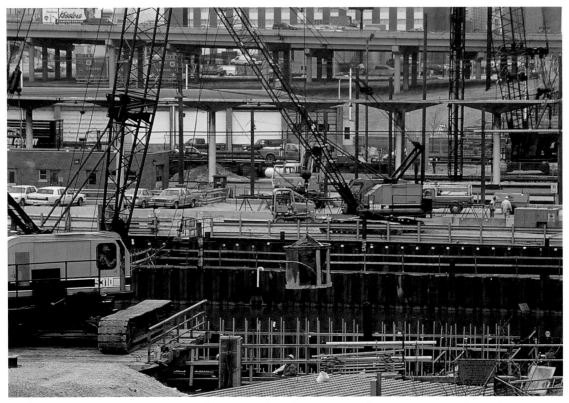

Construction of the new Sixth Street Bridge. If a tree falls in the city, will anyone hear it?

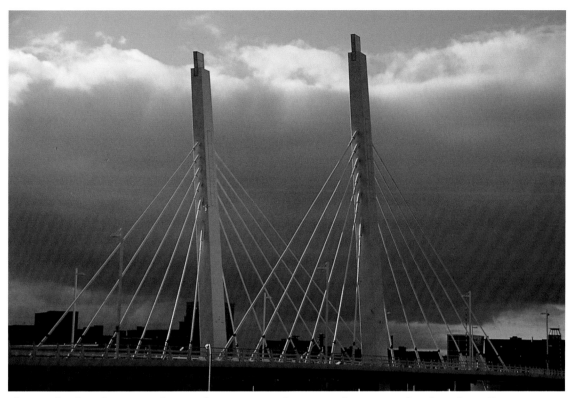

The completed Sixth Street Bridge signals a new point of entry into downtown Milwaukee, physically and symbolically linking adjacent neighborhoods with the valley floor.

industrial core of a major city. It is especially invigorating to touch the wild spirit of the river that lies at its heart, feeling the vitality of it, tried but unbroken.

In warm weather, the wear on this trail indicates regular traffic. But snowcover makes clear how rarely used it is in winter. Two, maybe three people and one dog have preceded me this week. The infrequency of human visitation likely explains the enormous number of ducks and geese taking advantage of this refuge between the stadium and the 27th Street Viaduct. Away from the edge of the bluff, out of sight of the waterfowl below, their constant murmur can be heard like a softly chanted litany. When my form appears at the rim it is as if a shot had been fired. Pandemonium ensues, and the entire congregation rises. Within a minute they are gone. All is silent but for the trickling of the current and the low rumble of a single truck high and far away on the viaduct.

In his essay, *Walking*, Henry David Thoreau claims to "speak a word for Nature, for absolute Freedom and Wildness."[3] I wish to speak for *relative* freedom and wildness. They are virtues that can coexist within society and culture while providing a contrast made poignant by the intimacy of their juxtaposition. Thoreau wants to "regard man as an inhabitant, or a part and parcel of nature, rather than a member of society," but it

need not be an either-or proposition.[4] Rather, we must reconcile our social and natural selves as intertwining facets of a single whole. Indeed, until we can see them as one and the same society ignores nature at its peril.

Thoreau chastises all who are "faint-hearted crusaders" unwilling to commit to true walking. This would require, he says, leaving family and friends, settling all one's affairs, and setting out without thought of returning. That is a journey Thoreau himself made only briefly and symbolically. I, too, am content to retrace my footprints in the snow, back to my parked car, my family, and the life I've made in a city graced by a measure of wildness.

The Calm Heart of the City

The former Milwaukee Road railyard is a "neighborhood in transition" but worlds apart from the usual gentrification of dilapidated houses. Here and there, young box elders and other aggressive trees spring exuberantly out of a sea of tall grass dappled with blue, yellow, and white flowers. The double-rutted contours of an old dirt road are softened and nearly concealed as I peer down the track into the deepening wood near the river. Despite the early hour the air is sultry, thick, and still, the heat already uncomfortable. Crickets have established a repetitive thrumming, audio accompaniment to the oppressive atmosphere. It is surprisingly peaceful and calm considering the location: in a fallow land, a former marsh, filled and leveled for industry, then abandoned to time and entropy. The heart of metropolitan Milwaukee beats to the cadences of nature.

The City Disappears

I am surrounded by the sounds of the awakening city, oddly muted like the distant rumbling of an approaching thunderstorm. Traffic is light on the long 35th Street Viaduct that passes overhead like a steel frame on a panoramic landscape. But Interstate 94, the major arterial freeway feeding workers downtown from the western suburbs, has already slowed to a rush-hour crawl. At the nearby industrial equipment factory a truck eases into gear, but the heavy machinery remains silent. A pickup truck raises a cloud of dust from the dirt road along the base of the viaduct. The dust hangs in the air, gradually becoming indistinguishable from the gray ozone haze forming the lowest layer of stratified gases that hover over the city like unstirred salad dressing.

It's going to be another hot day.

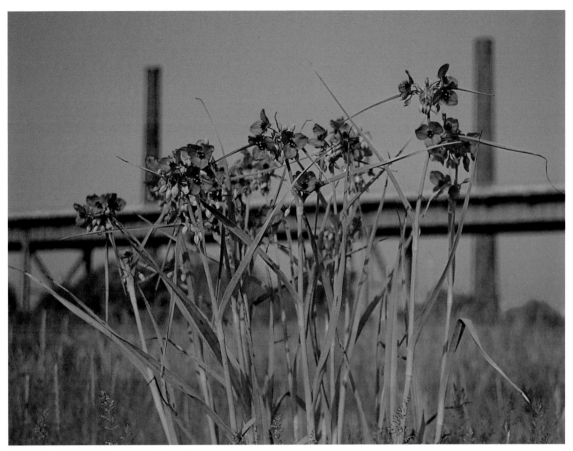

Spiderwort near the 35th Street Viaduct.

The vertical lines of two, towering, brick smokestacks make more emphatic the horizontal viaduct and the wide, flat valley. Disconnected from their function they are all that remains of a once great industrial powerhouse. Cranes idle nearby, waiting to move in among broken buildings, to crush and clear the rubble. A falcon glides from its perch atop one of the stacks. Blackbirds and sparrows in the shrubs fall silent, then resume their chatter as the predator rises on a thermal updraft, diminishes, and dissolves into the sweltering sky.

Climbing down the steep bluff to the riverside I find respite from the heat and dust. The canyon-like river corridor feels like a distant land. The city disappears. Soft light filters through the high canopy and refreshingly cool air washes over me. A limb detaches itself from a tangle of fallen trees and is transfigured into a great blue heron as it spreads enormous wings. It seems to float up to the treetops, then skims away low along the water. I feel an acute affinity for the falcon and the heron, both solitary birds, and although their flight leaves me standing, earth-bound and clumsy, my spirit rises to join with them.

Power Plant

One-hundred-twenty feet up the smokestack of a coal-fired power plant wind roars in my ears. Far below and all around are the signs of a century of enterprising development and subsequent decline. Black roofs mark the few remaining factories. Vacant parcels are littered with faintly twinkling glass. Tiny trucks pick and prod at a mountain of coal to feed the furnaces beneath my feet. They have the look of ants fussily tending an anthill. Across the canal in the city impoundment lot, carelessly arranged carcasses of abandoned automobiles lie atop the contours of a huge mound of gravel. In another direction lies their probable fate: scrap metal awaiting reclamation is being sorted into irregular piles.

This isn't the kind of setting one expects nature lovers to seek out; nevertheless, this vertiginous height is one of several area nesting sites for the once-endangered peregrine falcon. As such it is a significant outpost in the urban wilderness — symbolic of a dramatic environmental success story — and I am witnessing as much wild fury as a pair of falcons can muster.

Tolerance of humans and adaptation to their synthetic environments has helped to bring the species back from the brink of extinction, but tolerance has its limits. With no way to communicate our benign intentions the banding team is provoking the falcons in the most distressing way possible, by raiding their nest and stealing their young.[5] In a frenzy, the adult birds dive at us, swerving by as close as they dare. They circle around and dive again, screaming all the while in high-pitched desperation.

Greg, the naturalist in charge of the operation, is getting an equally ferocious reaction from the fledglings in the nest. In what they can perceive only as a battle for existence, they simultaneously claw, peck, and struggle to evade his grasp with great feathery commotion. But it is a futile fight, as gloved hands deftly snatch each chick and transfer them to the waiting cage. All the while the parents continue the attack. Capable of speeds as high as 230 m.p.h.—which makes them the fastest animals on Earth—their intimidation is real. The larger female aims straight at my head, eyes blazing with intensity. Just beyond reach she stalls her headlong plunge with a wide sweep of her wings, talons writhing with frustration, and veers away.

Once in their lives these wild creatures must endure this violation because our society has decided to care whether they live or die. The look in their eyes is a clear sign that banding doesn't tame them, but it creates a platform on which we can build a case for mutual survival. In the urban wilderness, nature's indifference must be guided by humanity's care and stewardship.

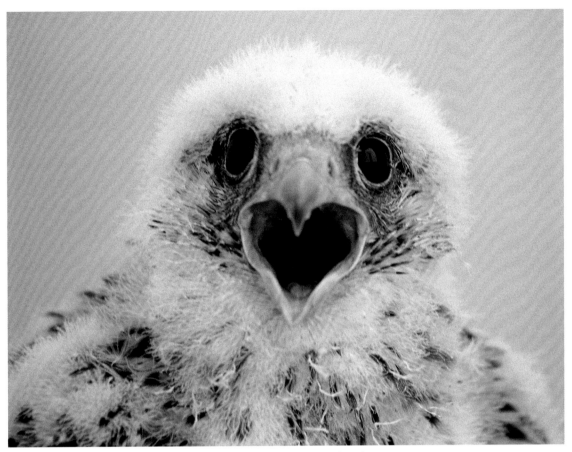

A fledgling peregrine falcon, Menomonee Valley Power Plant. In Milwaukee, visionary scientists worked with industry leaders to help bring the species back from the brink of extinction.

Once inside identifying bands are applied expertly to the fledglings' legs. Held as gently as possible they nevertheless struggle continuously. Sharp beaks and talons flex and strain, eyes glare with a vehemence born of panic. The banding team's calm, scholarly attention to detail belies a genuine respect and affection for the fate of the individual birds as well as the species. They are given names. Personalities are noted along with physical traits. All is done with such alacrity that we are soon back up on the smokestack, returning them to the nest. No longer attacking, the elder falcons continue to circle, eyeing us suspiciously.

When I return to solid ground I turn to look up through a lattice of steel structures toward the tiny, white nest-box affixed to a narrow railing on the massive vertical form of the stack. Two even tinier black specks with wings whip around like torn bits of cloth whirling in an updraft. Then each circles the stack one more time, swoops gracefully up to the nest, and disappears inside. The only sound is the wind in my ears.

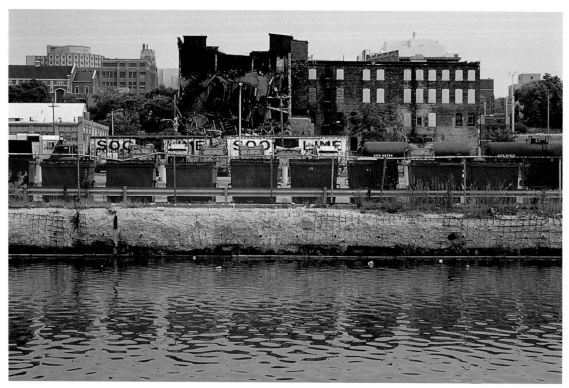

The Menomonee River canal near Sixteenth Street. This stretch of the Menomonee reminds us of Milwaukee's industrial past.

Canoeing the Milwaukee and Menomonee Rivers

I put my canoe in at a dock on the Milwaukee beside a new condominium complex. More are being erected on both sides. Even on a Saturday the sounds of construction echo off the stained brick wall of a dilapidated tannery across the water. The tannery building awaits renovation. Chemical cleaning will restore the grimy gray surfaces of the local bricks to the milky yellow glow that gave Milwaukee the nickname "cream city."

I paddle through a downtown bustling with weekend activity. Families stroll along the elaborate riverwalk. A cheerful buzz of conversation carries across the water at regular intervals as I pass open-air cafes. Couples lounge under multi-colored umbrellas. A boisterous group of revelers leans over a riverside bar and calls out as I pass by. On an apartment balcony a man forks something sizzling on his grill. As I pass a band shell the rhythm of my paddling assumes a zydeco cadence. The park teems with animated humanity.

South of the I-794 overpass twin rows of new pilings show where the riverwalk is being extended in an already successful effort to work its riverfront revitalization magic. Old warehouses gleam with fresh coats of paint; new windowpanes sparkle; satellite dishes sprout from rooftops like extravagant flowers.

A steady stream of pleasure boats of all sizes motor slowly past. The parade continues to cruise on toward Lake Michigan as I turn into the mouth of the Menomonee River. None follow.

Historically, the navigable portion of Milwaukee's namesake river suffered many of the same indignities as the Menomonee. However, after a decade of concerted efforts on the part of city government and downtown redevelopment interests, the two rivers could hardly present a greater contrast.

The rust-encrusted trusses of a swiveling railroad bridge, a still operational relic of a bygone industrial era, loom low overhead as I enter the Menomonee. Bright sun on the other side cannot dispel the shift of mood cast by its gloomy shadow. The riverfront wall of the central post office seems to rise out of the water like the sheer, unapproachable palisade of a brutalist fortress. Its ominous presence is made even more oppressive by the incessant roar emitted from huge vents high on its facade as if mammoth mechanical beasts caged within bellow in constant pain.

"River" is too elegant a name for what I now encounter as I paddle between retaining walls made from a great variety of materials with varying degrees of stability. Concrete predominates, much of it showing the ravages of winter ice in jagged joints and crumbling surfaces. Checkerboard patterns of reinforcing mesh protrude in places. The

Interstates 43 and 94 and the High Rise Bridge. Even here wildness persists!

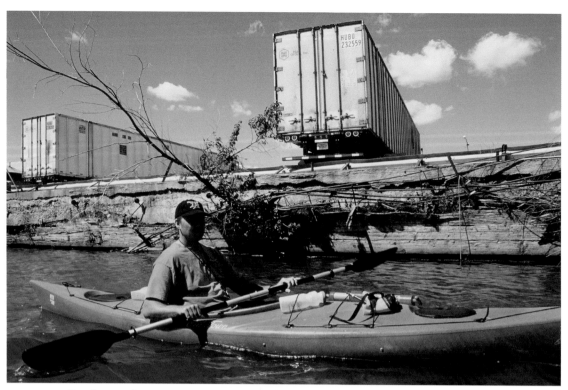

Kayaking in the Menomonee River canal. The challenge is not how to choose between nature and human enterprise but how to reintegrate both for a sustainable future.

few wooden pilings that remain are gray and cracked with age. Deep crevices reveal the repellant black of residual creosote. Little is intact. A rotted wall has been shored up with formerly neat rows of cut stone that buckle wildly.

"Where is the wilderness?" you might well ask.

Distilled into the most elemental cipher it persists! Wherever it can gain a toehold life bravely clings to the riverway, propagates, even flourishes. Wooden boards anchored to the vertical sides of concrete walls sprout tufts of grass and tiny white flowers. A rusting barge has become a floating island, its stanchions overhung with burgeoning shrubbery. In the shadow of the high-rise freeway bridge, a vacant lot is forested.

Dull walls of corrugated steel, concrete, and chemically resistant wood all sport a green fringe of unruly growth, bright and vivacious with spring. Grasses are succeeded by flowers and shrubs, superseded in turn by trees. Their dynamic shapes and rhythms interrupt the monotonous regularity of the canal walls with organic assertiveness, an arabesque of freedom.

Ubiquitous herring gulls adorn every available post and fence rail, but they are joined by a few more discriminating birds. A goldfinch glints amongst poplar leaves. A green heron plays tag with the canoe as I make my way upstream.

In the shade of the 27th Street Viaduct, I pause to gaze upstream at a river divided. The south bluff grows rampant. Towering trees block all view of the city beyond. Smaller ones sprout right from the water's edge and hang over it, creating a haven into which my intrepid green heron finally disappears. On the north side a corrugated steel rampart rises to protect the mammoth machinery of one of the valley's few remaining heavy industries from the wildness of the river in flood.

We are at a pivotal time in our understanding of the river and the watershed. Here is the paradox that reveals the nature of the challenge. We cannot tear down the factories and recreate a natural paradise in the city. That is neither practical nor desirable. But neither should we return to past development practices which so devastated the productive environment that drew people to this valley in the first place. The challenge is not how to choose between economic development and preservation of nature, but how to reintegrate both for a sustainable future. The natural river can — and must — coexist with the factory.

I rest briefly between these visible polarities, then release myself into the current and let it carry me back toward downtown.

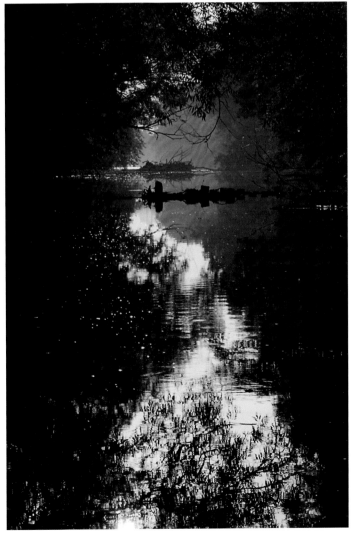

Menomonee Valley, Milwaukee.
Canyon-like the river feels like a distant
land, and the city disappears.

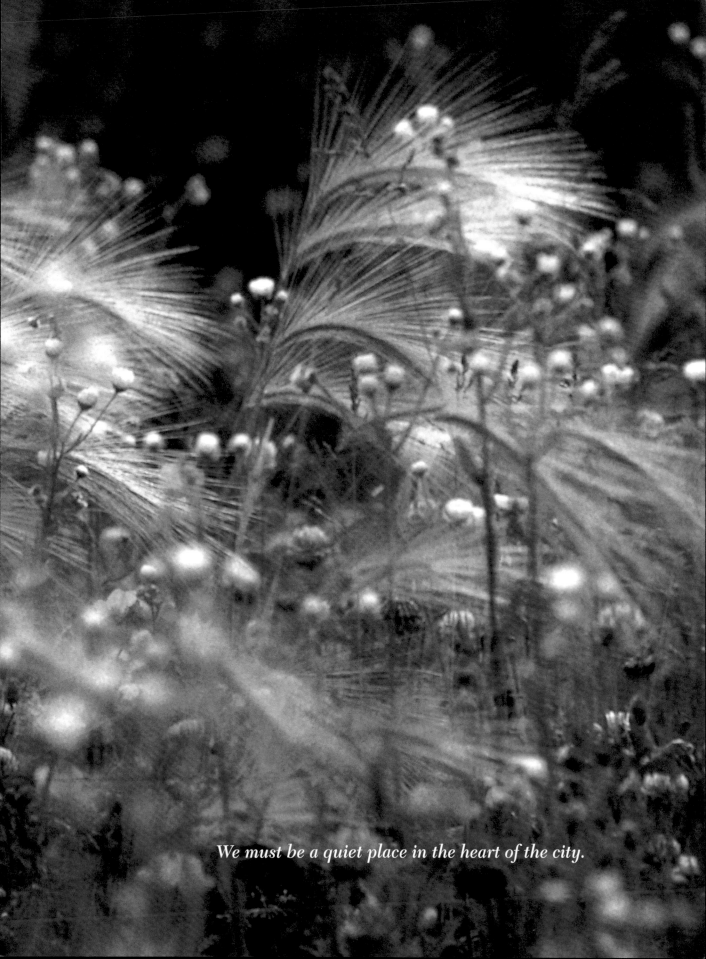

We must be a quiet place in the heart of the city.

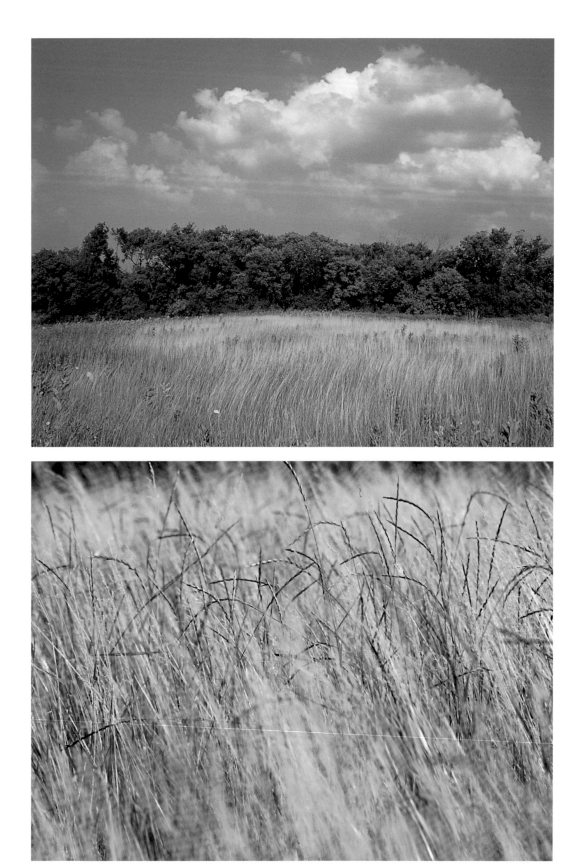

Top and bottom: rye grass, Wauwatosa; previous spread: squirrel tail grass and exotic wildflowers, Little Menomonee River Parkway.

AFTER TRAVELING THE VARIOUS AND CIRCUITOUS ROUTES from headwaters to the river's mouth, we return to the heart of the watershed to complete our journey, to a place that represents many of the land-use issues that face urban communities throughout the nation. These issues include public and private ownership, preservation of natural areas, recreational development, sustainable commercial development, flood mitigation, and the quality of urban life.

Imagine the astonishment and delight with which you would greet the discovery of buried treasure in your backyard. Then imagine emotions that might accompany news that, despite undisputed ownership, you would not be allowed to keep it. Not long ago, people in Milwaukee County experienced these things collectively. The treasure was 235 acres of county-owned open land buried in plain sight under bureaucratic neglect. Its legal and emotional disinterment came when the county proposed selling the land for residential and commercial development. County government quickly backpedaled when it encountered overwhelming opposition from the public and discovered a huge, vocal constituency that supports the preservation of green space.

This was a parcel of land of both subtle complexity and startling contrasts; one that was once thoroughly developed but which had been largely abandoned to the ravages of time and unhindered access. Ultimately, it reverted to a semblance of

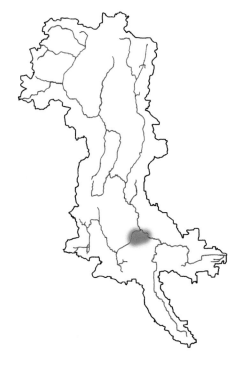

wildness that coexists with a great variety of activities. Soccer fields teem with players of all ages. Community gardens sprout flowers and vegetables. A county nursery is being phased out for a mammoth flood-control project. Tennis courts, golf, and archery aficionados have designated places. A day camp is tucked away in a forty-acre hardwood forest. Several businesses rent slowly decaying historic structures. There's a pauper's cemetery, without gravestones, for those who died working on the county poor farms that were once located here. A boneyard reminds us that hogs were butchered at one of those farms. There are a log fort, a makeshift wigwam, and several less noticeable hideouts fashioned by children with free imaginations. I've seen the sheriff's department use the area as a training ground, preparing to pursue less imaginary foes. And all of this is interconnected with a crazy quilt pattern of dirt roads and trails on which people drive, stroll, jog, walk dogs, ride bikes, hold hands, pick flowers, and daydream.

There's even room for wildlife. I've seen coyotes, foxes, raccoons, opossum, groundhogs, rabbits, turtles, snakes, frogs, mice, plenty of deer, and birds too plentiful to enumerate. Although I've never laid eyes on one, I've also smelled skunks.

Welcome to the Milwaukee County Grounds, a place large enough to absorb all of this and still retain a rolling prairie-like character. Do we need a prairie in the city? The land is large, but it will never be larger than it is today. Perhaps our grandchildren should decide.

Alive

The air is crisp and raw, so clear that the contours of distant trees snap against a receding sky, infinitely blue. Every twig on every branch of every tree is minutely defined. Scattered clouds alter the landscape from moment to moment. By turns it is ashen and lifeless, then brilliant and golden. Stark, wintry light flashes in incandescent bursts across the snowless hills, an exhilarating tonic and antidote for claustrophobic interiors and deadlines. Fleeting luminescence makes each tall blade of meadow grass stand erect and cry out with joy, "See the wondrous, dazzling world!"

The city falls into shadow. Winter withdraws from the blazing sun. The earth is alive.

Wading

Waist-deep and saturated with pre-dawn moisture, walking in the grass is like wading in the river. It takes less than five minutes to be soaked to the knees and through to my toes. My shoes and socks squish with every step. The first rays of the rising sun break

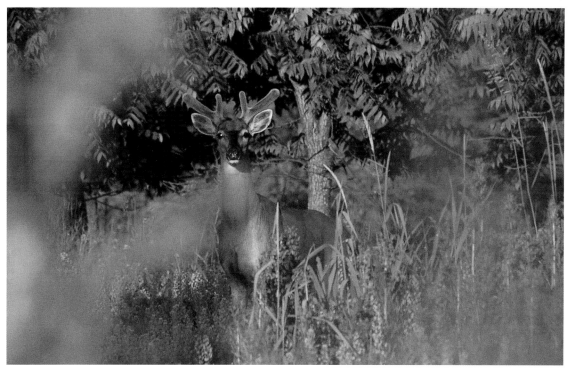

White tail deer, Milwaukee County Grounds, Wauwatosa.

through the tree line and play like searchlights across the landscape. Light pierces dew-drops in a wide arc across the field and a thousand vials of perfume are unstopped at once. A powerful, complex, and evocative scent rises from mingled flowers, grasses, and pines. The dimness and stillness of the landscape sharpens the aromatic effect. Here is a place to participate in the reawakening earth, to feel its newness spill all around and to breathe an intoxicating charge for the dawning day.

Three big bucks look up from their morning repast, glaring at me. Velvety racks and golden flanks take on the sheen of lamé in the early light. When I refuse to go they snort their disgust and leave me in my reverie and my soggy socks.

A Quiet Place

In his much-admired speech directed to President Franklin Pierce in 1854, Chief Sealth (or Seattle) is said to have lamented, "there is no quiet place in the white man's cities."[1] We who live in cities today cannot comprehend how profoundly intimate a relationship with nature he and his people experienced. "Every part of this country is sacred to my people. Every hill-side, every valley, every plain and grove has been hallowed . . . Even the rocks that seem to lie dumb as they swelter in the sun along the silent seashore in

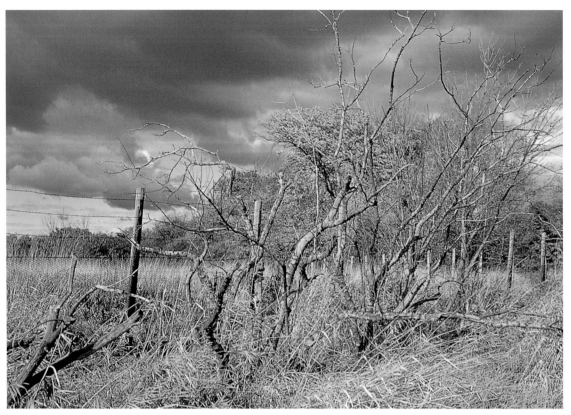

Approaching storm, Milwaukee County Grounds nursery. This was a parcel of land of both subtle complexity and startling contrasts, one that was once thoroughly developed but which had been largely abandoned to the ravages of time and unhindered access.

solemn grandeur thrill with memories of past events connected with the fate of my people, and the very dust under your feet responds more lovingly to our footsteps than to yours, because it is the ashes of our ancestors, and our bare feet are conscious of the sympathetic touch, for the soil is rich with the life of our kindred."[2] By comparison Thoreau was a dabbling novice. And I am even further divorced from nature than he. Under my feet I am more likely to feel pavement than dust. Like all city-dwellers I have adapted to an artificial environment which is never completely at rest. But I still need that quiet place. All who love the wild must carry that place in their hearts. We must *be* the quiet place in the heart of the city.

The Long View

I stand in a field of wildflowers surrounded by hundreds of fluttering monarchs, mesmerized. They waft on the breezes alighting momentarily, tiger-striped wings outstretched against the white of flowering boneset. Glancing up I am struck by the breathtaking view

of downtown from the crest of this hill. A sweeping slope falls away, and the vastness of space resides in this place like a tangible presence. Milwaukee's white towers shine in bright afternoon light. They seem impossibly remote, almost a mirage. The firmness of Earth and the largeness of sky, keenly felt, is the more reliable truth.

The view is equally compelling on a clear evening when lights sparkle off the distant buildings and stars sparkle overhead. But it is a view that should not be taken for granted, for that sparkle is as fragile as the flickering of candles in open air, as the future of this wide hilltop is being debated in halls of power and neighborhood meetings.

That such a lucrative piece of property remains in a semi-wild state is a quirk and an opportunity, one that communities face all across the nation. In Milwaukee, we are at a crossroads. By zoning this 235-acre parcel of land institutional where its institutions did not need to expand, Milwaukee County inadvertently preserved prime real estate from development. We have been granted the luxury of choice. Powerful forces drive an effort to privatize this publicly owned land and make it "economically viable." Historically, such forces have often moved forward with an impunity that borders on inevitability, but a potent groundswell of popular opinion has grown to oppose unplanned and shortsighted development.

Gazing out at the limitless horizon adds force to the phrase "in perpetuity for the benefit of all." How can the value of one more housing subdivision or commercial strip be weighed against this unique place in the metropolitan region where there is such a view, where there is more meadow-grass than pavement, more trees than structures, more wildflowers than anything?

Balance

A fog develops in the hollows, rising from the dampness after summer rain. In gathering dusk, the stillness of the shrouded landscape is reminiscent of a dim, vacated house in which the furniture has been wrapped with sheets. Mist softens every feature, rises, gradually thins, and dissolves into the pale evening sky. Seamless, land and sky become a floating world of fantasy out of which some fabulous vision seems likely to appear at any moment.

Then it comes, a point of balance in the fading light. Pink-orange illumination from streetlights and the unseen city rises out of the misty soup to meet and match the dwindling blues, lavenders, and opalescent grays of the darkening sky. An electric glow seems to emanate from the fog itself while the pale blues of the sky fade to a deep indigo gray. It is a moment both magical and sublime—a moment of harmony between the heavens and Earth.

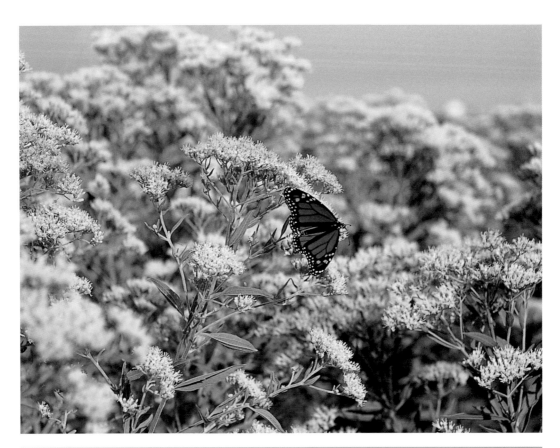

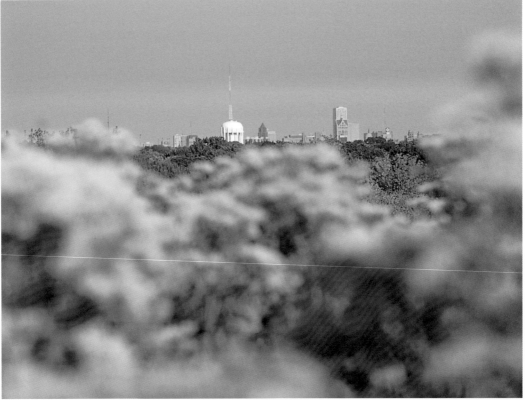

A monarch butterfly on boneset (top) and a view of downtown Milwaukee (bottom) from Milwaukee County Grounds, Wauwatosa.

And then it passes: the sky darkens, recedes into inky blackness. The immaterial Earth is incandescent orange; a mystical place somewhere between home and infinity.

Prairie Burn

What this place needs is a good burn! The suggestion is bound to elicit shrieks from the metropolitan fire department. But fire benefits biodiversity in meadows, and fire would facilitate the development of a more genuine prairie from this series of fallow fields overrun with nonnative vegetation. The publicity generated by a burn might even bring Milwaukee national attention. How many cities can boast of having a prairie this size to burn?

It almost wasn't so. Not long ago this publicly owned land was declared "surplus" by the county government and slated for residential and commercial development. Talk about a burn! That proposal created a political conflagration. Those who like to walk this land in solitude learned that we are not alone but are joined in spirit by many who feel redemptive power in open spaces, who prefer wildflowers to Wal-Marts and the occasional opossum and coyote to permanent condominiums. It is exhilarating to discover in this urban concentration a critical mass of support for the preservation of wildness. And what a symbol of wildness a controlled burn would be, to capture the imagination of the community, to quell the fear of fire so frequently broadcast by the evening news, to do good to the land.

Right now it is easy to imagine a prairie burn. The hills are aflame with unusually thick and tall goldenrod. The radiance of its blossoming fills entire fields in riotous extravagance. Bending and swaying, it reels in the wind like the flickering of resplendent fire.

Coyote

My first sighting of a coyote in Milwaukee was several years ago. Being flexible and resilient, coyote populations have benefited from the greater acceptance of a more environmentally conscious society. Coyotes have made increasing inroads in suburban, and even urban, areas where there are natural lands and river corridors to enable mobility.

I took it for a dog at first, but its gaunt, leggy frame and feral wariness registered immediately as peculiar. The fallow lands of the county's institutional grounds are very popular with dog walkers. Grateful dogs from all over the area are brought here to "run wild." But this was a truly wild creature. It materialized out of roadside brush, loped

furtively across, and disappeared again, blending into meadow-grass and goldenrod like a whisper of sunlight.

Since then I have occasionally spotted coyotes in various parts of the watershed but only in similarly evanescent encounters. An abundance of dog and deer tracks generally obliterates those of the vastly outnumbered coyotes, but now and then the distinctive print, with its longer and sharper toes, is visible. Its scat, threaded with the fur of its prey, is also easily distinguishable from a dog's, with its domesticated diet.

Such signs are encouraging. A stable population of coyotes in the watershed would benefit regional and local biodiversity. As the dominant predator it helps to control the proliferation of smaller predators such as raccoons. An overpopulation of smaller predators threatens many bird, reptile, and small mammal species. Coyotes can provide balance. But coyotes are more susceptible to the fragmentation of habitat— one of many arguments in favor of preserving a network of connected natural corridors.

Perfection

The forest floor is a checkerboard of light and dark that has been warped into a crazy quilt pattern by the vagaries of sunlight and foliage. Hundreds of round clusters of Virginia waterleaf are thrown across this fabric as if all the white checkers of a dozen games had been gathered and tossed randomly, the black ones discarded. Each individual blossom is a spherical cluster that rises out of a sea of spiky leaves like an explosion of pale lavender.

Thin stalks shoot up tall before branching briefly into two or three stems; then they immediately burst outward in all directions. Each slender stem bulges into pointy sepals that cup a bell-shaped corolla of five petals. Completing and exaggerating the explosive effect, myriad stamens shoot beyond the ends of the petals, their thread-thin filaments terminating in tiny dark brown anthers like the burnt tips of firebrands.

Can there be a more satisfying wildflower? They spread like grass in moist woodland soil, a perfect form married to function and suffused with a transcendent beauty. The clusters mingle and dance, animating the woodland scene.

None of this is for an observer's amusement. The dance goes on, with or without audience, in fulfillment of prosaic and essential purposes within a narrow ecological niche. Any declaration of finding the perfect blossom requires an admission of its rarity, subject as these flowers are to the vicissitudes of the wild. Nature in its profligacy never aspires to an idealized perfection such as the human mind can conjure. Rather than round, most of the clusters are misshapen and incomplete. Unopened buds share the limelight with those that are withering and tinged with brown.

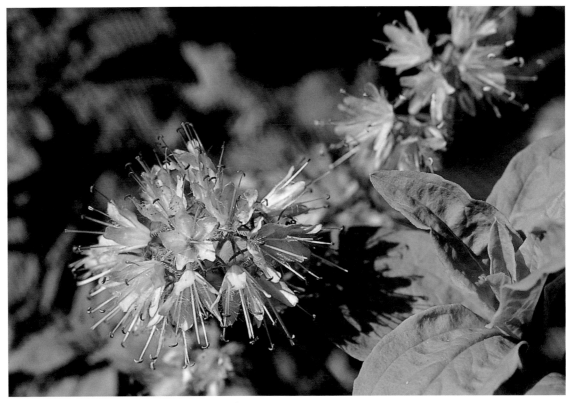

Virginia waterleaf, Milwaukee County Grounds, Wauwatosa.

Perfection and imperfection blur in the crowded forest, the flowers too numerous to be precious individually, too beautiful to be dismissed as inconsequential.

The Miracle

As I walk through Hoyt Park I am bathed in the soft glow of soothing lights placed at calculated intervals. Below the familiar bridge the water is unfathomably black, yet it gurgles peacefully like a tender lullaby. The inky void under the trees ahead, however, offers no such assurances. It takes a strong constitution or an act of faith to walk in the woods at night without a flashlight. Shadows with the opaque depth of unlit caverns elicit an irrational terror of falling; every branch is a threatening gesture. But those insecurities, common in any woodland setting, pale to pettiness in comparison with the mortal dread that many have of the *urban* wilderness at night, with its oft-perceived threat of violence. Here, darkness can acquire an aura of pure, palpable malevolence, and park lights are just one measure undertaken to exorcise our fears.

Taking the plunge I leave the park behind, then emerge from brief blindness into a world so transformed that it seems enchanted:

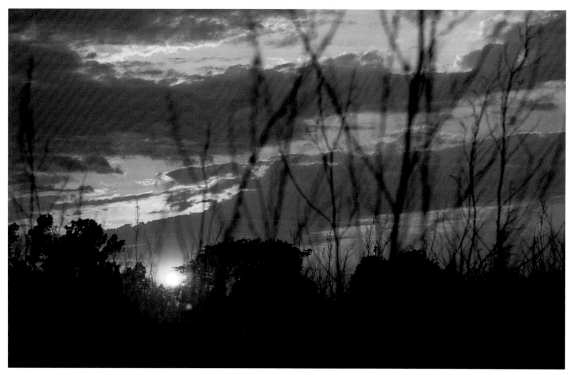

Sunset, Milwaukee County Grounds, Wauwatosa.

The full moon has an eternal magic beyond any imaginable metaphor.

The railroad tracks gleam like liquid silver streaks. Beyond them a prairie opens up as if a spell has been cast, and I peer through a parted veil into a mystical realm.

Though it is long after sunset the sky remains bright in the west, above an opaque silhouette of trees. Ragged ribbons of cloud catch dying rays of sun along their lower edges like a tattered banner of pale red, white, and blue emblazoned over the horizon. Toward the east the trees retain a colorless sheen as the moon rises over them behind a lace of clouds.

As the western sky continues to dim and the moon continues to rise a marvelous symmetry is achieved. The light shifts, leaving the eastern horizon in shadow, while the moon illumines the trees to the west in silvery filigree. Before long all save moonshadow is equally luminous. It seems miraculous.

The miracle isn't the moonlight, but rather being able to see it here in the city.

A full moon in all its glory looks pallid and feeble against the sodium vapor lamps on the streets. There can be no moonshadow where the fear of darkness dwells. But here, in a swathe of open land free of artificial light, the improbable happens. A surrounding screen of trees hides nearly all evidence of the city. A subtle pink aura hovers over downtown. A few red beacons blink atop water towers and radio transmitters. But they do not

overpower the fireflies in the grass, and the distant hum of traffic does not disturb the pulsating chitter of crickets.

A train rumbles by to challenge my perceptions and test my faith. The ground trembles and the air fills with thunderous clanking and ear-splitting squeals. But, in the rich silence the train leaves behind, the sound of crickets intensifies and the moon shines brighter. The sky has settled on a gray too light for stars. The dark is not fearsome tonight. It isn't even dark.

Winter Solstice

Late afternoon sun glows weakly through a thin skein of clouds. On this darkest of days it has never been far from the horizon. We leave behind a house and neighborhood as yet unlit, from which all color has been drained.

So begins my family's annual pilgrimage, a private tradition on the winter solstice connected to 4,000 years or more of ritual observances rife with the symbolism of renewal. At the winter solstice (which literally means "to stand still," referring to the celestial moment when the sun stops receding from the equator) ancient peoples often referred to the "unconquered sun" because its descent into darkness is arrested. Ritual helped to explain this event and drive off the "monsters of chaos" that might prevent the sun's return, with catastrophic consequences. Prior to the construction of elaborate structures for the marking of the solstices, such as Stonehenge in England, these rituals often took place at sacred natural sites, on hilltops, or in groves of trees.

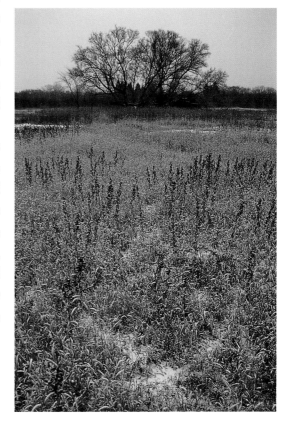

Traffic on the Menomonee River Parkway is thin, and its fittingly subdued sounds fade as we pass through the empty park. Across the railroad tracks, in the county grounds, urbanization slowly yields to wilderness. Turned but snow-free fields still bear meager, dryly rattling cornstalks, hollowed skins of squash, and carefully bundled staking sticks. Our footsteps fall on progressively softer earth; the concrete street gives way to

Fallow gardens in Milwaukee County Grounds, Wauwatosa.

asphalt sidewalk, then tire-tracked dirt road to earthen trail; then finally to grass as we step off the path entirely. No paths can take us from where we live to where we want to be today.

Formerly waist-high grasses lie in arrhythmic whorls. Rigid stalks of sturdier plants — goldenrod, teasel, and milkweed — stand like punctuation marks in an undecipherable text. Ahead stands the grove we seek, in an already shadowed hollow, as the sun burns softly on the horizon. Across the open meadow the wind is biting, but it dies when we reach the dell. Pushing cattails gently aside I test the ice atop the tiny rill. There is an open rift where water runs, black and silent, but the ice holds, and we step across into the heart of the grove. A galaxy of animal prints — rabbits, raccoons, and many birds — swirls around its center of gravity.

Among the smaller maples and ash is a tremendous, old black willow with so many trunks that they go uncounted. They radiate from its open center like ancient standing stones. Several have fallen and resprouted. One scarred limb lies horizontally across the middle, its bark completely abraded off by countless climbing shoes. It assumes the roles of megalith and altar.

Out of the wind it is suddenly warm despite the icy ground. To dispel the gathering gloom we light candles along the broken limb. Overhead the crown of the tree glows brightly. It is the moment of solstice — the standing-still sun. Our vigil combines solemnity with celebration; it also recognizes continuity between ancient archetypes and contemporary concerns. We honor the spirit of this place, the animals that share its shelter, the larger landscape all around, and the life-sustaining Earth; we uphold the unity of Creator and Creation; and we do all of this with a particular awe: we are here, minutes from home, in the center of metropolitan Milwaukee, and yet we are here, in quiet solitude, in the urban wilderness.

When we emerge again to the open field the golden horizon has cooled to magenta; a fierce winter wind flies in our faces. But the "monsters of chaos" have once again been contained; the darkest night will soon be gone; the land will persist; and — beyond superstition — the belief is rekindled that we as a people will learn to live in harmony with nature. The unconquered sun will be brighter tomorrow.

Top: the Cecropia moth is prevalent in the watershed; bottom: comfrey, Milwaukee County Grounds.

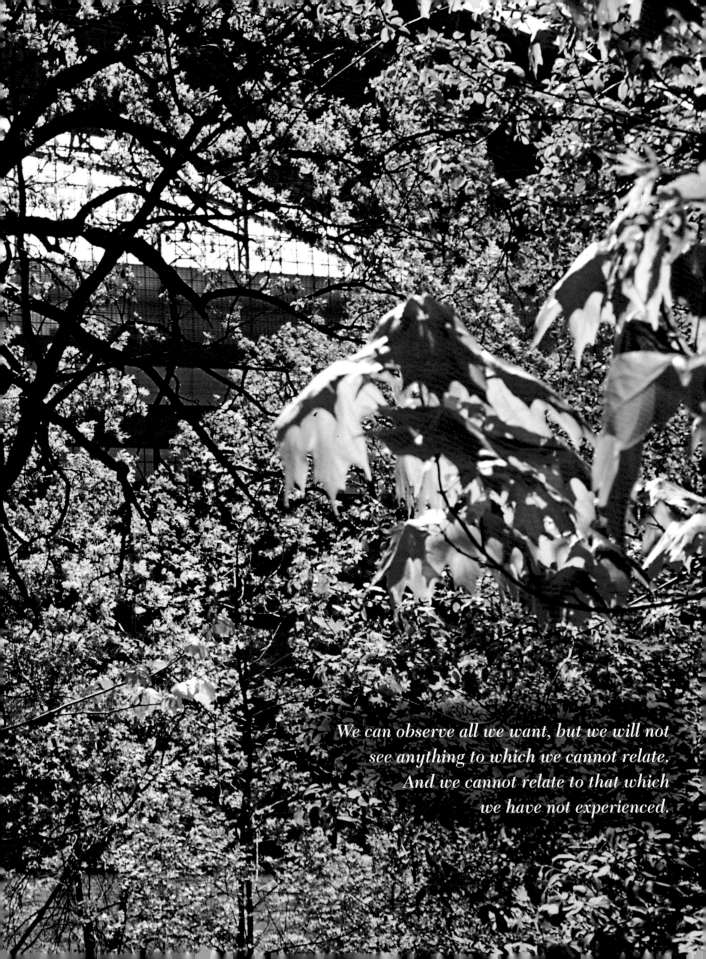

*We can observe all we want, but we will not
see anything to which we cannot relate.
And we cannot relate to that which
we have not experienced.*

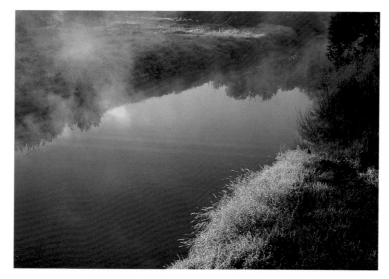

Top: Curry Park, Wauwatosa; center: salmon and roe, Menomonee Valley; bottom: Wirth Natural Area, Brookfield; previous spread: Miller Park Stadium, Milwaukee.

Survivors

Below a curiously deformed maple tree tiny yellow buttercups that were not here yesterday now spring from among greening cattails. The springs that feed the farthest reaches of the watershed remain mysterious abstractions like so much in an urban environment; like the water itself, which gushes, filtered and flourinated, from faucets and sits on supermarket shelves in plastic bottles with designer labels. But here, not far from the mouth of the watershed in the heart of the city, I finally find a permanent natural seep where water wells up from ground too saturated to contain it. The peculiar tree may have been shaped by native inhabitants as a trail marker. It is a long-lived variety of sugar maple that American Indians typically used for that purpose. It points directly toward a nearby prominence shrouded in morning fog. Following its lead I proceed along the now asphalt path.

Atop the ridge 200-year-old bur oaks rise out of the newly cut grass and into the mist. The oaks are survivors of fires set by the remnant Winnebago tribe (known in Wisconsin as the Ho-Chunk), themselves survivors of near extirpation in 1640. Prior to the establishment of the first European fur trading post on the valley rim in 1795, fire was used to manage the upland as a prairie. The oaks dwarf all the trees that have seeded themselves since the fur-trading Menominee settled in the lands of the more traditional Winnebago. The Menominee tribe was joined in the area by the Potawatomi, leading to a period of "pan-Indianism" before giving way to waves of European settlers. Eventually, those settlers established a soldier's home on this hilltop for survivors of their young nation's terrible Civil War and a cemetery for those who didn't survive. Today, on this hill, all that can be seen of these many different peoples are the solemn oaks and silent rows of identical white gravestones marching away into the mist.

This promontory is extraordinary for reasons much more difficult for the untrained eye to detect. At its base a sheer rock face rises from delicate columbines that droop in the damp morning air. All of the visible fossils have been picked from its surface, leaving

plain gray limestone. Here the titanic forces that shape the earth have heaved up a slice of time that is now 425,000,000 years old: a piece of reef that lived underwater during the Silurian geologic period. Like the oaks that grace its crest and the water that seeps around its base, the reef is a survivor. It sits at the head of the Menomonee Valley as the lone outcrop of natural bluff remaining after all the rest were torn down to fill the marsh they once surrounded and protected.

As the fog begins to thin the fragility of the earth grows clearer. Startlingly close at hand, a new presence looms overhead, dwarfing the oaks and ancient rock alike. The slowly brightening atmosphere reveals the dark mass of a wall more immense than any bluff the Menomonee River has known. It gradually resolves into a wide expanse of red-brown brick topped by the arched steel superstructure of the Milwaukee Brewer's new baseball stadium.

By the time I climb back up to the top of the hill and stand among the twisted trees once more the fog has burned off and the sun gleams through the stadium's glass. But the view of the river and the once-fertile valley that made this spot so prized by earlier inhabitants is completely blocked.

This impeded view at the head of the Menomonee Valley symbolizes the predicament we face. Often blinded by the technological progress that is one characteristic of our flexible and dynamic culture, we tend to identify one piece or another of the puzzle that is our planet rather than relating to whole systems. We can observe all we want, but we will not *see* anything to which we cannot relate. And we cannot relate to that which we have not experienced. The single factor that most determines who will grow to identify with nature or develop an environmental ethic is exposure to the natural world when young. We need places to have those experiences. The river can provide that opportunity. The city needs a *living* river and a system not just of parks, but of interconnected natural habitats. All people, but young people especially, need to have a chance to develop a habit of seeing nature. A living river corridor sustains wildlife, but more than that it sustains *people* who have a need to see herons and hawks, salmon and walleye, muskrats and turtles, foxes and wildflowers.

Looking out from hallowed ground above the inconceivably ancient reef, one must close one's eyes to envision not only the Menomonee River and its great valley beyond the stadium wall, but also the rest of the watershed all around. Doing so is not an exercise of imagination but an act of conviction and will that is an essential part of creating a sustainable city. Citizens, schools, businesses, institutions, and governments are beginning to see the value in standing on such a firm foundation. Doing so will enable us to join the ranks of the survivors.

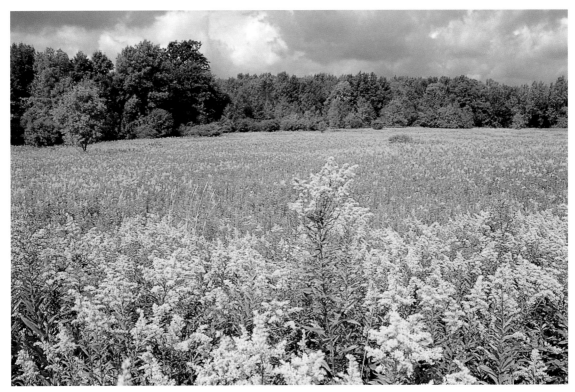

Goldenrod, Little Menomonee River Parkway, Milwaukee. A day-long hike from the center of Milwaukee County to its periphery, all on county parkland, proves the value of preserving environmental corridors in the city, suburbs, and rural areas.

We have choices: we can measure the span of our lifetimes against buttercups and columbines, bur oaks and sugar maples, or we can hold as our measure the Silurian reef, even deeper time. This new stadium will be considered obsolete some day, just like the stadium it replaced — which lasted forty-eight years, a long time by today's standards. Standing between it and the bluff the choice seems particularly stark. We have grown complacent living as if we existed somehow outside of nature, in a kind of bubble with a retractable roof. I walk back through the oaks, past the trail-marking maple and the seep, and return to the base of the bluff where columbines caress the face of limestone. To be survivors creating a hopeful future means to understand that we are as embedded in nature as fossils in an age-defying reef.

Corridor

The first two hours of my journey are tame, and I frequently pass other travelers on foot or bike. The parkland is typically mowed close to the river's edge, although even here in most places there is at least a narrow buffer of wilder vegetation, and I can choose to

stroll casually in the open along with the joggers or walk along well-used but shaded paths next to the water.

The wildlife also tends to be tame, a contradiction common in urban habitats. Mallards ease themselves off sandbars as I pass. Canada geese gather around children throwing them breadcrumbs. A half-dozen painted turtles sun themselves on a log. Black raspberry bushes have been picked clean of ripe fruit, leaving only the tiny, hard, yellowish unripe berries. The occasional viburnum and dogbane liven up the mostly uniform groundcover of invasive species.

The longer I walk, however, the more the character of the river and the land along it becomes wilder and the choice between pavement or riverside path becomes more pronounced. Then, having chosen the riverside, I reach a point at which the path disappears. Hundreds of tiny leopard frogs scatter as I wade through the marsh's grasses. Dense crops of jewelweed with broad leaves and delicate yellow flowers hold out against garlic mustard. Untouched black raspberry thickets provide me with a welcome treat. A large marsh hawk distinguishes itself from the smaller red-tailed hawks. Great blue herons rise before me like signal flares at regular intervals. But they are not signaling, as may be imagined from these descriptions, my passing beyond the borders of the city. Incredibly, I have never left the city.

Thoreau observed, "When we walk we naturally go to the fields and woods: what would become of us, if we walked only in a garden or a mall?"[1] But, for those of us who live in the city, where are we to find these fields and woods? In Milwaukee, the answer resides along the riparian corridors of Charles Whitnall's parkway system.

A day-long hike from the center of Milwaukee County to its periphery, still within the Milwaukee city limits, provides the best evidence I've seen for preserving environmental corridors. As Charles E. Little points out in his influential book, *Greenways for America*, the impact of a corridor of natural land is much greater than the actual amount of land preserved.[2] This is due to the "edge effect" or the perception that a long, thin greenway is much larger than it is.

But the value of natural corridors is not illusory. They provide "concrete and quite immediate social, environmental, and economic benefits" to the communities in which they are located.[3] These benefits include recreational opportunities, maximizing the health of the ecosystem and the integrity of wildlife habitat, and creating a more livable and attractive metropolitan area, thereby stimulating economic and community development and stemming residential flight from the city to the suburbs and beyond.

As I reach the county line at the end of the day I count the tenth street that I have crossed over — or under — but without once having to cross private property. Sadly, my

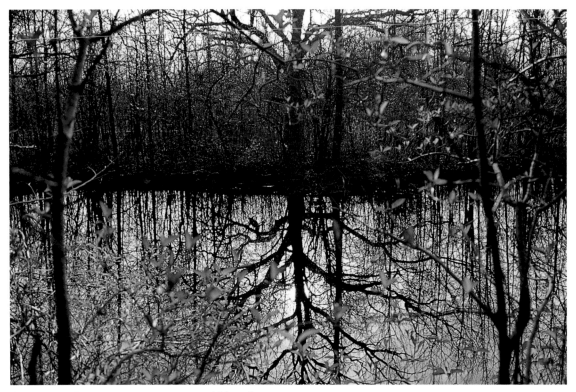

Greenseams Program conservation area, Milwaukee.

hike ends at the county line; though the river runs on into Ozaukee County and it still looks wild and inviting, "no trespassing" is posted on the other side of the road.

A regional extension of the Milwaukee County park system would greatly enhance the benefits already enjoyed within its bounds. A network of environmental corridors, as envisioned by numerous local and national organizations and individuals, would enlarge and improve the city's remarkable urban wilderness by connecting ecologically important habitats. It would also help people to reconnect with the land and remind us that we are not separate from nature.

A lone coyote slips into view up ahead, sniffs warily in my direction, then darts into the brush. I look up as two pairs of sandhill cranes soar like elegant wraiths over the tree line. They move smoothly together, like synchronized swimmers shooting upwards in unison without ruffling as much as a feather. They seem to be symbols of themselves—long, brown necks, pointed wingtips, and slender legs all equally outstretched like petroglyphs upon the dome of the sky. I swivel back toward the city of Milwaukee and watch as they slowly descend and, finally breaking formation, splash down among the geese and ducks that dot the lake in the Little Menomonee River Parkway.

Note to the Reader: Full citations appear in the *References and Suggested Readings* section.

EPIGRAPH

Olson (1976), p. 35.

INTRODUCTION

1. See Louv (2005) and Nabhan/Trimble (1994).

2. See Evernden (1992), Nash (2001), Oelschlaeger (1991), and Vale (2005).

3. Snyder (1990), p. 12.

4. *Ibid.*, p. 181.

5. It should be noted that there is no lack of planning and that the importance of natural areas has long been identified by the Southeastern Wisconsin Regional Planning Commission (SEWRPC), which was established in 1960, and to varying degrees by the cities, towns, and villages themselves. Unfortunately, the recommendations of SEWRPC are purely advisory, and the implementation of all plans is subject to fiscal restraints and political will. Many identified natural areas and primary environmental corridors are in private hands and remain unprotected.

6. Emerson, "Nature," in Atkinson (1940), p. 3.

THE MENOMONEE RIVER WATERSHED

1. Southeastern Wisconsin Regional Planning Commission (2005), pp. 1–2.

2. *Ibid.*, pp. 62–68.

CHAPTER 1: HEADWATERS

1. Silko (1995), p. 156.

2. Southeastern Wisconsin Regional Planning Commission (1997), p. 224.

3. Hayles (1996), p. 410.

CHAPTER 2: MARSHES AND SWAMPS

1. McKibben (1989).

2. Nash (2001), p. 6.

3. Proctor (1996), p. 281.

4. A Roman poet, as quoted in Nash (2001), p. 10.

5. *Ibid.*, p. 27.

6. This lake is unnamed and is in the north parcel of the Little Menomonee River Parkway.

CHAPTER 3: SUBURBAN RIVER

1. Friederici (1999), p. 89.

2. The freeway referred to here is US 45 in Germantown.

3. Bergquist (2005), p. 1.

4. This unnamed lake is a large retention basin at the Orchard Ridge Landfill in Menomonee Falls.

5. The landfill referred to is really two landfills that straddle the Waukesha County/Washington County line. Orchard Ridge, in Menomonee Falls, is currently accepting 4,800 tons per day of mixed municipal and industrial refuse. It does not accept hazardous waste, which is transported to facilities outside Wisconsin. Immediately adjacent to Orchard Ridge is the Omega Hills Landfill, in Germantown, which is currently closed. When operating, "The Omega Hills North Landfill [was] one of the largest landfills in Wisconsin, accepting 2,000 tons per day of mixed municipal and industrial refuse (about 550,000 tons of wastes annually). From 1977 to 1982, the site was licensed by the State to dispose of hazardous wastes, including liquids. More than 12 million gallons of liquids were accepted annually. The site stopped accepting hazardous wastes in November 1982 and liquid wastes in April 1983." Once a Superfund clean up site, in 1996 the U.S. Environmental Protection Agency determined that remedial actions had been completed and it was

removed from the Superfund National Priorities List. (Source: http://www.epa.gov/super-fund/sites/npl/nar723.htm and http://www.epa.gov/superfund/sites/npl/d961211.htm).

6. Berry (1986), p. 130.

CHAPTER 4: FRONTIER

1. Frederick Jackson Turner, as quoted in Nash (2001), p. 146.

2. Louv (2005), pp. 16–18.

3. The "classical" aesthetic in landscape painting originated in a post-Renaissance Europe that had long ago tamed most of its wilderness. In addition to the frequent intro-duction of architectural references to ancient Greek or Roman civilization into the land-scape, the classical emphasized a fundamental orderliness and calm dignity, and a pastoral scene was preferred over truly wild nature. Nineteenth-century Romantic artists, such as those associated with the Hudson River School and the Luminists, by contrast took pains to celebrate a wild landscape often devoid of human references alto-gether, especially in the New World where a vanishing wilderness began to be associated with nationalistic pride. See Nash (2001), pp. 67–83.

CHAPTER 5: HEART OF THE RIVER

1. Charles Whitnall was Secretary of the Milwaukee County Park Commission from its inception in 1907 until 1941.

2. Beveridge and Rocheleau (1998), p. 43.

3. Gurda (1999), p. 270.

CHAPTER 6: DESIGNING THE RIVER

1. Gary Snyder, as quoted in Barnhill (1999), p. 87.

2. http://www.epa.gov/region5superfund/npl/wisconsin/WID039052626.htm.

3. Rick Bass, "On Willow Creek," in Barnhill (1999), p. 216.

4. Leopold (1949), p. 41.

5. This lake is unnamed and is in the north parcel of the Little Menomonee River Parkway.

6. This Superfund site, administered by the Environmental Protection Agency's (EPA) region five, is known as the Moss-American site, after the company that established the

original wood-preserving facility in 1921. After decades of producing railroad ties, poles, and fenceposts preserved with creosote, the facility was closed in 1976. During some of its years of production, wastes were discharged into the Little Menomonee River. EPA's samples showed that the soil and groundwater in the vicinity of the site were contaminated with the components of creosote (including benzene, ethylbenzene, toluene, xylene, and polycyclic aromatic hydrocarbons) and that the river had been contaminated by runoff from the site. In 1987, the EPA began the process that would lead to the clean-up project that is described in this account. As of this writing, that process is on-going. (Source: http://www.epa.gov/region5superfund/npl/wisconsin/WID039052626.htm, August, 2005.) Another valuable book for general information is Hird (1994).

7. The EPA reports that, as of 2000–2001, measures implemented have successfully eliminated contaminated runoff into the river. In 2001, about 130,000 tons of contaminated site soils underwent a heat-cleansing treatment.

CHAPTER 7: ENTER AT YOUR OWN RISK

1. Nash (2001), p. xi.

2. *Ibid.*, p. 10.

3. See Cronon (1996), Nash (2001), and Oelschlaeger (1991).

4. Cronon (1996), p. 88.

5. See Santacroce (2005).

6. Nhat Hanh (1987), p. 57.

7. The local high school is Brookfield East High School.

8. Orr (1994), p. 12.

9. Louv (2005), p. 43.

CHAPTER 8: CONFLUENCE

1. McHarg's classic book, *Design With Nature* (1969; 1994), remains an inspiration for those who believe in ecological design and regional planning.

CHAPTER 9: CONCRETE CREEKS

1. Stegner (1996), p. 17.

2. As quoted in Beveridge and Rocheleau (1998), p. 32.

3. *Ibid.*, p. 30.

4. The duck pond is Lake Wheeler, which is part of the Clement A. Zablocki V.A. Medical Center.

5. Louv (2005), p. 2.

6. *Ibid.*, p. 43.

7. See Tuan (1989).

CHAPTER 10: INDUSTRIAL VALLEY

1. Cieslewicz (2002), p. 10.

2. See Jakle and Sculle (2004).

3. Thoreau (1862; 1992), p. 5.

4. *Ibid.*, p. 5.

5. The banding team was organized and led by Greg Septon, chairman of the Wisconsin Peregrine Society (now called the Wisconsin Peregrine Trust). The other members of the team were made up of employees of the facility where the nest is located, in this case the We Energies Menomonee Valley Power Plant. This policy promotes a sense of ownership and leads to long-term preservation efforts at each nesting site. There are four nesting sites in Milwaukee, three of which are in the Menomonee Valley. All of them are located on architectural structures. Other nesting sites have been reestablished throughout Wisconsin, some in natural cliff habitats. Dr. Thomas C. Hunt, Director of the Department of Reclamation, Environment, and Conservation at the University of Wisconsin-Platteville, was also a leader in the reintroduction of the peregrine falcon in Milwaukee when he worked for Wisconsin Power & Light Company (WP&L). Hunt worked with Septon and others to help bring the peregrine falcons back to Milwaukee. He persuaded WP&L's electric generating plants to install specifically designed nesting boxes to recruit breeding pairs, especially along the Lake Michigan flyway and elsewhere throughout Wisconsin. The program was quite successful: first, Hunt and WP&L fledged a significant number of birds, which ultimately helped in the de-listing of the peregrine falcon as an endangered species; second, the program created environmental interest and education; and, third, workers at the power plants took ownership of the program, including bleeding and banding the chicks each spring.

CHAPTER 11: PRAIRIE IN THE CITY?

1. See eJournal. As noted on the Website, this speech is controversial since there is "no verbatim transcript in existence." The familiar words quoted and attributed to Chief Seattle were a creative translation by Ted Perry, circa 1971. See http://www.synaptic.bc.ca; accessed 14 August 2005.

2. Chief Seattle, as quoted in Gifford and Cook (1992), pp. 20–21.

EPILOGUE

1. Thoreau (1862; 1992), p. 12.

2. Little (1995), p. 30.

Note to the Reader: An asterisk (*) indicates a text reference.

Abbey, Edward. *Desert Solitaire* (New York: Ballantine Books, 1968).

* Atkinson, Brooks, ed. *The Complete Essays and Other Writings of Ralph Waldo Emerson* (New York: Random House, 1940).

Backes, David. *The Wilderness Companion* (Minocqua, WI: NorthWord Press, 1992).

* Barnhill, David Landis, ed. *At Home on the Earth: Becoming Native to Our Place* (Berkeley and Los Angeles: University of California Press, 1999).

* Bass, Rick. "On Willow Creek," in Barnhill, *ibid*.

* ———. *The Sky, the Stars, the Wilderness* (New York: Houghton, Mifflin, 1997).

Bergon, Frank. *The Wilderness Reader* (Reno and Las Vegas: University of Nevada Press, 1980).

* Bergquist, Lee. "ATVs Lead the Pack" *Milwaukee Journal Sentinel*, Sunday, June 26, 2005, Section A.

Berry, Thomas. *The Dream of Earth* (San Francisco: Sierra Club Books, 1988).

Berry, Wendell. *Recollected Essays, 1965-1980* (San Francisco: North Point Press, 1981).

* ———. *The Unsettling of America* (San Francisco: Sierra Club Books, 1986).

* Beveridge, Charles E., and Paul Rocheleau. *Frederick Law Olmsted: Designing the American Landscape* (New York: Universe, 1998).

Bode, Carl, ed. *Thoreau* (New York: The Viking Press, 1964).

Carson, Rachel. *The Sense of Wonder* (New York: Harper & Row, 1965).

* Cieslewicz, Dave. *City Ethic: Urban Conservation and the New Environmentalism* (1000 Friends of Wisconsin Website, January 2002).

Cronin, John, and Robert F. Kennedy, Jr. *The Riverkeepers: Two Activists Fight to Reclaim our Environment as a Basic Human Right* (New York: Scribner, 1997).

° Cronon, William, ed. *Uncommon Ground: Rethinking the Human Place in Nature* (New York: W. W. Norton & Co., 1996).

Dillard, Annie. *Pilgrim at Tinker Creek* (New York: Quality Paperback Books, 1974).

° eJournal, http://www.synaptic.bc.ca.

° Emerson, Ralph Waldo. "Nature," in Atkinson (1940), *op cit*.

° Evernden, Neil. *The Social Creation of Nature* (Baltimore: The Johns Hopkins University Press, in association with the Center for American Places, 1992).

° Friederici, Peter. *The Suburban Wild* (Athens: University of Georgia Press, 1999).

° Gifford, Eli, and Michael Cook, ed. *How Can One Sell the Air? Chief Seattle's Vision* (Summertown, TN: Native Voices, The Book Publishing Co., 1992).

Gumprecht, Blake. *The Los Angeles River: Its Life, Death, and Possible Rebirth* (Baltimore: The Johns Hopkins University Press, in association with the Center for American Places, 1999).

° Gurda, John. *The Making of Milwaukee* (Milwaukee: The Milwaukee County Historical Society, 1999).

° Hayles, Katherine N. *Simulated Nature and Natural Simulations: Rethinking the Relation between the Beholder and the World*, from Cronon, (1996), *op. cit.*

Hird, John A. *Superfund: The Political Economy of Political Risk* (Baltimore: The Johns Hopkins University Press, in association with the Center for American Places, 1994).

Jakle, John A., and Keith A. Sculle. *Lots of Parking: Land Use in a Car Culture* (Charlottesville: University of Virginia Press, in association with the Center for American Places, 2004).

Jussim, Estelle, and Elizabeth Lindquist-Cock. *Landscape as Photograph* (New Haven: Yale University Press, 1985).

Ketchum, Robert Glenn. *Overlooked in America: The Success and Failure of Federal Land Management* (New York: Aperture, 1991).

° Leopold, Aldo. *A Sand County Almanac and Sketches Here and There* (New York: Oxford University Press, 1949).

* Little, Charles E. *Greenways for America* (Baltimore: The Johns Hopkins University Press, in association with the Center for American Places, 1995).

* Louv, Richard. *Last Child in the Woods: Saving Our Children from Nature-Deficit Disorder* (Chapel Hill: Algonquin Books, 2005).

* McHarg, Ian L. *Design With Nature* (Garden City, NY: Natural History Press, 1969; second edition, New York: John Wiley & Sons, 1994).

* McKibben, Bill. *The End of Nature* (New York: Random House, 1989).

Menominee Indian Tribe of Wisconsin, http://www.menominee-nsn.gov/index.asp.

Murray, John A., ed. *Nature's New Voices* (Golden, CO: Fulcrum Publishing, 1992).

* Nabhan, Gary Paul, and Stephen Trimble. *The Geography of Childhood: Why Children Need Wild Places* (Boston: Beacon Press, 1994).

* Nash, Roderick. *Wilderness and the American Mind* (New Haven: Yale University Press, 1967; fourth edition, 2001).

* Nhat Hanh, Thich. *The Miracle of Mindfulness: A Manual on Meditation* (Boston: Beacon Press, 1987).

Norquist, John O. *The Wealth of Cities: Revitalizing the Centers of American Life*. (Reading, MA: Addison-Wesley, 1998).

* Oelschlaeger, Max. *The Idea of Wilderness: From Prehistory to the Age of Ecology* (New Haven: Yale University Press, 1991).

* Olson, Sigurd F. *Reflections from the North Country* (New York: Knopf, 1976).

* Orr, David W. *Earth in Mind: On Education, Environment, and the Human Prospect* (Washington, DC: Island Press, 1994).

Perlin, John, and Robert Redford. *The Legacy of Wildness: The Photographs of Robert Glenn Ketchum* (New York: Aperture, 1993).

Porter, Eliot. *In Wildness Is the Preservation of the World* (San Francisco: Sierra Club & Ballantine Books, 1967).

* Proctor, James D. "Whose Nature? The Contested Moral Terrain of Ancient Forests," from Cronon (1996), *op. cit.*

Pyle, Robert Michael. *The Thunder Tree: Lessons from an Urban Wildland* (New York: The Lyons Press, 1993).

* Santacroce, Lisa. *Economic Impacts of Open Space Protection* (Connecticut Audubon Society, 2005, http://www.ctaudubon.org/advocacy/archives/open_space.htm).

Shaw, Robert, and Jason Lindsey. *Windy City Wild: Chicago's Natural Wonders* (Chicago: Chicago Review Press, 2000).

Sheldrake, Rupert. *The Rebirth of Nature: The Greening of Science and God* (New York: Bantam Books, 1991).

* Silko, Leslie Marmon. "Interior and Exterior Landscapes: The Pueblo Migration Stories," from George F. Thompson, ed., *Landscapes in America* (Austin: University of Texas Press, 1995).

Snyder, Gary. *A Place in Space* (Washington, DC: Counterpoint, 1995).

* ———. *The Practice of the Wild* (New York: North Point Press, 1990).

* Southeastern Wisconsin Regional Planning Commission. *A Regional Natural Areas and Critical Species Habitat Protection and Management Plan for Southeastern Wisconsin, Planning Report No. 42* (September, 1997).

* ———. *Water Quality Conditions and Sources of Pollution in the Greater Milwaukee Watersheds, Technical Report No. 39* (September 2005).

* Stegner, Page. *Call of the River: Writings and Photographs* (New York: Harcourt Brace & Co., 1996).

* Thoreau, Henry David. *Walking* (Bedford, MA: Applewood Books, 1992: originally published in 1862).

Trimble, Stephen. *Words from the Land* (Reno and Las Vegas: University of Nevada Press, 1995).

* Tuan, Yi-Fu. *Morality and Imagination: Paradoxes of Progress* (Madison: University of Wisconsin Press, 1989).

* U.S. Environmental Protection Agency, http://www.epa.gov/region5superfund/npl/wisconsin/WID039052626.htm.

Vale, Thomas R. *The American Wilderness: Reflections on Nature Protection in the United States* (Charlottesville: University of Virginia Press, in association with the Center for American Places, 2005).

Wilson, Edward O. *The Future of Life* (New York: Alfred A. Knopf, 2002).

* ———. *In Search of Nature* (Washington, DC: Island Press, 1996).

EDDEE DANIEL was born in 1952 in Bronxville, New York, in the greater Hudson River watershed, and he was raised along Nauraushaun Creek in Pearl River, New York. He received his B.S. degree in art education from the University of Wisconsin-Madison in 1976 and his M.S. in art education from the University of Wisconsin-Milwaukee in 1985. He has been teaching art and photography in the Milwaukee area since 1980, at Carroll College, Mount Mary College, the University of Wisconsin-Waukesha, and Marquette University High School.

His photography has been published in *Popular Photography, The Photo Review, Phototechniques, Photography as a Fine Art, New Mexico Photographer, Art in Wisconsin,* and *Family: A Celebration of Humanity,* by William Morrow. He has received awards from the Wustum Museum of Art, Wisconsin Painters and Sculptors, Savannah College of Art and Design, The Sierra Club, The Photographic Society of America, Upstream People Gallery, *Company* magazine, and Milwaukee Area Teachers of Art. The *Urban Wilderness Project* received the Kodak American Greenways Program Award from The Conservation Fund in 2003.

His extensive record of exhibitions includes the Milwaukee Art Museum, Haggerty Museum of Art at Marquette University, Charles Allis Art Museum in Milwaukee, Wustum Museum of Art in Racine, Wright Museum of Art in Beloit, Center for Visual Arts in Wausau, University of Miami (Coral Gables), Coastal Arts League of Half Moon Bay, California, University of Oklahoma (Norman), Central Washington University (Ellensburg), Upstream People Gallery in Omaha, Nebraska, and Aberdeen Gallery in Washington, DC.

He has been on the Board of Directors of Friends of Milwaukee's Rivers since 1999. He lives in Wauwatosa, Wisconsin, next to the Menomonee River.

Center for American Places

AT COLUMBIA COLLEGE CHICAGO

The Center for American Places is a nonprofit organization, founded in 1990 by George F. Thompson, whose educational mission is to enhance the public's understanding of, appreciation for, and affection for the places of the Americas and the world—whether urban, suburban, rural, or wild. Underpinning this mission is the belief that books provide an indispensable foundation for comprehending and caring for the places where we live, work, and explore. Books live. Books endure. Books make a difference. Books are gifts to civilization.

With offices in Chicago, Santa Fe, and Staunton, Virginia, Center editors have brought to publication more than 320 books under the Center's imprint and in association with numerous publishing partners. Center books have won or shared more than 100 editorial awards, prizes, and citations, including multiple best-book honors in more than thirty academic fields.

The Center strives everyday to make a difference through books, research, and education. For more information, please send inquiries to the Center for American Places at Columbia College Chicago, 600 South Michigan Avenue, Chciago, IL 60605–1996, U.S.A., or visit the Center's Website (www.americanplaces.org).

ABOUT THE BOOK:

Urban Wilderness: Exploring a Metropolitan Watershed is the twelfth volume in the *Center Books on American Places* series, George F. Thompson, series founder and director. The book was brought to publication in an edition of 500 hardcover and 2,500 paperback copies with the generous support of the Friends of the Center for American Places and those listed in the *Acknowledgments* section, for which the publisher is most grateful. The text was set in New Caledonia with Frutiger display, and the paper is Grycksbo matt, 150 gsm weight. The book was printed and bound in Singapore.

FOR THE CENTER FOR AMERICAN PLACES AT COLUMBIA COLLEGE CHICAGO:

George F. Thompson, Founder and Director

Amber K. Lautigar, Operations Manager and Marketing Coordinator

A. Lenore Lautigar, Publishing Liaison and Associate Editor

Catherine R. Babbie and Elizabeth S. Dattilio, Editorial and Production Assistants

Purna Makaram, Manuscript Editor

Marcie McKinley, Design Assistant

David Skolkin, Book Designer and Art and Production Director